Art, Culture, and the Semiotics of Meaning

Semaphores and Signs

General Editors: Roberta Kevelson and Marcel Danesi

Art, Culture, and the Semiotics of Meaning

Culture's Changing Signs of Life in Poetry, Drama, Painting, and Sculpture

Jackson Barry

St. Martin's Press
New York

Library of Congress Cataloging-in-Publication Data

Barry, Jackson 1926–
 Art, culture, and the semiotics of meaning: culture's changing signs of life in
poetry, drama, painting, and sculpture / Jackson Barry.
 p. cm.—(Semaphores and signs)
 Includes bibliographical references and index.
 ISBN 0-312-21967-9
 1. Semiotics and the arts. I. Title. II. Series.
NX180.S46B37 1999
700'.1'4—DC21 98-46252
 CIP

Design by Letra Libre

First edition: June 1999
10 9 8 7 6 5 4 3 2 1

CONTENTS

ILLUSTRATIONS

ACKNOWLEDGMENTS

It is my pleasure to acknowledge here the help I have received in bringing this book to fruition. The Semiotic Society of America and its members presented both a stage and an exchange for thinking about ways of making meaning that found their way into *Art, Culture, and the Semiotics of Meaning*. Closer to home, I owe a debt to various of my colleagues at the University of Maryland who in conversations and through their comments on drafts of my chapters helped me to clarify ideas and to find appropriate examples. On this score, I am particularly grateful to Stanley Plumly, Milne Holton, Neil Isaacs, and Mark Turner. Special thanks must go to Norma Procopiow for helping me to keep the good and throw out the bad. I must record as well my thanks to Roberta Kevelson, coeditor of the Semaphores and Signs series, and to Michael Flamini, senior editor for the Scholarly and Reference Division of St. Martin's Press, in whom my book found favor and eventual materialization. For the careful copy-editing which turned a manuscript into a book, I must record my gratitude to Enid Stubin.

Early drafts of the materials which appear as chapters 5, 6, 7, and 8 were presented as panel papers at the annual meetings of the Semiotic Society of America and appeared in the Society's *Proceedings*. I am grateful to the editors of the *Proceedings* for permission to use these materials here. A part of chapter 3 was given as a paper at the Fifth Congress of the International Association for Semiotic Studies (Berkeley 1994). For permission to reprint this material from the *Proceedings* of that meeting, I wish to thank its publisher Mouton de Gruyter. Material on Kenneth Noland and nonobjective art appeared first in my article "Meaning, Being, and Ostention: Semiotics and the Arts," *American Journal of Semiotics* 4 1986. I am grateful to the journal and its editor, Richard Lanigan, for permission to reprint parts of that article. All of these papers have been considerably expanded, revised and updated. I was very pleased to be included in volume 2 of the *Interdisciplinary Journal for Germanic Linguistics and Semiotic Analysis* with "Cognitive Science and the Semiotics of Art" (1997). That

article with only slight modification appears as chapter 9 of the present volume with the permission of the University of California Regents.

For permission to use pictures from their collections I must thank the National Museum of American Art and the Hirshhorn Museum and Sculpture Garden, both of the Smithsonian Institution, the Folger Shakespeare Library, the President and Scholars of St. John's College, Oxford, and the Museum of Modern Art.

I have been fortunate to be able to print a picture of the set for *A Streetcar Named Desire* specially prepared for this volume to show areas previously cropped. For this print, I owe special gratitude to the photographer, Eileen Darby, who made this new print from her original negative taken at the opening of Tennessee Williams's play in Boston, 1947.

INTRODUCTION

Authority versus personal responsibility; the free market and racial exploitation: what themes could be more meaningful to our time; what themes more important to create or find in works of art? Sophocles' *Antigone* will stimulate a discussion of the first. Langston Hughes's poetry can serve as a base for the second. Have we missed a meaning here? Given Antigone's dilemma, who cares about the meaning of Greek strophic form? Given a "dream deferred," who cares about the meaning of Hughes's prosody? I suggest that the kind of attention to the arts that almost exclusively focuses on the ethical generalities that are assumed to be art's thematic content inevitably impoverishes the arts. It leaves poems, novels, paintings, and dances bereft of those formal and material meanings that embody meaning in the very cognition of the human experience.

Outside the arts as well, content is king. We flock to "talk shows" without asking what is talk. We surf for information without considering its matter and structure, qualities that would link information to understanding. Obviously there is in the arts great popular appeal to the content side—the "story," the represented impressionist "garden"—while the attention to form is regarded as tedious, if not downright perverse. I will argue that through primary focus on content, especially in the experience of art, we are missing a meaning, one that lies very close to the root of our perception as seen by recent cognitive science. I believe that semiotics can provide a kind of epistemological base ideally suited to investigate these issues.

This book, then, explores the problem of meaning in the arts through the insights provided by what has been called the science of meaning, semiotics. There is considerable disagreement about whether artworks mean anything at all other than the literal referent of their iconic or symbolic aspects: a field with cows in a landscape painting, a tragic set of events in the life of a jealous general in Shakespeare's *Othello*. There is also

considerable disagreement about the ability of a discipline—semiotics—typically focused on the kinds of regularly coded meanings mentioned above to function both willingly and effectively in theorizing the kinds of noncoded meanings that I will suggest may be found to be functioning most forcefully, though certainly not uniquely, in the arts. The fleshing out of these problems will be the work of the chapters to follow. This fleshing out will here be focused on those problems of meaning that derive from the nature of artistic form (essentially here, the physical nature of the signifier), a realm that, I hold, presently deserves more study than the already much studied realm of the signified.

The problems of aesthetics, the nature and workings of art, are, as can be seen in any bibliography of the subject, demonstrably timeless in their appeal. I will argue, however, that a number of influences within the disciplines that study the arts make this moment in the last decade of the twentieth century particularly important for a rethinking of our relation to our art works. Since mid-century, all of the disciplines that deal directly or indirectly with the arts have seen remarkable developments and new directions of thought. Art-theoretical discourses have moved away from a belief in New Critical autonomy toward the generally anthropological and diachronic view of the New Historicism, which emphasizes the cultural contexts of an art scene enormously expanded from the previous canon of masterpieces. In this view, a new two-way exchange between the sciences and the humanities has created some unexpected and at times uncomfortable bedfellows for literary and art theory. Law, history, and even on occasion physics have become infected by the virus of deconstruction. The expansion since the 1960s of that omnivorous discipline, semiotics, formerly devoted mainly to the philosophical and linguistic dimensions of meaning, has initiated an uneasy mutual attraction to the arts. Outside this new mix of social, philosophical, and art-theoretical studies now vigorously marketed as Cultural Studies looms an as-yet unintegrated study, cognitive science, currently making enormous advances. The profound influence that this study seems sure to have on our understanding of culture makes especially compelling a new analysis of the arts, semiotics, and meaning that will orient these fields toward their inevitable meeting with the new "brain sciences."

In addition to disciplinary concerns within the academy, the art market itself, the turbulent day-to-day thrust of that culture we want so much to study, has itself taken a turn toward a more content-oriented interest in art. Flatly put, today's aesthetic discourse addresses not the golden mean

but the mean streets of our social discontent. When art speaks, it speaks of disenfranchisement, of race, gender, and class: of politics. Galleries favor photographs; theaters strain to make their political points in cross-castings and other repudiations of institutional domination. What foolhardiness, what utter unconcern, could inspire a book on *form* in the arts today? I urge that in form lies an important part of the very "reality" of the life that contemporary discourse is seeking. Of course this must be form with *meaning,* and here semiotics enters the picture willingly or unwillingly, for even semiotics is in many instances leery of form's power to tell us of anything other than its impenetrable self.

To establish the place of material and formal values in our considerations, I will argue that culture, in its arts high and low, means in two different ways. On the one hand, our symbols have a referential meaning different from themselves, as the words "I like Ike" told us that the subject of the sentence had a fondness for the distinguished general who would become the thirty-fourth president of the United States. On the other hand, the material quality of these same words: the crispness of the uttered phrase in the connectedness of their repeated "eye" sound, ostends a meaning, quite elementary in this particular example, but typically rich and complex in our best artworks.[1]

Today attention to the creation of this second meaning, either by the artist or the audience, is split by the political weight the artwork must bear. On the one hand, niceties of technique and form are decried as the meaningless products of a bourgeois aestheticism, a spirit most in evidence at the notorious Whitney Biennial of 1993.[2] On the other hand, "new formalisms" burgeon, as they have for example in recent poetry by feminist and lesbian poets, artists who, one would think, want particularly to avoid any implications of a traditional technique. At one time, a museum will deconstruct the autonomy of the pictures on its walls through the socially conscious placards and catalogues that politically reconstruct the meaning of its exhibitions, as the National Museum of American Art did in its 1991 exhibit "The West as America: Reinterpreting Images of the Frontier, 1820–1920." Yet that most "formalist" of arts—the nonobjective painting—closed the century in conspicuous splendor at New York's Guggenheim Museum, in its 1996 exhibit *Abstraction in the Twentieth Century: Total Risk, Freedom, Discipline.*[3]

In this confusion of means, meanings are missed. Even where form is stressed in some of the most technically and structurally complex of works,

these devices may become postmodern "quotations" or "parodies" of canonical works, signifying contents by convention rather than by the ostended force of their own being. Certainly and fortunately the shell of artistic autonomy has been broken. However, matter and form were never merely "aesthetic" trimmings but are themselves culturally derived and, in ways close to the bare earth of nature, define the political themes of the content through the particular formal articulation of this content. My business in the later chapters will be a consideration of these formal and material meanings in the comprehension of time, space, and language.

I have attempted here to write a book that would be useful to those who practice the arts and those who theorize about them. Inevitably in such a mix, the artists may balk at certain metaphysical niceties while the philosophers will decry summary treatments of complex issues. Yet if the current—and laudable—spirit of interdisciplinarity is to flourish at all, while even individual disciplines multiply their own internal complexities, a level of sophisticated, shared dialogue must be found. Semiotics, I hold, offers just the platform for such a discourse. Beyond the use of semiotics as theoretical base, another prospect for this necessary interdisciplinary dialogue may be found in the great changes that communications technology has brought to the old idea of the linear text. Though I have worked to produce a coherent and developing argument, one could regard the text offered here as a hypertext in which skipping is permitted and in which links to other texts are frequently embedded in the endnotes.

Semiotics can be great fun: observe how the skirted silhouette on the sign for the female bathroom hardly matches the jeans-clad woman who reads that emblem correctly. In this world of signs, such critical viewing is healthy, probably even essential, but a discipline that tells us only how we invest meaning in bathroom signs and traffic lights would provide little more useful knowledge than a parlor game. My emphasis in the present study will be to offer a more theorized semiotics tested in a number of analyses that will elaborate both the theory and the viability of the application. Specifically, I attempt to push beyond currently received dogma by spelling out more clearly the nature and use of ostention, or exemplification, a dimension of meaning that I take to be essential to the art experience. In another area of semiotics, I attempt, with some help from cognitive science, to redefine the nature of the categories of undifferentiated matter and content passed down from Hjelmslev to Greimas and Eco (Eco 1976: 50–54).

Theory and application must be closely bound, and to substantiate ideas floated in the first theoretical chapters in the later analytical chapters, I plunge into the material and formal realm with examples taken from, among other places, medieval diagrams, Renaissance rhymes, and modern stage settings. Applications of early semiotic and structuralist theory—most amusingly in Barthes's *Mythologies* (1957)—effectively "denaturalized" meanings we had taken to be inherent in our perceptions of the foods, clothes, and gestures of our daily lives. Thirty or more years later, much more needs to be done. In general, those early applications ignored the diachronic dimensions of analysis and—in keeping with the "linguistic imperialism" of the time—almost always ignored any aesthetic dimensions for a content-oriented political interpretation. I have attempted to place my analyses in a frame that would describe the cultural forces on the example's meaning and to account for whatever aesthetic values that may be significantly present.

The experience of art is always personal, and with only slight apology, I use my own experience as one basis for the cultural ambiance I attribute to the arts of post–World War II America. I have practiced—largely, though not exclusively, as a stage director and designer—all the arts discussed here. When I speak for the presence of meaning in the very material and form of art, I am impelled by my own involvement with those materials and by similar experiences shared with me by other artists, whose conversations, I must say, turn generally more to the medium than the message. This experience with the arts has had for me not only a material but a temporal dimension. Like an anthropologist returned from another culture, I look back now on my "field work" in the New York art and theater scene of the forties and fifties to appreciate, in the changes I see, the essentially constructed nature of our arts, and in that, their special relevance—their meaning—in understanding our life's situations.

A claim to cultural relevance and the changes that this entails must obviously commit me to an historicist view of the semiotic process, a view I gladly embrace. Following from this, and so that the effect of historical change may be more clearly seen, I have chosen my examples for analysis largely from works whose cultural bases have by now shifted enough to emphasize the "constructedness" of their meanings. At the same time that I adopt this analytic strategy, I want to stress my own conviction that our most exciting and meaningful experiences with art are those we gather from the works of the present moment, the works defined by and defining

the culture in which we live. Yet before these pages are set in type, the "latest" gallery shows will have closed, hit movies will have been retired to video rental shelves, and prize-winning novels will have been remaindered. Considering works of the past—both distant and near—gives one a chance to recollect in some tranquility the mechanics of their meanings, something we are loath to do, and perhaps cannot do, with the painting, poem, or dance currently in the public eye. I hope that through a look at some art that is no longer contemporary, we can experience all the more fully the play of meanings of that art that is contemporary.

The same attention to the forces of cultural change mentioned above demands the recognition that the works of the past could only have been created out of the fullness of their own moment and will never mean again exactly what they meant at that time. But I would not give up past works to the complete relativism of a "Shakespeare Our Contemporary" mentality. It is both valuable and possible to reconstruct enough of an historical context to enjoy most works with something approaching their original meaning. It is here that semiotics, as a theory of meaning-making, can effectively guide the logical selection of plausible interpretations. In such an historical approach, evidence that a given interpretation was indeed plausible as a meaning to persons of the time is a prime requirement, and I have tried in each case to supply demonstrations that the proposed usage was then current. If we value diversity, as we are constantly encouraged to do, certainly cultural diversity in time as well as diversity by geography or gender deserves our attention.

Let me turn, in conclusion, to a brief outline of the chapters, which are offered as support and demonstration of the positions taken above.

Chapter 1 introduces the concepts of meaning to be used throughout the book. It emphasizes that beyond the conventionally coded meanings typical of the natural languages, there is, especially in the artwork, a dimension of meaning by ostention in which the qualities of the signifier itself exemplify such conceptual content as rigidity, balance, and opposition.

In chapter 2, I examine the process of meaning-making in which the available materials both physical—like marble or a dancer's body—and conceptual—like the brevity of happiness—contribute to forming the art sign and its attendant signification.

Chapter 3 explores the principles set forth above in a culture vastly different from the one we inhabit. Thus, wiping away modern ideas of calendars, birthdays, and careers, I look at the medieval device of the wheel

diagram as a form in which persons of that period were able to conceptualize the nature of a life as a circular process turning in fixed stages from youth to age.

Chapter 4 takes up the same circular form described in chapter 3 as, in the later middle ages, a "wheel of fortune" signifying the changes in the concept of time, which turned the passive idea of movement from youth to age into the idea of a career with its rise and fall. In these changes can be seen the beginnings of a secular history and the secular drama, like that of Shakespeare's, which developed around it.

In chapter 5, I move from the mixed media of wheels of fortune and plays of fortune to consider a semiotics of poetry, attempting to show, despite Archibald MacLeish's famous line, that a poem can both mean and be.

Chapter 6 considers poetry and the poet to confront a question urgent in today's concerns with race, class, and gender: how much and in what way does the character of the artist contribute to the meaning given to his or her works? Using once again a moment of the past to illuminate the present, I look at the time in which a now-dead white man—Robert Lowell—was considered the poet of the age.

We speak of meaning in the language arts with relative ease, but is it possible to say that spaces *mean?* I confront this question in chapter 7 by examining the spatial construction of those stage sets by Jo Mielziner that gave us such striking images of the fragility of our shelters in the postwar world of Tennessee Williams and Arthur Miller.

Mielziner's sets, however abstract, are iconic: they clearly represent dwelling places. In chapter 8, I push the argument for meaning in the arts to its extreme with the question: In what way, if at all, does a nonobjective painting *mean?* Arguing from the example of a painting by Kenneth Noland, I hold that especially here we come face to face with that "missing" kind of meaning that art quintessentially offers us.

Chapter 9 looks forward and backward as it surveys recent developments in cognitive science that must make us rethink any meaning-making—any semiotics. I suggest in this chapter that the central place given to pattern recognition in cognition appears to strengthen claims for the importance of the patterned art experience.

But first, some consideration must be paid to the tangled problems of meaning itself, to the cogent relationship between a physical signifier and a mental signified. We turn to this in chapter 1.

1

MEANING

Do the arts mean? Do *all* the arts mean? Do they all mean in the same way? Does an artwork mean in the same way in which a street sign means? Let me quickly say that the meaning of an artwork will be taken here to be whatever content the work may have as art. Such indexical meaning as that through which ownership of a Rembrandt indicates wealth or a preference for Schoenberg indicates musical sophistication will not be our concern. We can focus the present inquiry a bit more by rephrasing it as follows: "Do all artworks mean in a semiotically interesting way?" There would be little argument that a novel or a portrait means something in the sense in which symbols of events, aspects, or things in the novel or portrait refer to like entities in the "real world." On the other hand, some well-known artists and critics have denied that certain kinds of works—a Beethoven quartet, for example—mean in any commonly accepted sense of that term. George Dickie says of a typical string quartet, "Neither the music nor any part of it makes any reference to anything" (Dickie 1985: 8).[1] Thus we see problems with the contention that *all* artworks mean.

A further problem arises when we ask if all parts of an artwork mean. For example, in what sense do such qualities normally mentioned in any reasonably complete analysis of an artwork, as the rhythm of Hemingway's prose or the brushwork of a Van Gogh haystack mean in their novels or landscapes? Can these qualities, often described as unique, idiosyncratic, and immediately tangible, interest a kind of scholar, the semiotician, who must see them as uncoded and materially accidental, hence nonfunctional in the production of meaning (Eco 1976: 265)? For the structuralist or semiotician the vagaries of style—so essential in art—did not function as

meaningful. The graphic sign of the cross was meaningful, despite any elaboration, *only* as it differed from the plus sign. The meaning of the pronounced word "bat" was meaningful, despite any vocal shadings, *only* in its difference from the pronounced "bet."[2] However, unlike our expectations of the nonart text, our expectations of the artwork are that *all* aspects of the signifier have intended meaning, down to the color of the dancer's shoes, the mounting of the sculpture piece, or the typeface of the printed poem.

What does it mean to mean? I will define this concept through many examples in the following chapters in which I attempt to specify my sense of the meaning of various artworks. But to offer an immediate and somewhat rough definition, I would say that meaning is simply the referent of the sign: the mental representation of a preceding rainstorm as the meaning of wet streets, the mental representation of a feline as the meaning of the word "cat" or of a drawing of a cat. While these are not the only or necessarily the best meanings of the signs we have used as examples, they are among the most probable of the intersubjective meanings available for those signs. They are the meanings arrived at as a function of the denotations and connotations of these signs. In this sense the picture of a cat means the concept or mental representation "cat" because through a mixture of convention and iconicity the two-dimensional outline of the painted artifact we identify as "cat" resembles our memory of felines in the real world. There is, however, no flesh-and-blood cat in the picture; there is no urn in Keats's Ode.

The mention of convention and iconicity brings us to a crucial point, since it will be essential to my argument to distinguish meanings by the way in which they have been made. This is best accomplished, I feel, by the use of C. S. Peirce's well-known division of signs into icon, index, and symbol. The division is simple and effective, though as everyone admits, most signs draw their effectiveness from more than one of the categories. The problem comes with the terminology, for Peirce uses "sign" to cover *all* types of signifiers and "symbol" to indicate *one* particular kind of signifier. Confusion may arise since this runs counter to ordinary usage, in which "symbol" is used to cover many different kinds of signs that Peirce might call iconic or indexical. Briefly, the icon refers to its signified by resemblance and is best exemplified by a painted portrait, in which the shape of the painted face, the color of the hair, set of the eyes, etc. let us connect the iconic signifier with the person so signified. The index refers to its sig-

nified as effect to cause and is best represented by wet streets, which call our attention to the rain that probably caused the wetness. The symbol refers to its signifier by convention and is best exemplified by words in a natural language, in which words stand for the things or ideas they name not because they look like these things or have been caused by these things but because arbitrarily accepted conventions have designated that "stone" will stand for the small hard object. Obviously the category of symbols is very complex: some degree of iconicity is apt to slip into the supposedly arbitrary sign, as happens in such situations as the red and green traffic light mentioned below, in which some argument might be made that the green is iconic of vital ongoing life while red is iconic of fire, danger, death. On the other hand, symbolic conventionality sometimes underlies what we may take as pure iconicity but that on further analysis turns out to be resemblance that we have been trained to see and that others not so accustomed may completely miss. The power of the symbolic mode of signification to represent things or ideas *not present* is at the very center of civilization, but this very power to *stand for* but not to *be* is radically antithetical to the power of art to *be* that which it represents. Thus it is this special function of the symbol as defined by Peirce, that is, symbol as that particular kind of sign whose relation to its signified is arbitrary, to which I refer in my argument, not to the more popular meaning that would equate with that of Peirce's inclusive term "sign."

On the other hand, a meaning by what Eco has called ostention and what Goodman has called exemplification is typically present in the arts particularly and in other discourses occasionally (Goodman 1968: 52–57; 1978: 11–12 et passim; Eco 1976: 224–27).[3] It is really a meaning whose manifestation is actually present for perception *in the work.* The *ostended* quality of dissonance in a piece of music is present for the listener in the clash of cymbals and blare of trumpets but is not present in the appearance of the word "dissonance" which *symbolizes* but does not contain that quality.[4]

Actually the definition of "ostention" that Eco offers at the beginning of his treatment of that subject fits my usage only in the weak sense: "Ostention occurs when a given object or event produced by nature or human action (intentionally or unintentionally and existing in a world of facts as a fact among facts) is 'picked up' by someone and *shown* as the expression of the class of which it is a member" (Eco 1976: 224–25, emphasis in original). Thus we might hold up—"show"—a cigarette (Eco's example) to

mean that we want the viewer to bring us one such article. The sign process involved is that of token to type. In this sense the huge triangle in Noland's *Shoot* (see chapter 8) does refer, as a token triangle, to triangles, as the type: it demonstrates the kind of thing indicated. This, however, does not help with aesthetic meaning, for the specific signifier cigarette or painted triangle has been quickly transcended to its meaning.

Eco comes closer to the usage I want to establish when he allows to ostention not only the token to type signification but also the expression of properties. "I can show a cigarette in order to describe the properties of a cigarette (it is a cylindrical body, several inches long, white, etc.)" (Eco 1976: 226). After some further categorization of ostensive signs, Eco turns to the ostended art sign, reminding the reader of the Russian formalist emphasis on the "making strange," which fixes our attention on the artistic signifier (Eco 1976: 264). Eco's examination of the matter and meaning of art as ostensive signifier is productive to a point, but it disappoints us when Eco claims, "Once it has moved beyond this threshold [the cultural significance of the matter—such as gold—of the expression plane] the work of art seems to *stimulate reactions* but *not to communicate content*" (Eco 1976: 267, emphasis in original).

I argue, on the other hand, that content—meaning—*is* communicated by the arts, objective and nonobjective. As perhaps the most forceful example of this, I refer to Noland's painting *Shoot* discussed in chapter 8. Noland's triangle means—among other things—triangularity, but not in the weak sense of a mention or a description. It means this because its ostended qualities of triangularity have been made so very vivid, and so aesthetically appealing. They have, in the Russian formalist sense mentioned by Eco, been "made strange." *Shoot* does not *represent* a triangle; it *is* a triangle.

A similar point is made in the realm of music theory by Leo Treitler, who wants to maintain, as I do, that the meaning is *in* the work. Treitler criticizes Kofi Agawu for his use of such words as "denotes" and "represents" to describe the way in which music makes its meanings (Treitler 1995: 290). Such terms, says Treitler, "deny that our cognition of it ["instability" as the meaning of a series of diminished seventh chords] comes through our own response to . . . features of the music" (Treitler 1995: 290). In other words, the instability is in the music, not signified by some conventional sign that is not itself unstable. Treitler goes on to assert, against Agawu and Nelson Goodman, that the ascription to musical pas-

sages of such terms as "foreboding," "mournful," and "sad" is not metaphorical but as literal as calling a dark and rainy day "gloomy." The day and the music, in Treitler's excellent phrase, possess "a shared affective quality" (Treitler 1995: 292) since both in themselves exhibit—I would say "ostend"—qualities we find gloomy. Though I would draw back from specific expressions of emotion in music, I do feel that such "shared affective properties" as movement, climax, and resolution do express content that by the recognition of its sharedness vastly illuminates our understanding of the patterns of our experience. In an extension of the section on art touched on above, Eco seems to sanction just such knowledge: "But common artistic experience also teaches us that art not only elicits feelings but also *produces further knowledge*. . . . By increasing one's knowledge of codes, the aesthetic message changes one's view of their history and thereby *trains* semiosis" (Eco 1976: 274, emphasis in original). The cognitive sciences discussed in chapter 9 of this book suggest a psychologically real way in which this knowledge may be gained.

Before leaving this sign typology, I must say a few words in defense of ostention, a category that Occam's razor might threaten to excise. One could argue that the artistic meanings I seek are already covered by "iconicity." This is to some extent true; the conveyed meaning of triangularity I claim in chapter 8 for Kenneth Noland's painting can be attributed to the painting because it *looks like* a triangle. The problem is that iconicity covers too much and too little. It strains to cover too much in situations in which the iconic sign is said to stand for abstract qualities such as transition or closure in narrative and music or balance in a painting. In what sense does a musical transition *sound like* some series of events in life in the way in which Churchill's portrait *looks like* the British statesman?[5] Taken in the strictest sense of Piercean signs in which the signifier stands for a signified different from itself, the iconic sign covers too little. In a drawing of a bottle, for example, the iconic sign function is satisfied as soon as the likeness of the bottle shape to the concept "bottle" is recognized. In this minimal phase of museum- going, the sign has been transcended to its absent referent and the present—the ostended—qualities of the drawing ignored. Thus, two bottles, one lightly sketched in pencil, the other broadly and darkly rubbed in charcoal could have the same iconic referent, a real world bottle, but quite different ostensive meanings. Yes, iconicity might be stretched—uncomfortably—to cover both referents. But the thrust of my argument throughout is that despite Occam, the addition of a fourth

term, *ostention,* to spotlight those meanings so easy to transcend under the other three sign functions is essential to any examination of the meaning of art.

Meanings are inevitably value laden. Consider the following texts: "Your x-rays show no sign of disease"; "The bill signed by the president will provide immunization for all children"; "The Aids Quilt"; Bach's *St. Matthew Passion.* Most people would say—with some justification—that these are "about important things." When starvation ravages the south Saharan countries or drugs and crime ruin the lives of America's city populations, who needs a picture about triangularity, roughly the meaning I have suggested for Kenneth Noland's nonobjective painting *Shoot?* The value of this kind of content of form will be argued throughout the text, but I can say here that this kind of meaning, the kind most effectively produced in the arts, is typically, deeply, and actively about that conceptual area in which our knowledge of our selves and our world starts. The content of the forms of art instructs us in those essential temporal, spatial, and logical concepts through which starvation and crime are eventually understood and ameliorated.

Three brief examples—a stop light, a Christian cross, and an advertisement—should clarify the concept of meaning as I intend to use it and in the last example demonstrate the kind of meaning I have called a meaning by ostention, differentiating it from the more conventional denotational and connotational meanings.

The traffic light signifies its message of "stop" or "go" through a purely arbitrary cultural agreement that red will mean the former and green the latter, the sign situation that Peirce would describe as symbolic. (Though, as we showed above, attempts might be made to demonstrate that green and go have a motivated—or iconic—connection, conventional assignment of red to stop and green to go is a preferable semiotic judgement.) Pragmatic concerns will dictate that tokens of this type of sign be relatively uniform—a busy intersection is hardly a site for an "open work"—yet the exact shade of red or green or the size of the instrument itself do not in any way change its meaning.[6]

A cross may serve as a second sign whose reference—Christianity—is widely recognized. Though we may say that the red and the green, as the functional factors of the traffic light, are arbitrarily assigned to their meanings, the cross is connected to its meaning both through its metonymical relationship to the history of the life of Christ and through cultural ac-

ceptance reinforced by history. Of course the kind of sign we have reference to here is not *the* cross on which Christ died, nor is it necessarily *a* cross in the sense of a wooden standard with upright and cross piece suitable for carrying out the crucifixion of a grown man. The cross of Christian symbolism, the token of this type sign, has an iconic relationship to Christ's Cross, that is, it resembles the true Cross in appearance, a relationship so firmly established by tradition that widely different manifestations of the icon are recognized as the Christian cross. The cross is a supreme example of the kind of sign whose functional values are quite straightforward and that thus allows a wide variety of non-functional variation. The token cross may be made of almost any material, may be extremely large or as small as an earring. The sign of the cross may simply be scratched on a wall in defiance of a communist regime. The pragmatic meaning of these different enunciations will vary widely, but the semantic meaning remains the same. While the meaning of the traffic light is a simple binary stop or go, often responded to automatically by the driver, the cross has a signified both vague in outline and extremely rich in connotation. On the other hand, the form and matter of the signifier cross are either minimally elaborated—as when scratched on a wall—or elaborated in such a way as almost to eclipse the religious meaning—as in the many manifestations of the cross as jewelry.

I shall argue that artworks as artworks, either through the effective intent of the artist or the type of attention granted by the viewer/reader, add an important and different level of meaning to that normally functioning in the sign process of the traffic light or the cross. Thus for both the stop light and the cross, *any recognizable* token of the type sign will do to convey the content "stop" or "Christianity." A recognizable cartoon of the Mona Lisa, while it brings to mind the idea of the original painting, is definitely *not* the Mona Lisa and cannot convey the content of Leonardo's work.

As a third and final example of kinds of meaning, I want to turn to a visual text, an advertisement, a text located between the realms of commercial communication and art. This advertisement for Panzani pasta, the subject of Roland Barthes's "Rhetoric of the Image," (Barthes 1964) effectively conveys information about the company's product brilliantly analyzed by Barthes, and, through the sensitive elaboration of the form and matter of the physical signifier, conveys a further meaning, typically missed by Barthes. This latter kind of meaning, the meaning by ostention

of the material and formal nature of the signifier, the kind of meaning most typically found in works of art as a class, is what this study is most concerned to call to the attention of an information-hungry culture too prone to ignore it.

In the 1960s and 1970s Roland Barthes's preeminence as a structuralist, together with the brilliance and the breadth of his explorations, led one to accept as dogma the positions on which these explorations were based. Along with the very good things in Barthes, one tended to swallow the unfortunate linguistic imperialism that made it imperative that meaning for Barthes be always tied to the natural languages. Thus my use of a text from a generation past serves both as an example of ostended meanings and as an attempt to separate my understanding of meaning in nonlinguistic texts from a very popular and influential French tradition.[7]

In the 1960s, Roland Barthes avidly pursued structuralist-semiotic analyses of narratives, cinema, fashion, and commercial visual art, focusing for an important essay of 1964 on a very attractive advertisement for Panzani packaged Italian foods. The advertisement, a studio-produced photograph in yellow, green and red, displays a string shopping bag containing two packages and two cans of Panzani produce along with some fresh vegetables—tomato, mushroom, pepper, etc. The bag and its contents seem to spill down and spread from the upper left of the photograph leaving, at the bottom, about one eighth of the space for the simply printed words:

<div align="center">

PATES-SAUCE-PARMESAN
A L'ITALIENNE DE LUXE

</div>

The labels on the packages provide some further "accidental" verbal text (see plate 1).

The three types of meaning Barthes distinguishes in the ad are: a linguistic message (the labels and brief text); a coded iconic message (ethnicity); and an uncoded iconic message. The uncoded message is found in the photograph of cans, tomatoes, onions, shopping bag, etc. in which, Barthes holds, the objects appear untransformed (hence uncoded) and signify merely themselves (cans, tomatoes, etc.). This literal denotational message, Barthes states, cannot escape being part of the third, the coded iconic message, in which the objects spilling out of the shopping bag, the colors yellow, green, and red, and the vegetables conventionally connected

with this particular ethnic cooking *connote* "Italianicity;" freshness, flavor, home preparation, etc. (Barthes 1964: 46–49).

Barthes has as usual read the cultural signs with great panache, but I question the analytic accuracy of the three types of "message" he has set out and the absence of any account of the formal "message" in this carefully designed advertisement. For the moment I will concede a distinct type of "message" expressed by the few verbal texts on the labels and at the bottom of the ad, even ignoring the effective formal choices of typeface and layout of these texts. Barthes's "messages" types two and three should more realistically be combined into one coded type of message with the usual denotational and connotational aspects. Barthes's distinction here and elsewhere between a photograph (uncoded) and a realistic painting (coded) seems untenable (see the essay "The Photographic Message" [Barthes 1961]). A photograph of a can is not a can, and some *conventional* competence, however slight, is required to "read" such supposedly "uncoded" pictures. Thus these signs—and I would include the words inscribed—denote things and ideas different from those things and ideas to which by our semiotic conventions they refer. As is usually the case, these *denoted* meanings (real tomatoes and pasta) stir up other *connoted* meanings, such as the idea of Italian cooking, connected here through one's conventional knowledge of the important place tomatoes and pasta play in this cuisine.

These connotations are brilliantly pursued, as such types of connotations had been in Barthes's informal *Mythologies* (1957), but another source of meaning that, from the very professional appearance of the layout, would seem to have been knowingly intended, has been left unremarked: the *form* of the signifier. The ad is visually striking. The white lines of the string bag, standing out starkly against a dark background, thrust diagonally down and across the page, seeming to come toward the viewer. At the bottom, the rounded form of the bulging bag spills out a few items while containing in the rounded curve of the bottom what appears to be a plethora of other round organic forms, presumably vegetables. The stretched webbing of the bag forms an interesting irregular and organic pattern of both transparency and of containment that gives the formal contrast—and hence the formal emphasis—to the smooth regular cellophane and tin packaging, complete with trade name of the ad's sponsor. The form *presents*—or technically—*ostends* certain qualities, qualities that are there in the picture itself, unlike the denoted tomato or

the connoted Italianicity. Roughly, one could say of the form that an avalanche of items tumbles down and right toward the viewer in a cascade that appears to build as the items are more plentiful and more closely spaced at the bottom. The informality of the composition is accomplished by the irregular lines forming the iconic image of the bag, the way the Panzani items—with their prominent labels—are tilted back and forth against one another, and by the organic shapes of the vegetables. The "spilling" movement is halted by the upturned lines of the front of the open bag and by the solid items placed in front of it, especially the dominant regular red shape (tomato) furthest front of any of the shapes in the picture. All eye movement has been guided down past the Panzani labels to this tomato and to the regular, perfectly parallel text down right:

<div align="center">

PATES—SAUCES—PARMESAN
A L'ITALIENNE DE LUXE

</div>

I propose that the form here speaks a message that Barthes chose not to record, the content of which is specifically the qualities it ostends. Briefly, the form speaks of informality, of visually interesting organic qualities *combined with* the mechanical packaging of the sponsor's product, obviously a very clever formal strategy that places the idea of the freshness of raw vegetables alongside their processed counterparts. In addition we have the gentle cascade of items, made very attractive by their shapes and colors, toward the viewer's right hand.[8]

The Panzani ad and Roland Barthes's comments, as my third example of meaning, should form an effective transition to the major topic of the following chapters. The advertisement was deliberately and effectively *meaningful,* in obvious accordance with the costs undertaken by its sponsor to produce and publish it. It was meaningful in the "messages" denoted and connoted, those important meanings brilliantly analyzed by Barthes and present centrally in most texts we run across, artistic or not. These are the meanings that tell us of our perils and our powers, of appointments, deadlines, and the needs of our neighbors. These are the meanings in which Barthes and his colleagues in the *sciences humaines* would obviously be most interested for their sociology of signs and signifying behavior.

But if the Panzani ad was not art, it was artistic and could easily by a shift in point of view, which Barthes chose not to make, be treated as art

for the skillful elaboration of the expression plane of the signifier—the treatment, for example, of the patterns of the webbing of the string bag. This elaboration of the expression plane, the particular characteristic of those works we usually think of as art, produces its own special meaning sensed throughout the ages but infrequently articulated. It has sometimes been given up by artists themselves, as happened when the Art for Art's Sake movement conceded to the positivists. Formal meaning is easy to overlook in times of crisis, or when we speed down the "information highway." But in the darkest years of World War II, Piet Mondrian, one of the purest of "formalists," working as an émigré in New York, declared the work in pure plastic form to be the greatest expression of truth and essential to the destruction of tyranny.[9] In the following chapters we examine the nature of this claim in the nature of the meaning of art.

2

MAKING MEANING:
THE PHYSICAL AND COGNITIVE MATERIALS

The signifying process that is the source of our meaning has several sources. At the beginning it assumes the selection by a communicator of some sort of material with which to fashion the physical sign: verbal, gestural, auditory, etc. This material part of the total sign becomes the signifier and constitutes the expression plane. In the example of the stop light in the opening chapter, this would be the electric apparatus with its capacity to produce red, yellow, and green illuminations. At what might be called the receiving end of the semiotic process, this signifier has a signified, its meaning or content, constituting the content plane of the complete two-part sign of traditional Saussurean semiotics. The signifier, red light, has the content {stop}.[1] Just as the matter of the signifier, the lenses, glowing filaments, etc., was drawn from a continuum of available matter so, on the content side, the concept of coming to a halt was drawn from a continuum of movement concepts, especially those having to do with the crossing paths of vehicular traffic.

Louis Hjelmslev developed for his theory of language a scheme of sign production that included a continuum of matter and ideas and that divided both expression and content planes into form and substance (Hjelmslev 1943: 47–60). I describe below my own concept of this process as it functions in the work of art, touching briefly on each level of the scheme of categories I have derived from Hjelmslev by way of Eco and, with apologies to these critics, considerably altered. This effort should provide the theoretical framework for my analyses in the following chapters, where I concentrate on those categories that I feel call for the greatest attention without attempting a complete checklist for each category.[2]

Let me start with an example whose inadequacies will point to the necessity for the more developed model to follow. From the undifferentiated continuum of the content plane, our artist separates out a state of being—danger (she is pursued by bandits). From the undifferentiated continuum of the expression plane, she pulls a piece of charcoal out of the ashes of her campfire to construct the artifact of the expression plane, the signifier /help/ scrawled on the face of a cliff. The matter (charcoal) and the form (the bold, jagged lines of the desperate calligraphy) are clear. On the content plane we have the obvious denotation and connotation of the English word /help/, that is, the concept variously paraphrasable by such signifiers as /give aid/ and /state of danger exits/.[3] With this brief sketch set forth, let me attempt a better defined model that can illuminate the semiotics of the artistic process. Figure 2.1 may help in visualizing the relationships of the terms. It should be thought of as a circle with the one undifferentiated continuum surrounding all.

THE UNDIFFERENTIATED CONTINUUM

Here one may find the unprocessed matter, form, things, events, ideas, etc. that will be selected to become the signifiers and signifieds of communication. The precise nature—the ontology—of this continuum and the mechanisms by which its properties become known and used—its epistemology—will vary with each reader's philosophical stand; it is yet the necessary starting place for the motivation and the means of expression. Hjelmslev referred to the undifferentiated (or unstructured) continuum as "purport" (1943: 50–58), by which he seems to have meant both the matter of the expression plane and an idea—or content—not yet manifested in any particular medium. His examples include a concept that is manifested as the specific and slightly different—hence differentiating—concepts of the English words /green/ and the Welsh words /gwrdd/ or /glas/ and through this manifestation become cultural units, units with different content in Wales than in England (Hjelmslev 1943: 52–53).[4]

In the scheme presented in the present book, there is no separate continuum of expression and continuum of content. Though the expression plane draws from the continuum mostly matter and form but not ideas, all of these, including concepts of the nature of matter, can be part of the meaning of the content plane. In this amorphous continuum there is sim-

Figure 2.1

(unformed MATTER) (unformed CONCEPTS)

THE UNDIFFERENTIATED CONTINUUM

EXPRESSION PLANE

Matter
Form

CONTENT PLANE

MEANING 1: Meaning of FORM and MATTER of EXPRESSION PLANE
MEANING 2: Connotational and denotational meaning of the
 EXPRESSION PLANE
MEANING 3: Meaning of the FORM of MEANING 2

THE UNDIFFERENTIATED CONTINUUM

(unformed CONCEPTS) (unformed MATTER)

ply no satisfactory point at which one can separate the preexisting stuff of expression from that of content. (Such would certainly be the case in a materialist science of cognition in which even our thoughts are presumed to be simply patterns of neuron firings.) I shall concentrate first on the material elements of the continuum, those elements that will constitute the expression plane. I shall close the circle of the undifferentiated continuum at the end of the discussion, uniting the matter and the content: expression and idea.

THE EXPRESSION PLANE

Matter

From all the matter "out there," the communicator—henceforth the artist—will select some medium in a generally intuitive way motivated by cultural contexts and personal tastes. That matter may be the oils and washes of the painter, the bodily gestures of the dancer, sounds of the musician, etc. The sensitivity to material and the appeal of its sensuous presentation is traditionally a distinguishing feature of art. In this, the artist's choice of a kind of matter is almost always motivated by some sense of that matter's potential for expressing some as-yet unfocused content.

Though occasionally artists have attempted to create a medium "from scratch" (as John Cage did), the matter of the expression plane usually is taken up as already partly formulated. The western musician starts not with raw sound but with the half-tone scale represented by the keys of a piano. The architect's materials—glass, brick, steel beams—come preformed from the building supply companies. Not only the matter but the techniques of its use are developed prior to acceptance by the individual artist, a truth that holds even when the pre-existing technique provokes its own rejection. The contemporary artist who will signify his or her content through the matter of bodily movement must cope with the received movement techniques of Martha Graham, Alvin Ailey, etc. The Renaissance artist drawn to the verbal medium had to cope, for better or worse, with the popularity of the sonnet.

Form

Form on the expression plane is the product of those arrangements of the matter made possible by the physical nature of the matter itself. Form is, at least in some crude way, inherent in any physical manifestation of matter, even a pile of dirt. The exact contribution of the perceiving brain to the perception of this form is still in some dispute, but the following quotation by the biologist Gerald Edelman from Henri Focillon's 1934 *The Life of Forms in Art* points in the proper direction: "'To assume consciousness is at once to assume form. Even at levels below the zone of definition and clarity, measures and relationships exist'" (Focillon 1934: 44; Edelman 1992: 124).

Formal arrangement in art is extremely complex in execution—a factor in the individuality of each single work—yet quite simple in theory: it

consists largely of repetition and variation and includes symmetry, progression, balance, etc. As matter is appropriated from the continuum to substantiate the form of the expression plane, it is apprehended as having certain elementary characteristics generally thought to be the products of the apprehensive process, not as "real" characteristics of matter in nature. These elements—such as line, shape, texture, and hue in the visual arts, and gestural phrases, levels, weight, and lightness in dance, are subject to arrangements of repetition and variation. Fred Lerdahl and Ray Jackendoff describe a cognitive theory of the way in which such "mentally produced" structural elements of music as tonal phrases and metrical groupings are constructed by the listener from the raw data of sound (Lerdahl and Jackendoff 1983: 2 et passim). Their argument might easily be extended to cover the elements of the other arts, something I consider in the final chapter where the impact on semiotics of recent developments in cognitive science are explored.

THE CONTENT PLANE

Meaning on the content plane is that to which all the expressive elements refer.[5] It generally is the product of the elements of the expression plane, but as we shall see, it also can be generated at a second level by the relationships of denoted and connoted elements of the content itself. Meaning must be subdivided, as indicated in figure 2.1, into three categories, of which the second, the connotational and denotational meaning of the expression plane is the category in which we find content or meaning as they are popularly conceived. It is that level at which the written word /dog/ means the concept {dog} and the picture sign /house/ means the concept {house}.

Meaning 1

The meaning of the form of the expression plane is as elusive yet real as the quark. The greatest communicators in any medium have always exploited it, as did the layout artist for the Panzani ad described in chapter 1. It has been the subject of speculation in aesthetics from Plato to Susanne Langer. Yet attempts to express its nature seem esoteric in the manner of explaining why a joke is funny. It is the prime subject of this book.

I say very briefly here that this content will consist of the ostended qualities of matter as formed. This may be illustrated by referring once again to a famous example from Jakobson.[6] The meaning of the form of the expression plane of the signifier /I like Ike/ would be, among other things, {simplicity}, {concision}, and {inclusiveness}. These concepts are conveyed by formal features of the signifier, including the following. The complete subject-verb-object sentence uses only three syllables consisting of only three different phonemes. The "eye" sound of the first-person pronoun is repeated in subject, verb, and object words, giving a feeling of identity of person, action, and object. Did the form of this slogan have the meanings I have proposed (and the slightly different ones proposed by Jakobson)? It was remarkably "catchy" and concise enough to fit on the campaign buttons popular at the time. Since the denotation of the verbal phrase itself (that is, meaning 2) is banal, it would be reasonable to suppose that the effectiveness of this campaign signifier lay at least in part in the meanings I have just assigned to meaning 1, the form of the signifier. As we move away from verbal texts and toward music and nonobjective painting in the chapters to come, the amount of meaning assigned to this first category of content will grow while that assigned to the other two categories will shrink.

Meaning 2

Meaning 2 is meaning as we commonly understand it. It is the category into which 90 percent of the meanings assigned to the ordinary text—verbal, visual, or gestural—will fall. In the example used above, that content of /I like Ike/ assignable to meaning 2 would be {I have a fondness for the general who became our thirty-fourth president}. The meaning 2 content of the usual nativity painting would consist of iconic references such as {woman and child} and symbolic references—through haloes for instance—to {birth of Christ} and {miraculous birth}. Since most of the vast literature on meaning and its interpretation falls into this category, it is not necessary to explore it further here.

There is no hard and fast distinction between the meanings in the meaning category just discussed and those in meaning 3. Just as all matter must have form of some kind, so must all concepts. It will be helpful, however, to establish a category in which we can explore the ways in which the form that is the relationship of these concepts—concepts that constitute

meaning 2—can in its turn become a signifier for a further content: meaning 3.

Meaning 3

Meaning 3, meaning of the form of the content, will refer, as in the other categories of form, to the relationship of elements. In this case the relationships will be relationships between the denotational and connotational signifieds of meaning 2, not the signified meanings of the form of the expression plane, that is, meaning 1. At the level of content these will be relationships among the qualities, events, and things *represented* by the signifier but not themselves present in the matter and form of the signifier. This category, though present in ordinary discourse, is most fully exploited in literature. As such, it has been the primary concern of the American New Critics, who are "formalists" only in the sense in which their analyses apply to meaning 3.[7]

It is at the level of meaning 3 that the essential form of so called "narrative form" projects its meaning. Examples of this form can be found in the contrast between the success and the failure of actions depicted in a novel or the domination and subjection of figures represented in a painting. Relations between content signifieds also produce the further content meanings {tragedy}, {sublimity}, {comedy}, etc.[8] The contrast between the established worth of the protagonist and the character of his or her fate would signify the content meaning {tragedy}, a concept with an established meaning as a pattern of life experience. The relation of contrariness between the denotation of /profitless/ and that of /usurer/, that is, one who makes a profit by loaning money, gives us the content meaning {oxymoron} for Shakespeare's phrase "Profitless usurer" in Sonnet 4, as I discuss in chapter 5.

THE UNDIFFERENTIATED CONTINUUM OF CONTENT

In passing beyond the meaning of the form of content, we return to the beginning of this discussion, for I hold that here we find the same continuum, the same unmediated set of things, qualities, and relations prior to our construction of them in consciousness that was identified as the continuum of the expression plane. It is true that from this continuum, expression will ordinarily draw mostly matter and form, while content is

commonly thought of as a manifestation of previously inchoate ideas, states of being, etc. However, this division is difficult to maintain in a concept of a continuum where the construction and articulation of what may be called the content idea is necessarily mediated by the physical matter of the expression and where the choice and shaping of the expression signifier is motivated by the need to define the content idea.

The continuum of the content plane, like that of the expression plane, because it is by nature prior to our conceptualizations, is available only when shaped by whatever formalizing processes our cognitive machinery imparts. Skipping over epistemological niceties, we come down to the fact that the material of content is additionally shaped (as the material of expression for music, for example, is shaped) by the work of the culture within which the expression will take place. From all the things "out there" that we might write, paint, dance about, the culture will have focused on, and to an extent have preformed, certain preferred topics. There is, indeed, a drive in cultural processes to further define certain previously undifferentiated ideas such as problems of economic power shifts, technical innovations, etc., which brings new aspects of content into focus.[9] While the artist tends always to reshape this content—creating the form in which future artists take this up—he or she inevitably shapes only what is available already partly shaped for him or her. In this, I hold with King Lear that "Nothing will come of nothing" (1.1.92).

I have described several categories involved with the nature of the sign and that epistemologically difficult realm from which its matter and meaning are drawn. The clarification of these categories should help define the action and agency of signification, at once one of the most basic and most exciting of human activities. I want to turn now to look at the agent of the semiotic process, and, in the case of the particular subject matter of this book, to the most self-conscious of such agents, the artist. Taking a look at the creation of the art sign should be interesting not only in itself but in the fact that artistic creation is a particularly conscious and elaborate process in which one can study, as if it were in "slow motion," the considerations of matter and meaning that in casual communication have become hidden by habit.

Lévi-Strauss called the agent of myth making a *bricoleur*, that kind of French handyman who cobbles together the necessary items of his trade from convenient bits and pieces lying at hand (Lévi-Strauss 1962: 16–33). This same kind of joy in the discovery and use of odd materials and in the

improvisatory nature of its assembly calls very much to mind the work of the artist, obviously so in the case of a Robert Rauschenberg montage, but also the case in the most classically pure of media. The *bricoleur* has a tool to fix or an object to build; the artist has a content to express, something like Hjelmslev's purport floating undefined in the continuum. But the idea {content to express} requires, in the case of art, considerable qualification. Some artists do claim to write, dance, sing to express a message. Others vehemently deny such an ambition. Indeed, theater gossip enshrines the possibly apocryphal remark by Clifford Odets, surely thought of as a propagandist playwright, "If you want to send a message, go to Western Union!" I want to say that Clifford Odets sends a message and even Stravinsky—much as he denies it—sends a message, but this message has much more to do with their *bricolage,* their choice and nurture of their materials and the improvisation of their construction than it does with such admirable but hardly artistic messages as "Make the world safe for democracy!"

The artist-*bricoleur,* as the independent, free-spirited agent of signification, typically unites the material and the conceptual realms of the continuum. The energy of agency in this person draws content from matter and finds in the as-yet undefined contents of the continuum the meanings that will be materialized in the form of the matter he or she is drawn to.

Although I would say that the above holds true for all art-making, even when the media and the content are more or less conventional, the particular matter and meaning chosen by the African American sculptor Martin Puryear illustrate this point especially well. Puryear expanded on a traditional art education at Yale with work among the peoples of Sierra Leone and Lapland as well as training in woodworking with Scandinavian craftsmen. A photograph in the catalogue for Puryear's 1991 exhibit at The Art Institute of Chicago shows the sculptor surrounded in his studio by saws, rasps, drills, and chisels, plus the hammers and mallets which could pound the wood into place (Benezra 1991:138). Interestingly, Puryear has arranged his tools in workmanlike sets and rows so that these artifacts of the trade, presumably without intention, give off the same aura of intense yet practical craftsmanship as do his sculptures. This informal studio picture recalls particularly Puryear's exhibition piece *Some Tales* (1975–1977) in which six long, thin pieces of bent ash and pine—the longest and most dominant having a saw-tooth motif—stretch approximately 30 feet in horizontal rows (Benezra 1991: 58–59). This artist's particular interest in

wood—his chosen matter—with its patinas, its special tactile relation to the skilled craftsman's touch (the preexisting technique that Puryear absorbed and adopted) focused for his audience a part of that vague interest in the concept {third worldness} that hangs about the intellectual continuum of Western man. In these material and ideational contexts he was able, through form, to express a content that was not strictly referenced to Sierra Leone or Lapland, or to Thailand or Siberia, or to a plea for food aid. It offered instead a piece of knowledge about, as well as a celebration of, the forms of life in third-world material cultures. Puryear's abstract wooden hoops of bent saplings, his organic volumes defined by carefully joined wood strips, tell us more about such countries than does the literal and illustrative content of many a television documentary (see plate 2).

The specially motivated energy of the individual artist is clearly a primary factor driving the semiotic process, but he or she is inevitably both guided and limited by the matter and meaning that has been selected as important by the community at large. Anyone who knows the art scene knows that there is a modicum of truth in the Romantic picture of the artist as lonely genius, yet this must be tempered by at least a refined version of the structuralist prison house of language and, more broadly, by the structuralist idea that myths think in man rather than that man, as sole initiator or creator, thinks in myths.[10] It is from this anthropological point of view that I see the semiotic process as progressing. From the continuum of matter and concepts, the culture grasps and develops some special parts. In the chapters that follow, I illustrate some of the choices of subjects and materials of expression with attention to the cultural interests that appear to have motivated these. In the meanwhile, a brief look at the effect of cultural motivations on the work of Shakespeare and Tennessee Williams may clarify this point.

Jonathan Arac has argued against his fellow New Historicist critics, Stephen Greenblatt and Joel Fineman, that the "sense of character, and of literature, that they find in Shakespeare became available only in the nineteenth century" (Arac 1988: 312). In other words, the cultural material and concepts with which Shakespeare worked did not allow the kind of individuated and self-motivated character with which modern critics have endowed his presumably most "modern" character, Hamlet. Citing Coleridgean idealistic philosophy, the Gothic romances of Mary Shelley, and the settings of nineteenth-century melodrama, Arac describes the developments that would allow nineteenth-century artists—Arac concentrates on Dickens—to create,

from their notions of Hamlet, characters of a "Romantic" self-reflexive and inwardly motivated nature. In this, we can see the cultural interests of two periods creating out of psychological concepts possible at the time, a dramatic character who could be rational revenger to one and Romantic dreamer to a later industrialized age. The interesting point is that one intriguing figure could produce, when properly constructed—as by Burbage in the Renaissance or Kean in the nineteenth century—a character to define the anxieties of the period.

Retaining a focus on playwrights but moving closer to our own time, we can effectively observe the power of cultural interests through Tennessee Williams's domination of the American post–World War II theater. Williams, who would certainly fit the profile of the Romantic artist, took no market surveys and wrote from his own unique experience, yet his plays expressed a content in which America was interested at the time, and in which, I hold, it is no longer interested. Williams has become dated.

In terms of matter drawn from the continuum together with chosen techniques for handling it, consider the following. Electric light and the means of modifying and projecting it to create the effects of insubstantiality and nightmare (as I describe in chapter 7) had been developed from the New Stagecraft movements of the 1920s and inherited by Williams's principal designer, Jo Mielziner. Stanislavsky Method training was reaching the height of its influence in studios all over Manhattan, especially at the famous Actors Studio, in which Williams's most effective director, Elia Kazan, had an important voice. These studios were training the bodies, voices, and driving spirits of the actors, the matter of the expression plane of Williams's plays. In improvisation after improvisation, the actors learned to produce the deeply motivated confrontations on which Williams would structure his scenes, scenes that subsequently became material for the very Method classes that had fostered them. From the content end of the continuum came America's postwar fear of the new and so-called deviant. These fears found definition in the deep psychic structure of these conflictual scenes.[11] This artistic oeuvre, a product of a gifted individual and a ready cultural milieu, concretized in the matter, form, and meaning described earlier an image in which its audience could define some sense of the threat which a McCarthyite force held over any deviance from that mass desire for normalization that swept Eisenhower to the presidency in 1952.

The historical reference here is important to the dynamic view of the semiotic process I have been attempting to develop. While the arts undoubtedly

express some very general truths about the human experience, they draw their greatest impact from the immediate and specific concerns of the society which produces them. When the society's shifting interests draw different concepts from the continuum, older images inevitably lose their power to define. Thus, not only Williams's success but his eventual failure help make my point about the culture's power to select the relevant material and conceptual aspects of the continuum. Tennessee Williams's plays not only materialized the anxieties of the postwar experience with great effectiveness, but seemed obviously dated when these anxieties were replaced by those of another, and longer, war, this time in Vietnam. Williams's best plays lost currency from around 1965 and today are interesting and beautiful museum pieces, in the same way in which Shakespeare's plays, as *Elizabethan* plays, are museum pieces.[12] These brilliant dramas, which defined postwar man in Stanley Kowalski and the "somehow crippled" female in Laura Wingfield,[13] simply do not call up in recent readings or revivals the meanings that today's more socially and culturally diverse society needs to define its own problems and "plots." As the interest in feminism stirs up new concepts of female selfhood in the continuum of content, we may cast backward to Kate Chopin's 1899 *The Awakening* or forward to the numerous autobiographies of women of color, but Williams's masochistic heroines fail to supply an image useful in contemporary thought.

Though the witch-trial sadism of the anti-American investigations, which could be reflected in Williams's plays (and more literally in Arthur Miller's *The Crucible* [1953]), seems diffuse as dramatic content now, forty years after the fact, it is yet within the realm of the modern experience, re-callable with a nudge or two of recent history. An exploration of a far more distant scene defined in signifiers that teeter on the far edge of what would today be considered art and that sort out and categorize a content we no longer conceive in that culture's way will, in the next chapter, illustrate the workings of the signifying process to create a culture. I turn to the medieval period and its schemes of the Ages of Man.

3

SIGNS OF LIFE: MEDIEVAL SCHEMES
OF THE AGES OF MAN

This chapter moves our focus to the Middle Ages, where, in a culture quite unlike our own, involved with a set of artifacts quite heterogeneous as to artistic merit, a special challenge will be raised to my hypothesis about the kinds of meaning that a semiotics of the aesthetic signifier should be elucidating. We will be looking, then, at some "signs of life" of varying kinds and complexities that, over a roughly 600-year period, have functioned to define the significance of a people's experience. Any convincing demonstration of the process I hypothesize must involve at least some degree of Geertzian "thick description" of the historical and cultural situation within which I presume these artifacts to be functioning (Geertz 1973: 3–30), though, given the aims of this book, a true "history of the arts" is not intended. My own desire to focus on the frequently slighted first part of the signifier-signified pair will, in its turn, require a reasonably full description of what I take to be the form and matter of this, the expression plane. As I stressed in the last chapter, what gets said, painted, danced, etc. depends on two things: a society's current conceptual needs and such available and attractive matter and form as will best embody these. For the early Middle Ages the shape of a human life—something taken much for granted in today's well-marked chronologies—was of special and immediate interest, both simply, in the brief lives of the peasants, and in greater complexity, among the clerics of the monasteries. The necessary matter and form existed in the materials, such as ink, parchment, and church walls, with which to prepare the diagrams of geometric forms most frequently encountered in the ubiquitous "wheel,"

which appears in an early and largely conceptual form as Byrhtferth's eleventh-century diagram of the Physical and Physiological Fours (plate 3), and much later and more pictorially, in the sixteenth-century frontispiece to Lydgate's *The Fall of Princes* (plate 4). Thus a geometry and arithmetic from ancient times lay ready to "stand for" and to relate a whole corpus of physical and spiritual phenomena for which today we have much different schemes.

Since I have stressed the importance of the cultural dynamics of any such signifying system as is proposed here, a few words must be said about the contexts in which our emblems were produced and received.[1] While the intellectual community that developed these schemes in the early Middle Ages consisted of a small group of clerics writing in Latin, this monastic brotherhood was nevertheless dominant in the culture of the time and its collections of classical learning were widely distributed throughout Europe. Though I will be concerned with the play of sign and concept intended primarily for an audience of the lower clergy and lay persons, we must not forget the very complex disputations on the nature of being and knowledge taking place in the great universities at Oxford, Paris, Cologne, etc. It might be said that in such medieval philosophy, semiotic argument was at its most subtle.

By the twelfth century, at least some of the common people would have met the schemes of ages and fortune under the auspices of the Church: in church decorations and in sermons (Sears 1986: 121–133).[2] Wheel emblems and their narrativization in *de casibus* stories spread among the literate middle class with the invention of printing in the late fifteenth century and the translations and amplifications in the vernacular of Boccaccio's Latin manuscript *De Casibus Virorum*. Finally, as I describe in chapter 4, an even wider audience flocked to London's theaters in the closing years of the sixteenth century, when a general comfort both with wheel form and with sometimes quite oblique references to wheel lore seemed taken for granted.[3] With this said, I want to turn back and examine in greater detail the development of a sign system which for so many years marked out the nature of man's existence and his history.

The medieval mind was fascinated by signs, especially where numerical considerations were involved. Thus the philosophical realism of the chosen numbers and their derivative manifestations in geometry, calendars, and astronomies must be instructive to any semiotic epistemology. Thus

the divisions made by the medieval scholars stand as especially clear examples of what Eco—himself a medievalist by trade—describes as the "cultural units" made in the "undifferentiated continuum" by the process of sign production (Eco 1976: 66–68). It must be kept in mind, however, that what may appear as clearly arbitrary to postmodern eyes was not considered so by the clerics of the Middle Ages. Despite the fact that there was considerable disagreement as to when, for example, youth became middle age, the probity of making such distinctions in the first place was not questioned. After all, it was reasonable to believe that while God's cosmic order obviously existed, fallen man might well mistake its details.

The signs that manifest the ages schemes take many forms. The early descriptions, like those of Isadore of Seville written in the seventh century or those of Bede in the following century draw their aesthetic aura not from the text itself, which is a summary in Latin prose of earlier works, but from the authority of the ancient writers referenced and the various classical systems that would be understood to be thereby signified. These concepts inevitably melded with visual manifestations of the schemes implied as crude or elaborate diagrams began to fill out the manuscripts "so that the young priest who sees these things may be the wiser for it" (Byrhtferth, quoted by Burrow 1986: 17).

The ages, or stages in the life of man, were defined less by observation than by the exigencies of the particular scheme—with its inevitable numerical basis—through which human existence was being interpreted. The three-age scheme fostered by the biologists and supported by Aristotle's *De Anima* and his *Rhetoric* (Burrow 1986: 6–8) has an appealingly simple shape with wide applicability from the vegetative realm from which it was derived to the obvious outlines of growth, stasis, and decline in a person's life, to the progress of a day through morning, noon, and night and to the ripening, maturity, and decline of prosperity. The terms set by Aristotle, in the Latin of William of Moerbeke (1215–86), for this triadic scheme of vegetative life, and hence applicable to Man's vegetative soul, are *augmentum, status,* and *decrementum* (Burrow 1986: 6). Such a pattern, dividing a whole life into only three parts, presupposes rather a long duration to each. Dante, working with the biblical "three score and ten" (Psalms 90:10), allowed twenty-five years for the period of growth, twenty more years for maturity, and a balancing twenty-five years of decline (Burrow 1986: 7). Clearly the triadic shape supposed in the geometry of the number three encourages a concept of two offset movements:

one movement up to a level and an equal and opposite movement down from that level. The other feature presupposed was the peak risen to and maintained. (We must imagine our triangle resting on its point.) Here the Latin *status* fits well and supports Aristotle's argument in *Rhetoric*, Book II, chapter 12–14, about the moral superiority of maturity that adolescence and old age in their different ways lack.

Whether it was because a limit of three ages frustrated attempts to discriminate observable changes in human growth (which in the short life of the plant were uninteresting) or because the flat top of the inverted triangle, while morally and politically satisfying was, in everyday terms, undramatic, the threes got relatively little play in the popular emblems of the ages. As we will see, a more dramatic view of tripartite divisions comes when, in the Renaissance, we move from the *De Anima* to the *Poetics* and its "Beginning, middle, and end." At that time as well, Shakespeare concretized the medieval three ages in a sonnet (number 7) that devoted a quatrain each to childhood, youth (in the Latin sense of full manhood), and old age. Here the triadic pattern was figured forth in the wheel of a rising, peaking, and descending sun, to be clinched in the couplet with the expected homonym, "sun/ son."

As we advance to four ages we pick up the strength and influence of the Neoplatonists, which made this number the most favored by medieval scholars, incorporating, as it did, what were referred to as the Physical and Physiological Fours and dating back to the Pythagoreans who found in the number four "the root and source of eternal nature" (Burrow 1986: 12,14). In a long section (p. 12–36), Burrow describes both simple and extremely complicated Four Ages schemes in the European Middle Ages starting with the Venerable Bede's *De Temporum Ratione* composed in 725. The addition of one more age here was accomplished by a split in the early years, giving us *pueritia, adolescentia, iuventus,* and *senectus,* or childhood, youth, maturity, and old age.

The obvious link between the ages and the seasons of the year remains to this day a source for metaphor, as when we say "He has reached the autumn of his years," though we do not bother, as the medieval scholar did, to put a precise birthday to each turning "season" of man. The potentiality of the mighty Fours becomes apparent when we add in the four qualities (moist and dry, hot and cold), the four humors (blood, red choler, black choler, and phlegm), and the four elements (air, fire, earth, and water). Thus childhood, the spring of life, is naturally moist and hot. The child is

sanguine in the humor of blood and light hearted as air. So through each age, the Physical and Physiological Fours are easily accommodated in a way that would seem eminently "natural" (Burrow 1986: 12–13).[4]

Enthusiasm for the tetrad can spread well beyond ages and humors, as we see in Burrow's account of one of the diagrams in the *Manual* produced by the eleventh-century monk Byrhtferth, quoted above (see plate 3):

> The diagram . . . takes the circular form best adapted to display the four ages. . . . In the central circle . . . are inscribed the four letters of God's Latin name: DEUS. Corresponding to these are the four letters of the name of the first man, ADAM, inscribed in the next circle, to signify the close relationship between man and the creator in whose image he is formed. But man is also related outward, towards the circumference of the diagram, with the rest of creation. The four letters of his name mark the four points of the compass, named in Greek: 'Anathole' (east), 'Disis' (west), 'Arecton' (north), and 'Misinbrios' (south). The next circle names the four ages, *pueritia, adolescentia, iuventus,* and *senectus,* each coupled with the corresponding season of the year. The three outer rings name the twelve months . . . divided among the seasons by four spokes representing the solstices and equinoxes; and to each of these spokes is attached one of the four elements: air to the spring equinox, fire to the summer solstice, earth to the autumn equinox, water to the winter solstice. (Burrow 1986: 17–18)

All of these tetrads have a reassuringly metaphysical tone, which lends credence to their undoubted part in God's grand design; however, an illustration reproduced in Heninger's *Touches of Sweet Harmony* might have tried the belief of even a devout Pythagorean. This title page illustration of 1502 places the four major cities of Germany, which lie at the four compass extremes of that country's geography opposite one another on a wheel, and associates them with a body of water, a time of day, and an age of man. Mainz, for example, in the west, is associated with the Rhine, with sunset, and, appropriately, with old age (Heninger 1974: 173).[5]

The move from four to seven is a move from the logic of the *medici,* or doctors, with their humors to the astrologers with their seven "planets." The move was also historical, since the lack of interest in astrology in the Middle Ages was reversed in the Renaissance (Burrow 1986: 39–40; Sears 1986: 134). Thus, the Seven Ages of Man, which might in the light of Jaques' speech in *As You Like It* (2.7.139–66) seem the standard, were not dominant until well into the northern Renaissance.

If the Four Ages were characterized by the nature of the seasons, the Seven Ages were characterized by the nature of the planets that dominated them.[6] The moon dominated infancy (*infantia*) with its changeability, while Mercury dominated childhood (*pueritia*). Venus, bringing on the desire for love, takes over in adolescence (*adolescentia*), which gives over to the glory and mastery of the sun-dominated maturity (*iuventus*). Mars is unsettling in the next age (*senectus*), but Jupiter establishes thoughtfulness and dignity (*senium*). In the last age (*decrepitas*), "Sans teeth, sans eyes, sans taste, sans everything" (*AYL*.2.7.166) the coldness of Saturn prevails. As with the other age schemes, there is considerable disagreement about how long each particular age should last.

As I have been arguing, the available forms for the expression plane will have a considerable effect in defining the content so expressed. Thus in a formal scheme of sevens some interesting semiotic potentialities derive from the biblically established nature of the week and its extension into "week years," that is, seven-year eras. Actually a very early use of the week-year appeared in a scheme of ages attributed to Solon (?638–?559 B.C.). (An excerpt may be found in Burrow 1986: 191.) The week-years worked well in marking off the early stages of human growth at 7, 14, and 21, somewhat less convincingly for 28 and 35 (though 35 had an important place as half the biblical three score and ten) and the "middle of the journey of our life" as Dante locates himself at the beginning of *The Inferno* in the year 1300 and at his age of 35). After adolescence terminates at 21, to eke out four more convincing stages, however, put considerable strain on the systematizers, though ingenuity and a willingness to "cook" the figures as always served them well.

Seven figured not only in days of the week but in the canonical hours of the church day: matins, prime, tierce, sext, nones, vespers, and compline. As usual these sets could be either used or abused. Honorius of Autun associated the seven canonical hours with the Seven Ages of Man and—in a parallelism not mentioned yet—the seven historical ages of the world (Burrow 1986: 59). On the other hand, the complete set of hours was reduced or expanded by others to fit associative schemes motivated by different demands. The possible and surely recognized diversity of application for these numerical schemes makes it clear where the "reality" lay for the medieval mind. This was a Platonic semiotic scheme in which it would be assumed that the numbers—the threes, fours, sevens, etc.— represented basic nature and hence would stand for the facts of existence

while actual ages, temperaments, days, and hours were philosophical "accidents"—interesting but of little consequence for true knowledge.

The differences asserted by medieval scholars also provide interesting examples of the very way in which one culture may define what it takes to be "natural" units, which another culture, acting on different principles in different contexts, defines differently. Burrow notes, for example, that when clerics attempted to translate the neat set of terms for the ages as they had been set out in Latin, the available English words did not refer to the same time period, nor did they carry the same value connotations. *Juventus,* which meant "manhood" or "prime of life" in Latin, could hardly be suggested by its English derivatives "juvenile," "young person," or "youth." This variability recalls the point made by Eco (following Hjelmslev) about how different sign systems slice up the content continuum into different cultural units. Eco offers the example of the different content areas covered by the French and the German words for forest or, in another example, the English language differentiation between "mouse" and "rat" that subdivides the rodent population known collectively in Latin as "mures" (Eco 1976: 73, 78).

Character names in two morality plays of the early sixteenth century illustrate some of the confusion when Latin derivative tags attached to characters on the popular stage. Thus the "youth" in *Lusty Iuventus* (1547–53) is as a character clearly more grown-up—as the Latin original would have him—than his English designation would indicate. Upon his entrance, the eponymous hero of *The Interlude of Youth* (ca. 1513) brags that he is "goodly of person" (41), that his body is "pliant as a hazel stick" (48), and that he has already come into his inheritance (57–58) (Schell and Shuchter 1969: 144). This swaggering young *man* is not the "youth" of the *bildungsroman.* Thus do the definitions of our "ages" in different cultures, operating within the particular contexts of a time and place, define the subject who sees himself or herself acting in that society.

Taking another perspective on the culturalism of the ages, the medieval schemes would have meant little to the peasants, many of whom did not know how old they were, having marked their lives in the different patterns of such civil and religious ceremonies as marriage and the terms of apprenticeship (Burrow 1986: 93). It is very much to our point that such seemingly elementary matters as counting one's age by annual "birthdays" or assuming a "normal" time and character of "childhood" are in fact arbitrarily and culturally determined.[7]

So much, however, is the standard position of any "historicizing" theory today. I have been arguing, on the other hand, that the notion of cultural determination must be supplemented by a closer attention to the nature of the *forms* available to that culture for representing its experience, a statement almost banal in its obviousness were it not for the current overemphasis on ideological or content matters. It is not just the ideas and things existing "out there" (in fact no such unmediated objects exist) that make for the representations of a culture but the form and matter of the representing substance. These, together with the form and matter of the content level, determine how we represent and thus understand our world. On a mundane level the civil and religious ceremonies of the medieval community were more available *and* meaningful as signifiers to mark the stages in the life of an illiterate villager than was the more mathematically precise annual count of birthdays available to the cleric.

Most important for our purposes in attempting a semiotics of art—especially the kind of proto-art of emblems, diagrams, etc.—is to stress the aesthetic nature of these schemes, to show how the available materials, both cognitive and physical, could be put together (as by Lévi-Strauss's *bricoleur*) to provide signs for so much of the life experience. The triangle, the arch, the circle (wheel), the pictures or descriptions of seven persons from swaddled baby to toothless crone *ostended* a form signifying life. Through the form, life took on meaning, and this formal—aesthetic—quality was inherent not just in the picture or diagram, but, at least for the literate, in what I call the "conceptual art" of the very descriptions of the number schemes, enjoyed—like music—for the neatness and far-reaching resonance of its abstraction. Because for the medieval mind, number itself was a form (or Idea), descriptions of triadic or tetradic schemes inevitably resounded with the quality—for instance, geometric—of the number that related the winds, the points of the compass, and the letters in God's name. Even linguistically, a primitive aesthetic quality frequently supported the geometric form being described, as the repetition and variation in the words themselves came into play. Both the sound and meaning of *augmentum* and *decrementum,* where the contrary prefixes and repeated main morphemes tied together yet differentiated the ascending and descending sides of the triangle in Three Ages schemes. In schemes of four the repetition and variation in the traditional rubrics, *Regnabo, regno, regnavi, sum sine regno* (I shall rule, I rule, I have ruled, I am without rule) found on some Wheel of Fortune emblems made a wonderfully concise formula—

thanks to Latin's inflected nature—of the temporal stages of the wheel's turning. Looked at in a semiotic perspective, it can also be seen that the formal declension of a verb—in Latin and English here—creates concepts of performance in the future, the present, and the past, temporal distinctions that are differently defined in other languages. The construction and use of verb tenses and their syntagmatic arrangement can then be seen as a process of sign-making to define and differentiate phenomenological experience. Such self reflexive displays of the mechanics of verb tenses as we have in the *regno, regnavi* formula ostend what I would call "tenseness," helping us to sense all the better our construction of a narrative.[8] The meaning is present, ostended in the form and matter. Thus the sign's own nature both creates the concept it expresses and is called into its particular manifestation by the nature of the concept.

This examination of the aesthetic qualities of the signifier must lead us to consider the specific nature of the wheel and what its nature entails for the meanings that gather around it. In this chapter so far, the wheel or circle has served as a convenient frame for numerical schemes in which the arithmetic, not the circularity, drove the meanings. Such a construction of man's life as set forth in numerical schemes is largely uneventful, as might be a life seen from the monastic perspective on eternity. Seen from below, however, life has its ups and downs, very much as wheels do. When the specific qualities of a wheel, taken as basic metaphor, come forward, a more dynamic scheme of experience takes shape.

The force of a wheel as metaphor lies largely in its implied movement, a rotation upward to a highest point then down to the starting point. It also implies endless repetition as the wheel turns and turns. The medieval person's use of such obvious and compelling physical qualities as metaphorical material has been reassessed by modern cognitive scientists as a natural mental process for conceptualizing experience. Some such "root metaphors" as they appear in the arts are described in Lakoff and Turner's *More than Cool Reason: A Field Guide to Poetic Metaphor* (1989) and considered as part of a cognitivist approach to semiotics in chapter 9 of this book.

The idea of symbolizing the experience of a rise and fall in one's status by the turn of a wheel goes well back into antiquity. Gilbert Norwood claimed to have found a reference to the Wheel of Fortune in Pindar's Second Olympian Ode (476 B.C.). Actually "swinging aloft," "falls heavily," and "rotation" are mentioned, but "wheel" (*kyklos* with its obvious

reference to our "cycle" and "circle") is not (Norwood 1945: 132). Norwood's discussion of this reference, which includes a list of the recurrences of the Wheel of Fortune image in ancient Greek and Latin literature (253–54), is especially helpful from the semiotic point of view because it prefigures symbolizations we remark on in medieval times. There is, first of all, the mingling in the wheel figure of the ideas of Wheel of Life and Wheel of Fortune (134) and secondly the mingling of verbal and visual symbolism. In connection with this mingling of verbal and visual symbolism, Norwood remarks that *theta*, the first letter of the name of the man, Thero, for whom the ode was written, was in Pindar's time written as a character that resembled a four-spoked wheel, adding that in these early times orthography and graphic iconicity were not as distinct as they are today (132–33; Norwood's material on the wheel is found on pp. 131–37 and 253–55; for the wheel in ancient mystery religions, Jane Ellen Harrison 1903: 588ff is cited). As Norwood admits, the wheel became a much more popular figure in the Middle Ages when most scholars pick up the story with Boetheus, who describes the operations of a Wheel of Fortune in his *Consolations* (486). Later the author of the alliterative *Morte Arthure* (early fifteenth century) supplied a famous example in which King Arthur dreams of a wheel on which the classical Nine Worthies rise and fall (l. 3223–3455; see Janssen 1981).

In early medieval times the use of the wheel as a signifier representing rotation from cradle to grave added movement to a purely synchronic numerical scheme. When seven became the most popular number of ages, the rotating wheel very effectively gave us three ages of growth—*infantia, pueritia,* and *adolescentia* on the upswing and *senectus, senium,* and *decrepitas* as the balancing ages of the downturn. With form again defining meaning, *Iuventus* stands at the top of the circle as man's finest age, thus enforcing for those cultures most bound to this metaphor a special value for maturity as opposed to the "wisdom of age" or the "innocence of childhood." The continual rotation of the wheel promoted thoughts of the obvious repetitiousness of life's cycles. Some wheel emblems illustrated this with a combined cradle and grave at the bottom of the wheel into which the aged one falls, only to catch onto the rising wheel as a newborn infant.

As the later Middle Ages, existing in a period of greater stability, took more account of earthly matters, not only did the wheel's manifestation of rise and fall rekindle interest but so did the question of who or what made the wheel turn in the first place. Thus the need to conceptualize a cause

for observable changes from high to low and from impotence to power brought the figure of Dame Fortune into focus and set her prominently in the wheel emblems with her hand on the crank.

In the visual representations from the Middle Ages one typically found the figure of Dame Fortune turning a large wheel on which a number of figures were seen to mount, rise to the top (a point at which their worldly ascent would be attested to by the presence of a crown, a bishop's miter, etc.) and fall off the descending side. A key element in the interpretation of these emblems was the iconography of the figure of Fortune herself. Plate 4, from a 1554 print edition of Lydgate's *Fall of Princes,* one hundred years after the author's death, shows Fortune as, in this case, both two-faced and many handed, though elsewhere she was often depicted as blind, with the obvious suggestion of pure chance as determiner of one's fate.[9] Other versions depicted the Dame as two-faced, smiling and frowning, or, representing the saying "Grasp Fortune by the forelock," as sporting long hair in the front but being bald behind.[10] Since our concern is with the wheel emblem as a "sign of life," not with the teleology of fortune or the moral issues of fate and free will, we may move on to our business of describing the semiotic use of this device—that is, the form of the wheel and the shape that this would lend to the narrative and dramatic biographies of those who were taken to have clambered aboard.

With the approach of the Renaissance and its glorification of man, speculation turned to the activities of the wheel rider him or herself and to whether or not he or she might bear some responsibility for the motion of the wheel, thus setting the ground for a very different image of life's experience, the pattern of tragedy. As this change advanced, the wheel emblem as visual signifier faded; eventually tragic story and drama blossomed as the new schema for the significant life, life seen not as growth but as career. The wheel, as Wheel of Fortune, continued as basic shaping metaphor, but it did so as structure for a verbal signifier—story or play— not as visual artifact itself. Plate 4, the frontispiece for Lydgate's *Fall of Princes* mentioned above, illustrates this perfectly, for we see the author sitting with pen in hand ready to write the book that will be the artwork while he contemplates Fortune and her wheel, which will serve only as basic metaphor for the stories he creates.

The "wheel stories," illustrated or not, were an important and popular form of history, biography, and moral teaching, all of which tended to merge into one instructional genre. Three well-known collections of such

stories are of special interest here: Boccaccio's *De Casibus Virorum* (ca. 1363), Lydgate's *Fall of Princes* (ca. 1438), and Baldwin's *Mirror for Magistrates* (1559–1587). Boccaccio's *De Casibus Virorum* (ca. 1363) established the Renaissance tradition of books describing the fall of great ones. Written after the vernacular *Decameron* by a penitent Boccaccio, the *De Casibus Virorum* recounts in Latin prose and with an assertive moral theme the lives of a wide range of both men and women including Adam, Agamemnon, Queen Brunhilde, and King Arthur. Boccaccio's stories, based upon diligent research in his own extensive manuscript collection, were intended to be scholarly and historical. As we shall see, this tradition of historicity clung to the *de casibus* genre through Baldwin's *Mirror for Magistrates*. These cultural assumptions about what constitutes "history," "fact," "fiction," and "art" give these "signs of life" a particular kind of meaning, a basic understanding of what constitutes significant experience. It was, as I argue, intimately tied to that total schema of experience that the nature of a turning wheel as signifier constituted as a ruling metaphor.

To close this chapter on the wheel as a sign of life, I want to focus on Lydgate's version of Boccaccio without dwelling on the Latin original or Laurent's French translation/adaptation from which Lydgate worked.[11] This focus places us squarely in England and in a direct line to Baldwin's *Mirror for Magistrates,* with which I will open the next chapter. Taken as signifier in its form and matter, the *Fall of Princes* serves another purpose in that it clarifies the considerable differences between the meaning of Lydgate's book and the *Mirror* published 120 years later, a difference too easily glossed over even by the publisher of the *Mirror,* who thought of his book as pretty much an update of Lydgate.

Any full sense of the meaning of Lydgate's work must come from a close look at the artifact itself. First, as the "book" was written 40 years before the earliest book was printed in England, it was "published" as a manuscript limiting its circulation—even though it was quite popular—until the print edition of 1554. It is long, taking up 1,022 pages in the three volumes of the EETS 1924 edition. While Boccaccio and Laurent wrote in prose, Lydgate composed his 36,365 lines in ten-syllable verse using mainly a stanza of seven-line rhyme royal (*ababbcc,* the stanza most used in the *Mirror*). The book has a very crowded feeling with 143 sections (see Bergen 1924: xxiv–xxvii for a convenient list of these) and over 250 "princes." (Lydgate's wheel spun very fast!)

By far the greatest number of characters are drawn from Roman history or myth, including such Greeks as Virgil described; however, the first fall is appropriately that of Adam, and biblical characters do plentiously appear. Particularly in Books 8 and 9, medieval figures get into the story and the last character treated is King John of France, who fell—to the English—in 1356. (The politics of this story split Lydgate from his continental predecessors.) Control of the narration is taken by Lydgate himself, describing how the ghostly figures from the past begged Boccaccio to tell their stories, adding moral comments, and then telling in third person the story as recorded in Boccaccio/Laurent. Thus, for the greater part, the morals are pointed by the author, not by the characters, unlike the technique of the *Mirror for Magistrates* in which the ghostly characters tell their own stories and point to their own faults.

Although there is commentary within particular stories and several autonomous sections belaboring different vices such as an "Envoy advising Princes to set aside their concubines," "On Worldly Covetousness and Ambition," and "An Envoy on Ingratitude," Lydgate is as changeable as Fortune herself when it comes to settling on some common reason why these very different, and certainly not all bad, people should have suffered a fall. We learn that God will punish sin, that tyranny will be revenged, that avarice may end in want. On the other hand, ill fortune can turn to good as it does for Diocletian: "Thus can Fortune chaungen hir viage . . . Whos double wheel quavereth ever in doute,/ Of whos favour no man hath be certeyn" (Lygate ca. 1438: Book VIII, 943, 947–48). At the very end of his book, Lydgate, paraphrasing Boccaccio's Latin prose ("Here Bochas makith a rehersaile how fortune hath made high estates unwarly to descent"), sets out in eight eight-line stanzas his final word on Fortune. Stanzas one through four catalogue the different princes of the world—popes, emperors, kings, prelates—whom, in the last line to each stanza, Fortune "made hem to descend." In the next four stanzas an interesting switch is made to examples that demonstrate that no matter what one does or how good or bad one is, the varied refrain tells us, "Fortunis wheel bi revolucion/ Doth oon [one] clymbe up, another to descende" (1011–1012).

This is minor poetry, but it is poetry and as such its form ostends a meaning that can be seen in the balance and gathering of the two sets of stanzas. In the first set of four stanzas, people are gathered by degree, and through the force of a refrain, all—no matter how high or low—

are subjected to a fall. The second set of four balances the first and contrasts it. The riders of the wheel are categorized here—somewhat inconsistently—as high or low of birth, righteous or profane, earnest or careless. In the second refrain, these folk are all warned that whatever their merit, Fortune will decide their fate. There is order in disorder.

What can be gleaned from this popular sign of life? We have a book in regular stanzaic verse by a poet at the time ranked with Chaucer and Gower, a poet who was a learned man and a monk. We have a jumbled collection of many brief tales of characters, most of whom lived—in fact or fiction—more than 1,000 years before the author. These characters fall from great power and riches, brought low in keeping with the constant pattern of an abrupt turn of a wheel. As explanation we have little more than the very source of the metaphor itself: life is like a wheel; wheels rise and inevitably fall. Finally we have constantly repeated the reference to these stories as "tragedies," even in those cases in which the "tragic" protagonist is very far from exhibiting any kind of nobility.

That scattered and widely diverse persons—all but "Glad Poverty"— meet the same unhappy fall puts quite a different meaning, one of inevitable and unanswerable vicissitude, to the sign of the wheel, which earlier we considered as the essentially benign bearer of growth through well-plotted stages from infancy to decrepitude. But the wheel as sign was to have one more vital life in the second half of the sixteenth century, when as metaphor it came to the conscious notice of its riders who now self-consciously used the stages of its rotation not only to figure a more orderly rise and fall but more importantly to figure for themselves their own complicity in the wider progress of events. For this I turn first to the self-told stories of the *Mirror of Magistrates* and finally to the incorporation of these stories in the much more articulate mouths of the characters in Shakespeare's *Richard III.*

4

DEATH OF A SIGN

In this chapter, I address the process through which the expressive needs of a culture affect the making of signs as social change and new materials expand the meanings to be signified. I described, in chapter 3, the concept of a wheel that conveniently represented life seen as growth and decline—when the circular and redundant qualities were stressed—or the rise and fall of power—when the more active properties of a turning wheel were called upon to express Renaissance man's ambitions and their results. But the wheel's precipitous journey up and down as well as the inevitability of its fall were losing their interest, especially because they were seen to fit all: ancient, biblical, or medieval; emperor, priest, or soldier; good or bad. Even with the help of the figure Fortune, the wheel eventually proved unable to symbolize a force increasingly in need of finer definition.

The turning wheel, however, had not yet spun out its course, for the pattern of medieval *de casibus* tragedy, even in the mid-sixteenth century, seemed still to describe the form of a princely life. John Wayland, as we shall see, felt that English history down to his own time could be dealt with simply by extending the Boccaccio-Lydgate *Fall of Princes*.[1] After all, what Boccaccio and Lydgate had thought good enough for Adam, Caesar, and King Arthur would be good enough for the last Plantagenets. But a number of these more recent wheel riders had risen and descended within living memory, making their stories less amenable to the mechanical and impersonal treatments accorded figures of ancient times. Along with a change in the culture and nature of "princes" on the content plane, the invention in the fifteenth century of the printed book brought revolutionary change to the material for the expression plane. With these currents at work in the background, the authors of the *Mirror* stories, in ways they

themselves probably did not fully recognize, can now be seen as grasping for conceptualizations of life's actions that are more personal, self-conscious, and self-responsible than those of their *de casibus* predecessors. However, at least as guiding metaphor, the image of a turning Wheel of Fortune clung on in the *Mirror,* and at the end of the century reappeared in a vastly different and more nuanced medium, the theater, where a number of the characters Baldwin and his colleagues had represented in print mounted the stage to play out their own stories. Thus in Shakespeare's *Richard III,* Richard, Buckingham, and Hastings rise to a peak of success and fall from it while self-consciously articulating their change of fortune under the sign of the wheel. The conceptualization of a life in this pattern, however, was already yielding to more modern concepts of human will and the chances of history. The wheel that had been a vital sign in medieval thought had by the turn of the century reached the state of dead metaphor trotted out as a cliché of life's mutability, far too mechanical to express the new sense of man's self-fashioning. To describe the process of this change, I must turn to the composition of the two works, the *Mirror for Magistrates* and *Richard III,* chosen to represent it.

WHEEL FORM IN THE BOOK

In 1553, having support from Queen Mary and presumably sensing an appetite for such a revival, John Wayland secured a patent to bring out a new edition of Lydgate's *Fall of Princes,* first published in manuscript almost 120 years earlier. To Lydgate's translation of Boccaccio was to be added "the fall of al such as since that time were notable in Englande" (Campbell 1938: 5).[2] Wayland selected William Baldwin, a very highly regarded "philosopher, poet, printer, playwright" (Campbell 1938: 23) to supervise this new edition, and having divided the task with some learned friends, Baldwin set about collecting the required stories.

Several things about these stories deserve our particular attention. These are not stories of biblical or classical figures but of men and women of the recent past. (Richard II was killed in 1400; Richard III was killed in 1485, roughly 70 years before the first set of stories was gathered. The older *Mirror* authors might well have known persons familiar with some of the characters they portrayed.) To the closeness in time must be added the closeness in experience: the contributors of the *Mirror* stories were, with the exception of Churchyard, highly placed courtiers and lawyers

whose skill in diplomacy is attested by their ability to maintain royal favor—and their heads—under four contentious rulers (see Campbell 1938: 20–48). They knew not only the kinds of men and women they wrote about but the kinds they wrote for: the princes who governed and the "magistrates" like themselves who served them. This was instructional literature tuned to the true Horatian demand both to teach and delight.

The *Mirror* authors were not only courtiers and historians; they were, in the wide sense of the word at that time, poets, writers of some renown, responsible for major translations, essays, and poems. Several of these authors had important connections with the Tudor theater and were thus early explorers in the art of putting the roughly drawn figures mounting the wheels in the emblem books onto the stage as living actors. Baldwin, general editor and author of most of the stories in the 1559 printing, was a playwright and with his friend and closest *Mirror* collaborator, George Ferrers, supplier of entertainments in the court of young Edward VI. Sackville, whose story, with "Induction," of the Duke of Buckingham was then and is now the most praised of the contributions, was the author of what is known as the first English tragedy, *Gorboduc,* performed at the Inner Temple (a law school and thus not a popular venue) in 1560–61. John Skelton, author of the very brief tragedy of King Edward IV, is more famous for his early morality play *Magnificence* (ca. 1516).

I want to direct attention to the form of these *Mirror* stories, stories that have generally been considered mostly for their moral thrust and for their influence upon the developing idea of tragedy. In themselves they were first of all poems, of somewhat varying quality but generally thought to be quite good at the time. Sir Philip Sidney, in the very small list of contemporary poetry he found worthy of mention, accounted "the *Mirrour of Magistrates* meetly furnished of bewtiful partes" (Philip Sidney 1595: III.37, probably written ca. 1583; see also Budra 1992: 2). They were roughly structured as wheel stories with a marked rise, climax, and fall, a form frequently called to the reader's attention by references to Fortune's Wheel in the stories themselves. Unlike the Boccaccio-Lydgate stories, the *Mirror* stories were devised as dramatic monologues by the princes themselves returning in ghostly form. Thus life seen in the form of a "mirror story" is life seen retrospectively, as the ghost's reflection on his or her career. Even so, these are not lives maturing in mathematically programmed stages but lives signified by the moments of the grown-up protagonist's struggle for power: basically no struggle, no life. (An interesting hint that

some mature ambition and direction were required for a proper *Mirror* protagonist may be had in the fact that the story of Edward IV's two boys, who were murdered in London Tower, though assigned—to Lord Vaulx— was never completed [Campbell 1938: 297].)

The *Mirror for Magistrates* stories have what in theory is a very clear plot, which frequently gets muddied in the telling. The ghost starts with an admonition, as in this typical opening of Buckingham's complaint: "Who trustes to much in honours highest trone/ . . . Beholde he me, and by my death beware" (l. 1,5, Campbell 1938: 318).[3] The protagonist tells of his or her rise, the misdeeds committed (these need no longer come strictly from the catalogue of the Seven Deadly Sins), the trusting and betrayal, the punishment, and finally adds another summary admonition. There is a liveliness and purpose to these warnings, both in the stories themselves and in some of the prose links, suggesting a sincere moral purpose on the part of the writers and on the part of an audience wide enough to call forth the succeeding editions.

To appreciate the meaning of life that was being communicated by Baldwin and his fellow authors, a closer look at the immediate structure of the stories is important. As we will see, the turning of the wheel was more halting, more pictorially oriented, than it would become later when Shakespeare framed these characters in a dramatic, causally motivated structure.

The semi-dramatic monologues that make up the *Mirror for Magistrates* are generally not what we today would consider well structured. Though when Sackville's story of Buckingham was read before the little group of the *Mirror* authors it was especially well received ("The tragedy excelleth" [Prose link 22 in Campbell 1938: 346]), it is more moralizing and temporalizing than active. Buckingham speaks of rising with the treacherous Richard and sharing in the blame for his misdeeds, but on his downfall and death—ordered by Richard—Buckingham does not curse the King but a man named Banister to whom Buckingham had shown favor and who had betrayed him to the sheriff. With the line "O let no prynce put trust in commontie" (line 421 in Campbell 1938: 333), Buckingham launches into eleven late stanzas cursing the common people who had turned against him. Thus the action is delayed while Buckingham's ghost supplies the necessary examples of those whom "Ingrateful Rome" (449) had exiled. This is interesting for any cultural semiotics in its manifestation of a form—the exempli—and subject matter that today seems only to hold up the plot but that in the Renaissance seemed important enough for

Lydgate to insert in the *Fall of Princes* as an "Envoy on the Fickleness of the People" (II.389.90) and for Shakespeare to dramatize in his Roman plays *Julius Caesar* and *Coriolanus*.[4]

Hastings's story is a little more closely focused on action, but the plot is diffused over different periods and several different sins: pandering for Edward IV, his own adultery with Shore's wife (a mistress whom he had inherited from Edward), and his part in the murders of Henry, Prince of Wales, and of Rivers, Vaughan, and Grey. The narrative structure is most damaged by frequent lapses to stanza after stanza of exempli, after which the plot line will be picked up again only to be sidetracked by more examples or speculations such as the semiotically interesting note on what Peirce would have called the indexical sign. ("What should we thinke of sygnes? They are but happs./ How maye they then, be sygnes of after-claps?" [Campbell 1938: 287, lines 489–96]).

The editor, Baldwin himself, probably fashioned the reasonably well-knit "complaint" for the unfortunate Lord Rivers, brother to Edward IV's queen. This contains nice bits of dialogue and effective description of the settings such as those toward the end when Rivers, at his inn at Northampton, is feasted and then betrayed by Richard and Buckingham (lines 386ff). Yet the effect of Rivers's story is weakened by Baldwin's indecision about the cause of his fall. The brief story of Richard himself, by Francis Seager, was quite tight: his sins were clearly defined and directly related to his fall, though it might be said that Seager had an easy target for a moral piece.

Thus we have as a "sign of life" life conceived as a moral example and of course, as corollary, the idea that this was the significant life, the defining life, which might in some small part be lived by anyone, though the authors made it clear that they were writing for that statistically small part of the population who were "magistrates" like themselves. The 1559 and 1563 editions of the *Mirror* caught the culture in a particularly raw period, licking its wounds in Tudor times while looking back on the devastation, of the contention between the houses of Lancaster and York. The material was fresh and especially relevant because the figures involved in these stories had directly affected the political climate under which the readers of the *Mirror* lived. However, the rapidly changing cultural forces at the end of the sixteenth century demanded different signs for their new concepts, causing a great falling off in popularity for those editions after 1578. The final edition (1609–10)—distanced and generalized by Higgins with early

English materials—failed to entice even the bourgeois city audience it had been designed for, an audience that was finding the formal and conceptual force of the theater more effective (see Budra 1992).[5]

It has been mentioned that the *Mirror* stories are in verse; they are poems by a set of very well-educated men who could have been counted on to know the rules and theory of the great classical works. We must consider what effect this formal dimension has upon the meaning of a collection of moral discourses too easily dismissed as simply versified histories.

The general details of poetic form are soon told. All stories are in stanzas ranging from a twelve-line stanza for Skelton's Edward IV to a two-couplet, four-line stanza for Baldwin's Henry VI. The default form, however, was the rhyme royale, a seven-line stanza rhymed ababbcc. Twenty-three of the twenty-seven stories in the 1559–63 editions were composed in this scheme: the form used by Chaucer for his *Troilus and Criseyde* and, later, by Shakespeare for *The Rape of Lucrece*. Meter, with rare exceptions, was loose iambic pentameter.

The stanzaic form of rhyme royale prescribes, for any narrative that it structures, a particular kind of rhetorical paragraphing. The tendency will obviously be to conclude a thought with the new—*cc*—rhyme in lines six and seven and to start a new thought, or more particularly, a new phase in the action with the first line of the new stanza. Comparisons are generally molded to the stanza, developed to the length of 70 syllables—no more, no less—whereupon a new comparison or exemplum may be taken up or a return to the plot announced. In short, this set arrangement of lines with its tight rhyme scheme parcels out the intellectual movement of the narration in a way that nonstanzaic narrative verse—Chaucer's "Miller's Tale," for example—does not.

Poetic form may be seen to have further semiotic content here due to the emphasis on the material of the expression plane and the sound of the words used, enforced by the demanding rhyme scheme and probably by a lingering sense of medieval alliterative verse. It is true as well that rigorous schooling in the "figures"—such as the polyptoton described below—heightened a writer's consciousness of these linguistic devices, thus subtly leading him or her to code experience in the forms that the nature of language itself as material offered to creation. A particularly interesting example of this effect may be drawn from Dolman's story of Lord Hastings.

John Dolman, son of a rich manufacturer, was, at the time of writing, a young—23 at most—law student at the Inner Temple (where Sackville

and Norton's *Gorboduc* was performed in 1561). The reception of young Dolman's piece then and now is particularly interesting. When Baldwin read the story aloud, the gathering found it "very darke, and hard to be understood" (Prose link 21, Campbell 1938: 297). For the 1574 and later editions a number of the "darker" passages were unscrambled, presumably by the new editor, John Higgins. Lily B. Campbell finds Dolman's "the worst poetry in the *Mirror*" but "in learning and in thoughtful philosophizing on the rewards of evil doing . . . second only to Sackville's tragedy" (45–46). In his volume of the *Oxford History of English Literature* (1954), C. S. Lewis finds Dolman unsatisfactory in the way that what he dismissively characterized as "Drab Age" verse was unsatisfactory, but he allowed that Dolman seemed to understand "what a poem *ought* to be" (Lewis 1954: 243 my emphasis). Indeed, Lewis noted that Dolman's "darke" passages contained the "tough, sinewy conceits" that he would praise in the "Golden Age" verse of Spenser, Sidney, and Shakespeare.

A close look at Dolman's history of Lord Hastings suggests that aside from the very interesting speculation on the meaning of indexical signs mentioned above, Campbell's praise of Dolman's philosophizing is excessive. There is no doubt that the writing is turgid and certainly hard to understand, some of it merely bad, straining for a complexity beyond the author's capacity to control. On the other hand, Dolman's tragedy contains interesting poetic devices found in the other stories in less vivid examples. Here especially, the material of the discourse and the sounds and rhythms of the words, together with their semantic relations, structure the nature of the portrait being limned. Dolman, more than any of the other *Mirror* authors, seems taken with the power and materiality of language itself: with repetitions of the same word in a different sense (polyptoton), with contrasting meanings tied together in similar sounding words, etc. Thus it is easy to see the associations of sound and sense so strikingly put defining the picture of a man whose "virtue" must breed a "vice," whose "sense" must control its "non-sense" because seemingly the aesthetic nature of language itself demands it.

In the first two lines, Dolman puns on Hastings's name, a not-irrelevant allusion since the lord's execution was rushed to take place before Richard dined (see line 593 of the complaint) and links "prayse" of life and "plaint" of death: "Hastyngs I am, whose hastned death whoe knewe,/ My lyfe with prayse, my death with plaint pursue." In the last three lines of this first stanza Dolman, in one of those "sinewy" conceits that must have delighted C. S. Lewis, adds a further bit of polyptoton:

> Though bared of loanes which body and Fortune lent
> Erst my proud vaunt: present present to thee
> My honoure, fall, and forced destenye.

(In the edition of 1574, the last two lines were changed to the very prosaic "My selfe here present do present to thee/ My life, my fall, and forced destenye" [Campbell 1938: 268]). Twenty-three lines later, while still elaborating his admonition and considering how the evil actions of men may ironically serve God's just revenge, Hastings says "O Iudgmentes iust, by uniustice iustice dealt" (31). To do justice to Dolman, the cramped style of the first few stanzas is loosened as he gets into the story. The word play continues but in a less cryptic vein.

From the overall structural level of the wheel metaphor itself to the immediate level of the sound and the sense of the single line, it is clear to see the meaning of the expression plane. Here, at the level of the line, the shape of a life is coaxed out by the nature of the contrary and the contradiction: life versus death, justice versus injustice. These semantic contrasts are linked in the set space of one ten-syllable line by concurrence on the phonetic level, the repetition of the *p*s life, praise; death, [com]plaint. (Dolman, as most of the *Mirror* authors, tends to combine his concurrences of sound and contradictions in meaning rather with the alliteration *within* a line than with the rhyme words in succeeding lines.)

Whatever dramatic touches might be felt in the stories Baldwin had collected, these were still stories, intended for and presented on the printed page. Yet the *theatrum mundi* metaphor lurked just below the surface as the opening lines of Sackville's tragedy of Buckingham demonstrate:[6]

> Like on a stage, so stept I in strayt waye
> .
> As he that had a slender part to playe:
> To teache therby, in earth no state may stay,
> But as our partes abridge or length our age
> So passe we all while others fyll the stage.
>
> (l. 44, 46–49)

A little more than thirty years after the first appearance of the *Mirror for Magistrates,* Shakespeare put Buckingham and the others on an actual stage, and it is to the theatrical setting of the wheel story that I wish finally

to turn in examining the evolution and eventual death of these cyclical "signs of life."[7] My interest here, as throughout, is in the effect on meaning of the material and the form of the signifier: from the ink and paper of the emblem drawings to the elaborate mechanics of the Elizabethan stage and from dominant numerical and geometric patterns to something approaching an Aristotelian concept of an action.

WHEEL FORM ON THE STAGE

Shakespeare's *Richard III* rests precariously on that border between the Middle Ages and what is now being called the "Early Modern" period (Marcus 1992: 41–63). This play looks backward to expressions of life in the patterns evolved in the emblems we have described and forward to a drama that must be linked with the forms and ideas of early modernism.

This modernism, however, had not fully possessed Shakespeare by 1591, and his renderings of fifteenth-century history in the *Henry VI* plays and *Richard III* took dramatic shape in a progress that the characters themselves saw as patterned by the wheel. Indeed, old Queen Margaret, in her de facto role as choral leader, announces the position of Richard's ride on the Wheel of Fortune at the opening of act 4: "So now prosperity begins to mellow,/ And drop into the rotten mouth of death" (*RIII* 4.4.1–2). Richard had risen to the top of the wheel and secured the crown through the deaths of his two elder brothers and the suppression, largely by murder, of all who would have opposed him. His greatest crime and most important act of self-insurance had been achieved in the arranged assassination of the young Prince of Wales and Duke of York (the children of Richard's brother, Edward IV). But the wheel has begun to turn down, for as Richard has told us at the end of the last act, Buckingham, Richard's former partner in evil, has taken up arms against him, and the powerful Bishop Morton has fled to Brittany to support the claimant Richmond (who does indeed conquer Richard at the end of the play and take the throne as Henry VII).

This moment of mellowing—with its obvious connotation of autumn—locates itself in the third quadrant of the wheel's circle after the peak of the wheel's rise, which in the play might be pegged at Buckingham's proclamation, "Long live King Richard, England's worthy king!" (3.7.239) almost exactly half-way through the play—50.1 percent by line count.[8] The play is clearly shaped by the rise and fall of one protagonist, Richard. That

this rise and fall may be seen—as Margaret sees it—as a wheel story does not detract from its dramatic effectiveness; this is a play about the career of one person, not a collection of tales about many. However, the force of wheel, or *de casibus,* form was still strong enough to lure Shakespeare into incorporating three wheel stories into his plot. This late use of an antiquated form bears semiotic interest in the way in which the medieval narrative pattern is adapted, with some of its meanings still clinging on, to the newer concepts of a self-determined, self-responsible tragedy.

The wheel stories I refer to within the determining form of the protagonist's story are those of Rivers, Vaughn, and Grey, of Hastings, and of Buckingham.[9] Each story has a similar shape and a similar conclusion in what I will call the "halter speech." In these stories we have two formal elements. The first consists of those staged moments when the characters are at or reach their height of power and the moment when, fallen, they regard their execution. Though abbreviated, the *de casibus* pattern is clearly suggested. The second formal element is the "halter speech" just mentioned. This moralizing, retrospective narrative, though its speaker is alive, not ghostly, bears an interesting resemblance to the much longer retrospective stories in the *Mirror.* On the other hand, as "halter speech," it acknowledges another and more political genre of "last words" that continues to this day. Hastings' wheel story can well stand for the wheel-story genre here. It is the most developed of the three and, since it could probably be cut by a modern producer who wanted to "tighten up things," represents a sign whose meaning and importance has not outlasted the times.

Hastings, old and gullible, the adulterous inheritor of Edward's concubine, Jane Shore, enters the play in the very first scene as his wheel begins to rise with his release from prison. Restored to honor in the Yorkist court, he receives Margaret's curse in act 1, scene 3 and, in act 2, scene 1, hypocritically promises peace with the Queen's kindred, who he believed were responsible for his imprisonment. Though the audience knows he is being duped by Richard, Hastings counts his fortune high when he receives news of the impending death of the Queen's brother and son—along with Vaughan—at Pomfret (3.2.49). Shakespeare fills this scene with irony as the foolish Hastings ignores the warnings of Lord Stanley and Catesby's double-edged condolences ("'Tis a vile thing to die, my gracious lord,/When men are unprepar'd and look not for't" [61–62]). Hastings gloats to a scribe—also named Hastings!—that this day his "enemies are put to death,/ And I in better state than e'er I was!" (101–02). Here, with

special clarity, we feel the meaning that form adds to the literal informa-
tion of the text. Hastings is made to declare his position at the top of the
wheel, locating himself in a circle that we know has a bottom as well as a
top and adding the mortal sin of pride (augmented, in the case of this fool-
ish man, by blindness). The connotations suggested by the form of the
wheel are furthered in the speech just quoted by having Hastings, in the
same sentence, link the fall from the wheel of his enemies with his own as-
cendancy. With these oppositions, the form of irony, in which high is low
and good is bad, gives bitter meaning to the contrast we know between
Hastings's words and his true standing.

The omens in Hastings's journey toward his fatal meeting with Richard
in the Tower—meeting with a priest and the stumbling of his horse (signs
that Dolman had effectively described and theorized in his *Mirror* story)—
are picked up and dramatized by Shakespeare before he opens on the con-
ference itself in scene 4. Hastings, though his death has already been
decided on by Richard, counts himself so much in favor that, led on ma-
liciously by Buckingham, he presumes to speak for Richard for "I know he
loves me well" (3.4.14). Sixty-two lines later, on completely spurious
charges, Richard has pronounced Hastings's death sentence.

Hastings's halter speech expresses his concern for the land he leaves and
a recognition of his own fault: "Woe, woe for England; not a whit for
me—/For I, too fond, might have prevented this" (4.3.80–81). He re-
counts the signs that should have warned him and acknowledges the cal-
lousness of his own gloating over his enemies' death. In this speech, much
attention is given to the turner of the wheel—Fortune—and to the insub-
stantiality of her favor. It also links the fall into the grave to Margaret's
"drop into the rotten mouth of death" and, as Hammond comments, to
Clarence's predeath nightmare at 1.4.20 and 30 (Hammond 1981: note
on 3.4.98–101).

> Who builds his hope in air of your good looks
> Lives like a drunken sailor on a mast,
> Ready with every nod to tumble down
> Into the fatal bowels of the deep.
> (3.4.98–101)

Hastings concludes the speech and the scene with a sober and prophetic
couplet: "Come, lead me to the block: bear him [Richard] my head./ They

smile at me who shortly shall be dead" (3.4.106–07). As Hastings exits to his execution, Richard and Buckingham, both of whom "shortly shall be dead," enter for the next scene ridiculously clad in "rotten armour, marvellous ill-favoured" (3.5.sd) attempting to convince the populace of their fear for Hastings's presumed "plot."

That moment at the end of the wheel's journey dramatized by the "halter speech" as subgenre provides a useful example of the kinds of meanings I am asking semiotics to mark out, for here the form itself can be seen to transcend the specific referents of the words uttered. In this case the nature of the signifying form includes the pragmatics of the real or dramatized situation: presence before a final judgment. This situation displays a character distinguished by the overriding sense that his or her career lies in the past and that however the shape of that career may have been visualized, he or she is somehow marked by the metaphor of the "fall." In short, the whole summary nature of this radically contextualized "sense of an ending" speaks to the community at large well beyond the literal message stated. A famous Elizabethan example of the genre, though slightly later than the writing of *Richard III*, was the speech of Robert Devereux, Earl of Essex, accused of treason by Queen Elizabeth and executed on February 25th, 1601. The presence of this kind of formal meaning inhabiting situations in vastly different ages and contexts can be suggested by noting in modern times, "those Irish minigenres the speech from the dock or the graveside oration" (MacDiarmid 1994: 40; a note on this passage cites the speeches by Robert Emmet [1803] and Roger Casement [1916]).[10]

As the wheel completes its cycle and its passengers "drop into the rotten mouth of death," another voice appears to enunciate that final "sign of life," the marking of its passing in the formal lament. Though the lament would not be considered integral to the wheel story proper, those laments we shall examine in act 4 of *Richard III*, by linking the overlapping names of the Plantagenet nobility, form stark signifiers of the toll of civil war. While the wheel stories of women as well as men have been included in Boccaccio's, Lydgate's, and Baldwin's collections, the role of women in the history of the period are revealed most strikingly in these choral laments of Shakespeare's. These formal laments make manifest, in a way that only this gendered form could do, that the human form of history has its testament in the words of the women who have brought forth the ascendants and descendants of the wheel. It is especially appropriate here, at the end of the wars between the two Plantagenet houses of York and Lancaster,

that these laments by the women mark the death of so many of their husbands and children.

I have stressed throughout the cultural dynamics of the art form, so here a few words are necessary to fill in what the Elizabethan audience would, at least in a general way, have known about such women as we are dealing with. They would have this knowledge not only through some acquaintance with English history and their knowledge of contemporary lords and ladies but through dramatization in Shakespeare's three *Henry VI* plays, produced just before *Richard III*. Through all of this, one should keep in mind that probably the most powerful monarch in Europe at the time of Shakespeare's play was England's Queen Elizabeth, a monarch whose original claim to this power lay in a woman— the widow of Henry V—whom the relatively unknown Owen Tudor had consoled and married.

It is easy to overlook the immense power, even in an unregenerate patriarchy, wielded by the noblewomen of the Renaissance. Clearly this power was utilized in the limited sphere of the household, but for a duchess like Richard's mother, Cecily Neville Plantagenet, Duchess of York (1415–1495), this would have entailed the management of a very substantial enterprise.[11] Though Shakespeare mentions only four of her children (the surviving males Edward IV, Rutland, Clarence, and Richard), the Duchess gave birth to twelve children, five of whom died young. The three unmentioned surviving daughters all married dukes and indeed the son of her second daughter, Elizabeth, was an embarrassment to Henry VII's reign since he had been named successor by Richard III. The Duke and three of the surviving males—Rutland, Clarence, and Richard—were killed in the Plantagenet struggles for power. The Duchess died at 80, ten years after the death of her youngest son Richard, born in her thirty-seventh year. Of the other mourners in act 4, scene 4, Elizabeth, though mocked by Richard and Buckingham, was no commoner, being the daughter of a lord, and had reigned as queen for almost twenty years. The old Queen, Margaret of Anjou, had married Henry VI at about the age of 15 in 1445 and fought for the rights of her reticent husband and her son until her decisive defeat and the murder of her son in 1471. Her presence in the court of Edward IV is Shakespeare's invention, for she had actually been banished to her native Anjou. Thus a poignancy in the scenes of lament must have moved the original audiences through a sense we now lack, both of the power of these women and the multiple deaths they were

forced to mourn. This immediacy of semiotic impact was strengthened by another meaning which the more literate of that audience picked up as the reference back to the women of Troy (see note 14 below.)[12]

Margaret, Elizabeth, and the Duchess of York are the principle mourners—plus Anne Neville in act 1, scene 2, 1–32—whom Shakespeare uses in two extended sections of formal lament (*RIII*.2.2.34–88 and 4.4.1–135). Of these laments, only the last can concern us here. In act 4, scene 4, the final scene with the women (except when they appear as ghosts in act 5, scene 3), Margaret lurks in the shadows while Queen Elizabeth and her mother-in-law, the Duchess of York, enter to mourn the deaths of Elizabeth's sons. As the Duchess of York, the "mother of these griefs" (2.2.80), bewails the children's deaths and seats herself "on England's lawful earth / Unlawfully made drunk with innocent blood" (4.4.29–30), Margaret comes forward to join the two women, inviting them to "Tell o'er your woes again by viewing mine" (39). Margaret then tells o'er her woes in a quatrain balancing the murders of her son and husband with the murders of Elizabeth's two boys, each line ending in the six-syllable refrain denouncing the "hell-hound that doth hunt us all to death" (48):

> I had an Edward, till a Richard kill'd him;
> I had a husband, till a Richard kill'd him:
> Thou hadst an Edward, till a Richard kill'd him;
> Thou hadst a Richard, till a Richard kill'd him.
> (4.4.40–44)

The Richard of the refrain is, of course, Richard of Gloucester, now Richard III. The Edward of the first line is Margaret's son, Edward, Prince of Wales; the Edward and Richard of the third and fourth lines are Elizabeth's two sons, murdered in the Tower. Though the identifications just given must be correct for the quatrain, the audience would have detected echoes of a Richard—the Duchess's husband—killed by Margaret and an Edward—Elizabeth's husband—who was the killer, with Richard and Clarence, of both Margaret's son Edward and her husband, Henry VI. The irony and tragedy of this history is manifested in the formal repetition of names common to the warring Plantagenets that mixes murderer and victim as a Richard kills a Richard and an Edward kills an Edward. Glancing ahead to our own time, I would add here that two remarkable late-

twentieth-century artifacts testify to the semiotic power of lists of names in lament: the Vietnam War Veterans' Memorial in Washington, D. C., and the AIDS Quilt.

Margaret, as choral leader, continues the laments cursing the instigator of the tragedy—Richard—and balancing, in yet another review of the dead, her losses against those of the Yorkists. In her last speech of the play, Margaret uses an effective and highly formal 34 lines combining the *ubi sunt* and "then-now" topoi (see Clemen 1957: 183) to underline Elizabeth's fall. Most important for our present concerns, though, is the way in which Margaret paints Elizabeth's career as a wheel story, depicting her as "One heav'd a-high, to be hurl'd down below" (86) and (in the quarto but not the folio texts) "Thus hath the course of justice wheel'd about/ And left thee but a very prey to time" (105–06). In addition, Margaret's imagery theatricalizes this wheel story, describing Elizabeth as a "painted queen" who will "fill the scene" of a "direful pageant" (4.4.83,91,85).[13]

I have been attempting throughout to go beyond the regularly denotated meaning of the texts to show how the form itself adds a meaning of its own. To further this point concerning a semiotics of the formal aspects of a text, I want to suggest a few of the meanings added by the form of the signifier as staged lament. I mention first the meaning added by the difference in the gendering of the figures occupying, for a brief moment, the fluid stage space of the Elizabethan theater, a space just vacated by the male plotters in the previous scene and to be reinvaded at line 135 by the men "marching with Drums and Trumpets." Further, the responsive patterning of the speeches which follow Margaret's revealing herself to the others plays out a trope of lament form: the contest of "whose woes are deeper" (as Margaret says, "let my griefs frown on the upper hand" [4.4.37]).[14] Thus the tabulations of losses so extended and repeated here—and using to the full the sound and rhythm potential of Elizabethan iambic pentameter—manifest in the form and matter of the signifier the pathetic meaning of enmity and contestation over *shared* tragic loss. This meaning is encapsulated in Margaret's quatrain quoted above in which the *same* names are repeated as victim and victimizer, as Lancastrian or Yorkist. None of this material gives us new information; the section could be easily cut. Such a cut, however, would leave out not only much of the meaning of gender in this play (considerably expanded from Shakespeare's previous three history plays) but leave out as well the ostention—in the

form—of that very tragically repetitious and tragically divided sameness that is the essence of civil war.

Shakespeare was never again to write a play that paused so long, even if so effectively, to fill out the rhetorical formulae of the late Middle Ages. Thus, with Margaret's exit from the scene and the play at line 125, I close this inquiry into a set of signs of the struggle of human life, signs that could be found both before and after our arbitrary boundaries but that, I argue, had most immediate meaning for the culture from the early medieval Ages of Man diagrams to the theatricalized wheel stories of the sixteenth-century history play.

We can look back to see the simple materials of the expression plane as the paper and ink with which medieval writers transcribed the geometric forms that would define the ages, humors, seasons, etc. of human life and forward to the great Elizabethan theaters where the persons involved were figured forth in the space of a large stage. Here costumed actors could literally ascend to a throne, put on or take off a prop crown, and give voice to the rhythms and repetitions of the naming, as the actor playing Margaret in the scene just described must have done.

The lives we are caught up in have little intrinsic meaning or shape. In our own time they are marked by annual "birthdays," by graduation from the succession of schools we must attend, by terms of elective office. Modern biographies usually sculpt the form of adult life in individualistic stories of achievement, of doing our "personal best." Our serious dramas tend to concentrate life within the bounds of the rebellious—but not too rebellious—individual's failing bout with the same repressive society that we all participate in outside the theater. This chapter, has examined a few signs of life from a premodern culture to see how a semiotically directed inquiry into these schemes of human life could illuminate the ways in which the form and material of our art objects, profound or petty, mark out and give sense to the experience of existence. We have considered the numerologies and geometries of ages and the cosmos. We have traced the cycle of the wheel, which could take one from birth to death or from supreme power to sudden failure. Finally, we have examined the lingering effect of the wheel metaphor in a history play that took its Herculean heroes to kingship and death, which, with its hints of modernism, was already outgrowing the meaning of that circular form, assigning it to that realm of "dead" metaphor in which a general concept remains but the immediate form and matter are quickly transcended. We have studied as a

semiotics how these signs, reacting to and acting upon the cultures in which they worked, gave life and its phases a meaning. And we have explored most specifically how a few medieval art forms used the available physical and intellectual materials to effect this meaning. With the perspective gained by looking semiotically at some curious signs of a distant culture, we may perhaps gain better tools for understanding the often overlooked but deeply mediating meanings in the forms of our own arts.

In examining the wheel as sign, we have had to deal with an image either drawn or described. When, in these descriptions or dramas, language was used, it often was formed into poetry—good or bad. Though we have touched on the force of such poetry, it has been secondary to the larger form of the wheel. We turn in the next chapter to a semiotic investigation of the poem itself.

5

THE SEMIOTICS OF POETRY:
THAT A POEM MAY MEAN AND BE

In the previous two chapters, I considered the ways in which certain Pythagorean forms, most notably those involved in medieval wheel diagrams, gave meaning to the passage of time and the nature of life's experience. As the Renaissance approached, these wheels more and more often were represented verbally rather than pictorially. In these narratives of a wheellike rise and fall, verse—crude in the *Mirror for Magistrates,* sophisticated in the work of Shakespeare—became the most frequent medium. It is time now to move this essay on the semiotics of art away from narrative or dramatic genres and to direct it to the lyric poem, that genre that to many will seem the essence of literary art.[1]

I find the idea of a semiotics of poetry interesting precisely because there is reason to believe that there should be no such thing. To the extent that the poem utilizes natural language to convey a message, it, like any other verbal text, is open to analysis under the theories of semiotics. Such analyses, dealing largely with the content level of the text, have been liberally forthcoming. On the other hand, to the extent that the poem emphasizes its formal qualities, qualities often manifested to some degree in other, "nonpoetic" texts but not emphasized there, it falls into an awkward realm that lies between semiotics and aesthetics. This is the realm of the "uncoded," the "ineffable," the "self-referential," the "unique," "the nontranslatable," which prompted Archibald MacLeish to declare "A poem should not mean/ But be" (1926). If a poem does not mean, it would certainly have no proper place within the discourse of semiotics. Given this problem, I want to propose a theorizing of the lyric poem that would

slight neither poet nor semiotician, a properly disciplined theorizing dealing not with interpretation—the *what* of the poem and the object of the literary critics's usual attention—but with the *how* of the poem, how the poem means as poem, how the poetic text, which arguably contains no linguistic materials unique to it, nonetheless, when read as a poem with an emphasis on the form of its content and matter, means in interesting and important ways in which street signs, for example, do not.

I see a proper semiotics of poetry as describing the cultural work that defines the world of its time through the signs it generates, working with the raw matter and the concepts available to it as does Lévi-Strauss's *bricoleur.* Cultural interests change not only the favored subject matter of poetry, as they did from the time of Chaucer to that of Shakespeare, but the very way in which texts are taken to mean. Thus, after examining the meaning of form as found in a Shakespeare sonnet, I move at the end of the chapter to consider the ways in which the very fact of writing a sonnet establishes this act as a signifier embroiled in the debate about the cultural meanings of minority experience and majority language. Describing the way in which such connotational and conventional meanings are generated on top of the regular and ostended meanings of the poetic form can throw an important light on today's ways of meanings and their significance. But in the terms of a rhetorician Shakespeare would have known, Puttenham, I have put the wagon before the horse, and I must now return to the basic problem of a "poetic language."

To talk about poems, we must talk about language and face the fact that there is *nothing* simple about this common means of communication. Even the word/world relationship of a simple declarative sentence like "The cat is on the bed" has its epistemological problems,[2] yet when language is processed by author and/or reader to construct a literary work, words, worlds and their relationships become increasingly but more interestingly complex. The first order relationship of word to world, very roughly that by which we know that, in Sonnet 4, Shakespeare is telling the young man to be generous with Nature's inheritance, will not be of central concern here. Both historically and in our time, this relationship has been thoroughly examined. Since literature has been considered a second-order semiotic system, constructing literary entities like character, theme, irony on the first-level literal referents of the text, we will assume without further analysis the efficacy of first-level communicative modes and concentrate instead upon the less explored secondary meanings, ask-

ing specifically how semiotics can clarify the nature and mechanism of these formal meanings.

A clear definition of form in poetry is a very evasive commodity surrounded by much fool's gold. First, every statement, poetic or banal, has form of some kind. Even when some compromise definition is reached, the kind of effects described as part of the form of the work vary enormously, so that a formal analysis may, on the one hand, be describing the metrics of a poem and, on the other, the unity of imagery, arguably part of the content. I will utilize here the same categories of matter and content described in chapter 2. That description assumed an undifferentiated continuum—ontologically prior to any meaning-making process—that contains both matter and concepts. As specific matter and specific concepts shape each other, analysis can distinguish in the work of art levels of matter and form on both the expression and the content planes (see chapter 2, figure 2–1). Working from that position and focusing now on poetry, I raise here the problem of *how* matter and form, which the artist is generally assumed to foreground, have *in themselves* cognitive content. Our concern with poetic examples, such as Shakespeare's Sonnet 4, will focus less on procreation, the identity of the "young man," etc. than on the genre of questions typified by the query: Does rhyme mean? I hope to show that, yes, it does mean, mean in a way that, while often not consciously noticed, refers profoundly to our comprehension of our language and its relation to our world. This said, let me now turn to a few verbal texts, some of which would generally be considered to work as poetry, some of which, for various reasons, would not.

This sign, which directs user behavior in the University of Maryland's McKeldin Library, communicates very clearly that the library staff does not want journals one may have picked up to be placed back on the shelves where they were found. The sign, neatly printed and carefully centered on

Please do not

Reshelve

Periodicals

flat white quarter-inch card stock, is of very little interest in itself. One could note, though, that even in this minimal communication, the addressee depends on a reasonably sophisticated "script" about library use to decipher the content of the text and on similar sophistication as to how to deal with the material signifier. For example, he or she knows that the size or shape of the card, the color of the stock it is printed on, or the typeface used are not functional aspects of the signifier. Manipulation of any of these, however, *can* become part of the overcoding of a typical artistic communication. One may, in other words, subvert the normal haste with which we transcend the signifier with some kind of formalist "making strange": printing all the words in very tiny type, for example. With ordinary utilitarian texts, like instruction booklets, the meaning is remembered while the signifier is forgotten.

The point is worth belaboring only to bring into clearer focus the special kind of semiotic function I am predicating of art—in this case, the poem. While I subscribe to the view that in theory there is no distinct line between the poem and the sign on the library wall, nevertheless most readers, including off-duty literary theorists, when they are looking for poetry, pass beyond the "Please do not reshelve" sign to the places where *Partisan Review, Ploughshares,* etc. are found.

What does one find when he or she has located a poetry journal? For an answer, I would abandon the current periodicals and, because I want to make a point about the diachronic and culturally motivated nature of sign functioning, turn to a Renaissance example, Shakespeare's Sonnet 4.

Unthrifty loveliness, why dost thou spend
Upon thyself thy beauty's legacy?
Nature's bequest gives nothing but doth lend,
And being frank she lends to those are free.
Then beauteous niggard why dost thou abuse
The bounteous largess given thee to give?
Profitless usurer, why dost thou use
So great a sum of sums yet canst not live?
For having traffic with thyself alone,
Thou of thyself thy sweet self dost deceive.
Then how when nature calls thee to be gone,
What acceptable audit canst thou leave?
 Thy unused beauty must be tombed with thee,
 Which used lives th'executor to be.

A glance at the text above assures one that Sonnet 4 is in the regular Shakespearean form: fourteen lines rhymed *abab cdcd efef gg.* Iambic pentameter rules the metrics with a few effective variations to be commented on below. Each of the three quatrains defined by the rhyme scheme may be considered a unit, each ending with a full stop and yielding, when combined, the usual mathematical pattern of (3 x 4) + 2 = 14. No discussion of form would be effective without some agreement about the literal meaning, the "plain prose sense," on which it builds. This could be roughly stated as: young man, do not be stingy with the generous legacy Nature gave you. Since, in addition, we want to approach the form and meaning historically, a brief note about the breadth of the Renaissance understanding of "legacy" must be added.

Within the cultural context that these poems reflect, the idea of a legacy or inheritance passed down from parent to child and presumably to be passed on from that child to another generation of children was both particularly practical and particularly wide in range of meaning. The self-made man was rare in this age, and most young men of the aristocracy, including, presumably, the "young man," depended not upon initiating a career but on inheriting a living from their father.[3] The range of entwined meanings generated by "inheritance" was wide because, unlike today, the inheritance was not primarily monetary but was principally an inheritance of land, which carried with it the inherited title—as "Duke of Gloucester"—and the money that land might produce. Deeper than all this was the notion that the inherited land and manor houses on it came as an inseparable part of an inheritance of *blood,* hence the title and hence the nobility, gentility, and, at least in the Platonic sense, beauty that were part of the package.

In the case of Sonnet 4, the inheritance is figured in the form of a legacy from Nature and worked out in the body of the text in specifically fiscal terms: "unthrifty," "spend," "bequest," "give," "lend," "frank," "bounteous largess," "Profitless usurer," "sum," "traffic," "audit," "executor." A subtext for Sonnet 4 was undoubtedly the Parable of the Talents (Matthew 25: 14–30) in which a master gives each of three servants sums of money ("talents") to be kept until his return. The clear message of this parable was that he who had most fully employed and multiplied the money was the best and most faithful servant.[4]

As a first step in considering the significance of the matter and form of Sonnet 4, I should mention the special interest that the matter itself—the

English language—had at the time. Shakespeare took up pen at a time when, 200 years after the death of the greatest Middle English poet, Chaucer, modern English was just being regularized. Questions of meter, whether quantitative or accentual, and of rhyme versus alliteration, even of orthography occupied the "poet maker." It was a time when puns, which were a bore to Samuel Johnson in the eighteenth century, raised a laugh from the Elizabethan audience. Beyond the sheer materiality of the verbal medium, this "Early Modern" age was coping with the breakdown of medieval linguistic realism in ways both deeply philosophical and immediately practical.[5] Juliet, as practical nominalist, asks pointedly, "What's in a name?" (2.2.43). Thus, at the very lowest level of the material and formal nature of the signifier, I would claim for the Shakespeare poem a referent that was knowledge of language itself. I believe we would want to claim this significance for all poems, but in Shakespeare's happy time in the formative years of our language, such significance at the signifying plane must have been all the more cogent.

A complete taxonomy of the material and formal features of Sonnet 4 is not relevant to the essentially theoretical argument that is my goal. Thus, avoiding extended comment on those features that the reader will need no help in recognizing as common to the class of sonnets, I want to center my discussion on three aspects of Sonnet 4 that I take to offer meanings particularly relevant to the Renaissance audience.

First, I want to comment on the pattern of argument that divides the main body of the poem into two syntactic sets of question-answer-question; second, on the semantic pattern established around the words "use/abuse"; and finally, as we look at some of the assumptions of Shakespearean "literary competence" (Culler 1975: 113–30), on the meaning imputed to numerical patterns. In each case I will be holding that the pattern or form in and of itself ostends or exemplifies a meaning in a way different from and with an effect different from the method and meaning generated by those signs that refer to signifieds different from themselves. Roughly speaking, this would be the difference between the meaning of the word "fat" as signifier and the word graphically overcoded as

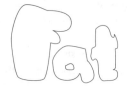

Playing across the neat end-stopped set of quatrains in Sonnet 4 is a pattern of argument that addresses the young man in two parallel sets with a question, initiated in both instances by a phrase of direct address ("Unthrifty loveliness" in the first set and "Profitless usurer" in the second). The two-line question is followed by a two-line statement, which in turn is thrown back at the youth as a further two-line question. The argument roughly takes the form of saying, "Why are you doing X?"; "X is harmful"; "Then why do you continue in that way?"

The form of argument is manifested here on several levels, each reinforcing the other. On the most primitive level of the form of the matter, the printed text displays the phrases of the argument in equal sets of discrete lines of type, the discerning of which calls for no knowledge of the language. Some knowledge of Latinate alphabets and their pronunciation might yield the supposition that the typographical line was merely a visual result of a regularity of sound units, again a product of the form of the matter, though this is a fairly sophisticated perception, not always grasped even by those who read the language. With competence in English would come the additional sense that each two-line group formed a complete sentence, and that these sentences made up two sets, each consisting of a question, a statement, and a further question.

Turning to the form of the content, one would perceive that these metrical and syntactical regularities supported a pattern of logical argument, a form of content. The young man is asked "why dost thou spend?" (4:1) and "why dost thou use?" (4:7). He is reminded that a selfish hoarding is not good, and finally, in both sets, a responsive question is posed in the form "Then . . . why?" (4:5) and "Then . . . how?" (4:11). On an abstract level we discern in the pattern of questioning a certain behavior, asserting the disadvantages of this behavior, and concluding with a question saying essentially: since we may assume the disadvantage to be real, why do you persist? The "heresy of paraphrase" is apparent in this clumsy and not entirely accurate way of explicating Shakespeare's original, but it is to be hoped that the formal and repeatable nature of the argument is clear.

That is neat, but that is not all. First, Shakespeare plays a kind of counterpoint by placing the two six-line units within a set of three regular quatrains, thus playing pairs against triplets. It would have been perfectly simple to have written the first twelve lines as two sestets, rhymed *ababcc* and *dedeff*. The *cc* and *ff* couplets would have emphasized the force of the final "then" question, though inserting two couplets into the poem might

well have diminished the force of the typical concluding couplet in lines 13 and 14.

Though couplets in lines 5 and 6 and 11 and 12—as suggested above—do not enforce the logic of the six-line segments described, the syntax of direct address and the metrical variation worked within this do (lines 1 and 7). Shakespeare achieves a keen dramatic effect by opening the poem with a direct question, as if to say, "Hey, Joe, why . . . ?" The clever "pet names," half praising, half damning the addressee in the first two instances, perk one up to pay particular attention to the question. Thus Sonnet 4 opens with direct address and employs it again in the second question of the first set ("beauteous niggard" [4:5]), but this phrase of direct address does not start the question or the line. When the second set of question-statement-question commences, Shakespeare marks this in two ways. The phrase of direct address ("Profitless usurer" [4:7]) makes up two dactyls ($'$--, $'$--) for the first break in what has been a fairly regular iambic pattern. It, as well, balances the opening "Unthrifty loveliness" with its own six syllables and sets itself off in another way from "beauteous niggard," which, at least in Elizabethan pronunciation, has only four. This marking of a new rhetorical pattern with a variation in the sound—form of the matter—is matched at the level of content by its bold oxymoron. (You can be lovely and be unthrifty; you cannot be a usurer and be profitless.) The reader has the feeling, as in music, of commencing a new variation on a just completed pattern.[6]

We know *what* the poet has said, what he means at the primary level. Can we attribute meaning to the *way* he said it, to the form? We certainly can do so if we consider the form to mean in the same way that an example means, that is that it represents in itself the kind of thing that it itself is. In Sonnet 4, we have just demonstrated the ostended "form of argument." The example is forceful and telling, that is, aesthetically interesting, precisely because it is such a clear and appealing instance. Each stage of the argument is delineated in two lines of ten syllables. Once completed, the argument is repeated in the same form but with some variation. The code that represented the content of the argument, an argument that could have spilled out willy-nilly in sections of varying length and syntax, has been overcoded with the nature of the poetic lines manifesting in their metric and syntactic equality the balanced stages of this type of persuasion. Thus I would argue that what those formal aspects of Sonnet 4 that we have just discussed mean is exactly its form of persuasion, that is to say, the force and eloquence of a question-answer-question argument. It means itself,

but in so referring it tells us eloquently—it is, after all, a poem—the kind of thing that argument is. This has a very important epistemological point, which I will claim for formal meanings generally, in that the clarity and interest, the effective overcoding, helps us to understand better the forms of perception and cognition that it ostends.

In terms of the diachronic semiotics we have been urging, one would immediately note the way in which Sonnet 4 defines the Elizabethan concern with mutability. Not so obvious but not to be overlooked, would be the way in which the form of argument we have been demonstrating repeats, for the reader of the day, the rhetorics learned in Elizabethan grammar schools.

One further example of meaningful form in the sonnet may be touched on here to clarify our point. The form of the figure oxymoron—the linking of opposites, a form of content present in "Profitless usurer"—was extremely popular, popular indeed to the extent of becoming a subject of parody, as in *Romeo and Juliet* 1.1.173–80 and *A Midsummer Night's Dream* 5.1.59–60. It had existed as a feature of the English sonnet especially since the days of Wyatt's famous translation from Petrarch, "I have no peace and all my war is done" (ca. 1540). This form, binding terms that logically could not coexist, expressed perfectly the feeling of a time when an elderly, testy, and homely monarch was praised—not hypocritically—as Diana, when one of the most exuberant times in English history coexisted with several crop failures, constant war in the Low Countries, and several devastating visitations of the plague. Perhaps the most dynamic coexistence of opposites was in the coexistence of the medieval Ptolemaic notion of order with the new heliocentric world. Thus a form—oxymoron—quaint to us and rarely used in serious poetry today had a lively and important semiotic function in the dying years of the Renaissance.

If form means, then rhyme must mean, though this lowly form of matter would hardly seem able to transcend its own materialistic existence. The words "use" and "abuse" (the *cc* rhyme of the second quatrain), linked by their root and differentiated by the Latin prefix "ab," set up a formal system of difference, understandable simply as such. While this type of usage is certainly not exclusive to poetry, those works usually chosen to be read as poetry provide more material for such a game than do other works. Certainly Sonnet 4 focuses the reader on the *use/abuse* concept through its place among the "procreation sonnets" in the sequence. In this group of

sonnets, the young man is urged to *use* his endowment of life and beauty to pass on this gift and preserve himself in another generation; his failure so far to do this constitutes a moral *abuse* condemned as selfish, proud, willful, and wasteful. It constitutes, in the ever lurking sexual implication, a hint that he is committing the sin of self-abuse.

In the *use/abuse* rhyme the form of the matter (the repetition and variation of sounds) ostends with its palpable linkage, the identity and difference of words with a common root and negativizing prefix. The centrality of this emblem of good versus bad behavior is obvious when we consider the importance of "use" in the English vocabulary thus, presumably, in any cogitation on human agency.[7] The root "use" is repeated in "usury" and, as participials, contrasted in the couplet, "Thy unused beauty must be tombed with thee, / Which used, lives th'executor to be." Held in orbit around the central and more general *use/abuse* pair are those words that define the using as having to do with property, such as "spend," "legacy," "sum," "audit," and "executor," mentioned above. The efficacy of the *use/abuse* pairing is manifest in Shakespeare's reuse of it as the *ff* rhymes of the third quatrain in Sonnet 134:

> The statute of thy beauty thou wilt take,
> Thou, usurer that put'st forth all to use,
> And sue a friend came debtor for my sake;
> So him I lose through my unkind abuse.

Here the phonetic/semantic deep pattern of benign and malign employment is played out in quite a different context, in which the poet is lamenting the fact that the young man has deserted to the Dark Lady ("So, now I have confessed that he is thine" [134:1]). In Sonnet 134 the tone is dark and resentful; there is no teasing play with phrases of direct address. The use of the Dark Lady's beauty is in this case not fair but abusive, not only to the deceived poet but, as implied, to any lover who must pay the excessive (usurious) interest for the use of this natural endowment. Here, in other words, the use of the endowment (the woman's use of her beauty) is evil, a mis-use, whereas in Sonnet 4 the young man's misuse of the largess ("given [him] to give" [4:6]) was less venal since he was hoarding (he was a "Profitless usurer")—a crime, at least in the Sonnets, more limited to the self, the self-abuse of selfishness. Unlike "legacy," "bequest," "bounteous largess," and "great sum of sums" in Sonnet 4, the terms em-

ployed in Sonnet 134 are largely negative: "mortgaged," "forfeit," "surety," "bond," " sue," and "debtor." Yet here we have, in this later, darker poem, the same deep pattern of sound and sense embodied in the *use/abuse* of Sonnet 4. The point is that a convenient rhyme pairs two words, adding a special quality to their semantic sameness and difference, a quality that would be entirely missing, for example, in *employ/mistreat*. The force of this rhymed pair is such that it is transferable both semantically (together with its linked words "free" and "usurer" from Sonnet 4) and formally as part of the sonnet rhyme scheme in both sonnets. My claim is that the *rhyme itself*, acting with the semantic components, has a meaning—here roughly the delight, the seeming naturalness of the phonetic mirroring of an important semantic contrast.

There is no magic in the fact that words with the same root and a different prefix will rhyme, supplying quite naturally the repetition with variation that helps make poetry what it is. Yet from our modern and naturalistic perspective we are apt to overlook the old appeal of that Neoplatonic epistemological realism that did see a kind of magic in the relation of language to the world it represented.[8] Thomas Greene has referred to a "crisis of semiotics" in which the magic of the relation of word to thing or of ritual to result slowly evaporated under the strains of a Reformation theology's demystification of the great Signs of Catholic doctrine (Greene 1996: 11–13). Thus relations between word and thing, which we would see as arbitrary, might in the Renaissance be seen as causally related, especially for those who, following Sir Philip Sidney, saw both the poem and nature as images of God's cosmos. This was a very exalted position for poetry, which our writers might well envy and which our semioticians must never neglect in considering the nature of the Renaissance signifier in the minds of those for whom it was intended to function.

As we consider a semiotics of the Renaissance poem, we must consider how the *use/abuse* rhyme, the question-answer-question form just discussed, or the very sonnet structure itself with its numerical properties, presented for the reader of the day an example by Sidney's poet-maker operating as the metaphor of the Divine Maker, of "real" aspects of the Neoplatonic cosmos. A compellingly large collection of statements by the poets of the age—Sidney, Spenser, Chapman, Campion, and Daniel among them—[9] give evidence that a Renaissance reader would likely have registered, as part of the meaning of the poetry he or she was involved with, a formal meaning of the type we have been concerned to

describe both here and in the previous chapter. Thus he or she would experience in the poem the kinds of numerical relations—or "harmonies"—that the Pythagorean mind saw operative in God's cosmos. Though Spenser was the most outspoken advocate of this number theory and the most devoted in its use, the general sense of such formal elaboration can be felt in most of the poetry of the period. The most obvious "quantities" would be perceived in the metrics but certainly tetrads and triads abounded in the three quatrains of sonnet form and the precious sevens in the fourteen lines of its prescribed length.[10] The Renaissance theorists—and occasionally Heninger—tend to shift between a position in which the numerical manifestation *stands for* something, as the four metals in Achilles' shield stood for the four elements (Heninger 1974: 380), and the opposite position in which the tetrads, pentads, etc. were simply themselves as manifested, that is, they were interesting simply because they *were* tetrads etc. I would, of course, want to stress this latter position.

Two publications (Heninger 1994 and Shapiro 1998) that appeared close to the writing of this chapter have also considered the possible modes in which poetic form may mean and have done so specifically with Shakespeare's Sonnets. Since I find myself in some disagreement with both of these positions, my own position may become clearer if I address these differences.

In a central chapter, "The Origin of the Sonnet: Form as Optimism" (Heninger 1994: 69–118), Heninger may be taken to support my thesis that form means, and means in a way different from that in which the verbal text means. Heninger takes the traditional Italian division of the sonnet into an octet and sestet (8 + 6) and reduces the proportion to 4 + 3, a move supported in part by the arrangement in manuscript copies of Petrarch (1994: 73–76). For Heninger, this establishment of the 4 and 3 is the key to formal meaning since 4 represents the world through the various Physical and Physiological Fours—discussed in Heninger's earlier *Touches of Sweet Harmony* (1974) and my chapter 3. The number 3 represents divinity through its reference to the mystery of the Christian Trinity. Moving a step further, Heninger adds 1 to the 4 and 3 by claiming that 1 is theologically implied in the Trinity as it exemplifies the Three in One. In a complex argument that involves Renaissance geometry and architecture, Heninger arrives at a journey through sonnets, cathedrals, etc. that takes the reader from the world to the divine and, at the end, to the per-

fect peace of the One (God). This meaning, he claims, is the contribution of form:

> Finally, note that the form alone makes this statement, quite apart from the semantics of the verbal system. Regardless of what the language of the sonnet might say, its form guarantees redemption and proves the forcefulness of providence. The form of the quatarzain [sonnet] is unmitigatedly optimistic. (Heninger 1994: 78)

While I accept that Neoplatonic number theory certainly played a part in the creation and interpretation of many Renaissance works, I hold that this is but one formal meaning and, most important, that this meaning is, just like the verbal meanings, *symbolic*. The meaning of a journey from the world (4) through divinity (3) to an optimistic unity (1) is not *felt* as a signified of a 4:3 proportion but is *symbolized* by taking numbers and letting them stand for conventionally determined concepts like the worldly Fours and the Trinity.[11] Not only is this a symbolic rather than an ostensive semiotic function, it is a limiting factor for formal meanings in that they must here translate into some other conventional symbolic sign that then gives the presumed "formal" meaning.[12]

In quite a different methodological mode, Michael Shapiro attempted to provide an empirical base for an iconic relationship of sound and sense in Shakespeare's sonnets. Shapiro, a professor of Slavic languages connected with the Semiotics Program at Brown University, has isolated at the syllabic level sets of sonorant units (SUs, roughly constituted by the presence of two or more vowellike sounds) and obstruent units (OUs, in which consonant sounds predominate). A count of SUs divided by the number of syllables in the poem (140 for the standard Shakespearean sonnet) produces a statistically high or low sonority quotient running from .393 (Sonnet 71) to a low of .086 (Sonnet 4). Since the degree of openness of the vocal tract when producing vowel sounds is greater than when producing consonants, where the tongue and lips "stop" or obstruct the sounds, Shapiro takes this to endow language sounds with relatively greater or lesser qualities of openness or constriction. The iconic relationship Shapiro seeks between sound quality and meaning is set up at the content level by asserting that " . . . meaning in Shakespeare's sonnets is uniformly understood . . . as being subtended . . . by the OPPOSITION BETWEEN FREEDOM AND CONSTRAINT" (Shapiro 1998: 84 capitals in original). Since sonorants

are, in Shapiro's words, "the freest sounds," a sonnet with a relatively high sonority quotient would likely be a sonnet whose content can be classified as liberal, open, uninhibited. And sure enough, in Shapiro's tabulation, "the match is complete: high sonority is isomorphous with the meaning of freedom, low sonority with that of constraint" (Shapiro 1998: 85). But isomorphism is not the final point, for Shapiro has said "The coherence between sound and sense is thus shown to be *iconic*" (Shapiro 1998: 81, my emphasis).

Is this particular relationship of sense to sound really iconic? In order for it to be so, two conditions would have to be met. Sonority would have to be recognized in some perhaps subconscious but definite way as having in itself the "open" quality of the vocal tract that produced it. Second, the physical sense of such unconstricted utterances would have to "sound like" freedom. Even if an iconic relationship could obtain between the physical qualities of some signifier and the abstract nature of an emotional state (as Wagner and Appia held), the present match, depending not upon the sound quality but upon its production, seems unpromising.[13]

But the problem with Shapiro's claim for iconicity between a specifically designated sound quality and the content quality "freedom" can best be seen at a more specific level. It happens that Shapiro has found Sonnet 4, discussed earlier in this chapter, to be, with a sonority quotient of .086, "the least sonorous in the entire corpus" (Shapiro 1998: 85). The iconic relationship between this sonnet's very low sonority and a content of restriction is then fulfilled for Shapiro, since "This poem bristles with the imagery of money, money lending, and inheritance . . . constituent strands of a main theme [of] . . . economic limitations on freedom" (1998: 85).

My own earlier discussion of the economic themes in Sonnet 4 had led me to compare it to the darker and more restrictive content in Sonnet 134, a content that would presumably be instantiated in an even less sonorant text than that of Sonnet 4. Shapiro's table of sonority quotients showed this not to be the case, for Sonnet 134 had a quotient of .207 (Shapiro 1998: 95), a bit below the mid-range of sonorities but decidedly more sonorous than Sonnet 4. Yet Sonnet 4's liberal "bequest," "bounteous largess," and "legacy" become, in Sonnet 134, the highly restrictive "mortgaged," "forfeit," "surety," "bond," and "debtor." Sonnet 4, on the other hand, urges the young man to be "free" and insists that his "bounteous largess" was "given him to give." This freedom is lost in Sonnet 134, where the young man has been captured by the dark lady ("he is

thine"[1]). Further along, in line 5, Shakespeare says of the young man, "he will not be free," and in the last line of the poem Shakespeare confesses, "yet am I not free." In this pair of sonnets as least, the linguistically more open vocal matter seems *not* to be iconic with a content of greater liberality and freedom.[14]

Granted that the force of Shapiro's argument would lie in some statistically relevant correlation between sonority quotients and themes of freedom, and that individual abnormalities should not count against him, yet Shapiro has claimed no mismatches, especially "at the extreme ends of the spectrum" (where Sonnet 4 lies) (Shapiro 1998: 85).

In sum, Heninger's formal meanings, though they do in fact transcend the semantic meanings of the words, are, like words, symbolic and arbitrary, not iconic or ostensive. Shapiro's formal meanings for the sound of Shakespeare's sense suffer from the difficulty of making the predominance of a particular kind of speech sound iconic with a theme of freedom simply because the human vocal mechanism is relatively less constricted when these kinds of sounds are articulated. I would instead argue, as I have so far done, that the material and formal meanings are produced much more simply in an ostensive mode that, in Sonnet 4, says that the English language is varied and wonderful in the specific range and variety of its phonemes, that the semantic meaning of our words interplays fascinatingly with the sounds they are made of, and that the logical syntax of argument is in itself a beautiful and meaningful thing. Too simple and self-reflexive? Not to the poet.

The argument for form and its meaning is easily made for the Early Modern period by way of the imposing example of a Shakespearean sonnet. I hope, in a brief look at some postmodern poetry, to extend the concept of formal meanings to a different and contemporary perspective. In this effort, I continue to focus on that obvious example of formal verse, the sonnet. My interest in formal meanings in contemporary poetry is coincidentally served by evidence of a similar interest in the poetry community itself: I refer to what has been called "the new formalism."[15] Enough articles on and anthologies of new formalist poetry exist to support the belief in a self-conscious turn by recent poets to traditional formal devices such as the villanelle, sestina, and even such minimal formalization as a pattern of regular stanzas and meter. Among the new formalists, my interest is drawn to the way in which this penchant for regularity has appealed to minority writers who deliberately

appropriate traditional conservative devices, with all the connotations these unleash, in order to compose an antihegemonic message.

The categories that semiotic analysis has established for us—as described in chapter 2—throw an interesting light on the motives and results involved with this expressive movement. Consider, as a first step, the continuum of matter from which the poetic signifier will be chosen. This expressive medium, language, which in Shakespeare's English possessed the freshness of its recent transformation from Middle to Modern, has recently come in for intense scrutiny by various minority groups, who claim that language is determined in its very syntactical and semantic makeup by a patriarchy that owns and controls the means of expression. True or false, such claims have certainly stirred a new interest in the linguistic medium. Among those so interested, feminist scholars and writers have been in the vanguard. With the notion of an *écriture féminine,* a kind of writing natural to women and their special experience, a debate has focused the writer's attention directly on the expression plane itself, on its capabilities of expressing or hiding the thoughts of one who receives a language not of her own making.

Given this deep suspicion of the received medium, why would feminists take up with a movement, the new formalism, which, by accepting the canonical patterns, appears to welcome the very things an active minority voice would want to avoid. The argument for a politically correct feminist formalism contends first that the actual poetic hegemony of the 1980s and 1990s, which they want to avoid, is not formalist but the free verse style of the later Lowell and the Beats, a pervasive and quite masculine tradition to which the return to fixed forms could well seem an experiment and a protest.[16] Second, to historically sensitive feminists, the return could well be seen as a retaking of their own historical property, an affirmation and revaluation of Christina Rossetti, Edna St. Vincent Millay, Marianne Moore, and other of the skilled female poets whose traditional styles had been mocked. Within this sense of formalism, both as newly experimental and as an honorable inheritance in the female line, has come a sense of the freedom that the assurance of a fixed form can give to the process of expression.[17] Third, and most interesting in the present context, is the way in which some of the more politically driven of these poets have deepened formal meanings by using the forms parodistically against their traditionally received contexts. One of the most successful efforts in this direction has been Marilyn Hacker's appropriation of the sonnet se-

quence, and I turn now to consider briefly the implications this can have for the semiotics of poetry.

Marilyn Hacker describes herself as "a woman, Jewish, lesbian, feminist, urban" (Finch 1996: 24), all categories from the continuum of content especially active today. As is clear in the long interview from which the above was quoted, Hacker is also very actively and self-consciously a poet, again a category actively thrashed out in the pursuit of a minority voice. Given, feminism and lesbianism in combination with the matter of a disputed poetic language and form, Marilyn Hacker's sonnet sequence *Love, Death, and the Changing of the Seasons* (1986) becomes an intriguing signifier.[18] We note first the relation, clearly suggested by Hacker in many quotes and allusions, to the Shakespeare sonnet sequence. Though the notion of a "story" and of implied homosexuality in the Sonnets is far from settled, Hacker uses this popular perception of Shakespeare effectively to establish a counterpoint to her own story of an older poet and young loved one in a relationship in which the young partner is ultimately wooed away.[19] By bringing Shakespeare's Sonnets, the canonical sequence of the formalist, Petrarchan, and thus eminently masculine tradition, to bear as an "interpretant" to her own feminine and lesbian sequence, Hacker introduces a sounding board that resonates with many of the ideas and images in her work. Though Shakespeare is not especially detailed in his narrative, Hacker elaborately localizes her story with mention of making love in a Bloomingdales's dressing room, suffering jet lag, getting drunk in Santorello's restaurant. Each pedestrian detail of the realistic and presumably autobiographical story in *Love, Death and the Changing of the Seasons* thus plays off the more Platonized images in Shakespeare, giving heightened meaning to both. Even the mixtures of diction play off against Petrarchan seriousness when Hacker, in the first sonnet after consummating her relationship with Ray, breaks from a rich and heightened tone to write:

> Or do I tell the world that I have got
> rich quick, got lucky (got laid), got just what
> the doctor ordered, more than I deserved.

This nest of clichés enters the sonnet just at the beginning of the sestet, the traditional turning point in the sonnet, where the argument of the first eight lines is altered to bring about the conclusion in the final six. (We should note that in Hacker's sonnet this sestet consists of three rhymed

couplets.) Hacker's change of argument, tone, and rhyme scheme—to couplets—effectively contrasts both the traditional diction of the male Petrarchan tradition and the more "poetic" moments of her own verse. In short, Marilyn Hacker has used this traditional form, so closely associated with denounced male attitudes (like the gaze and the objectification of the woman) in a way that both sets off the difference of her own experience and its language of expression and comments on the canonical expression. Her method is parody.

Some care must be taken here with the connotations of "parody," which in Hacker's usage, and in postmodern "quotation" generally, supports a delicate balance between scorn and reverence both for the parody and its object, a quality that sets postmodern parody off from the long tradition of this device. Parody, however, when seen in this more kindly light, is an extremely fruitful signifier of minority political concerns. One might think of the colonialized writer's parody of colonial discourse, or, in the areas of gender just observed, think of the connotations Hacker unleashes with a lesbian sonnet sequence and, from the male side, think of the parodic signification of the "drag queen."

But in such parodic meaning relationships it must be noted that the parody forms as signifiers give their particular signification in the symbolic mode, that is, by convention, not by ostention. They fall, in the scheme elaborated in chapter 2, into the category of meaning 3, that category of the meaning of the formal relationship—here the parodic relationship—of the denoted and connoted content in meaning 2—here roughly the connotations of a lesbian sonnet sequence compared to a Petrarchan one. If one doesn't know the material being parodied and its connotations, one misses much of the meaning of the new signifier. Considering the complex mass of feminist criticism that is interpretant to the full—and interesting—meaning of such gendered parodic forms, we have, as its opponents have pointed out, a discourse as elitist in its way as *The Waste Land*.

Many writers in the new formalism are neither females, feminists, or parodists; I have singled out a very fine sonnet sequence that is involved in some of the parodistic signification just outlined because I felt that the meanings of the sonnet form so used were a particularly interesting extension of the discussion at the beginning of this chapter. Another kind of meaning not necessarily tied to parody has, through theories developed in the study of minority writing, come to play a part in the current interpretation of literature. I have in mind here the tendency to enter the

person of the author—particularly as this involves his or her race, class, or gender—into the meaning of the poem. In the next chapter, then, I want to extend this semiotic exploration of meaning-making to explore in what way and with what consequences the "meaning" of the author may function in the interpretation of his or her text.

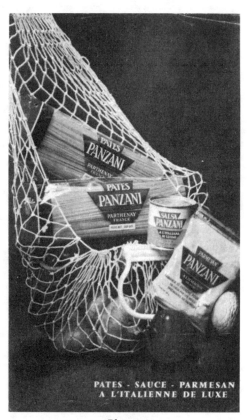

Plate 1
Panzani Pasta Advertisement

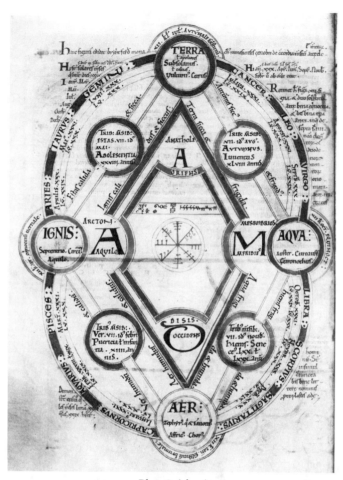

Plate 3 *(above)*
"Byrhtferth's Diagram." Wheel of the physical and physiological
fours, from Byrhtferth's *Manual,* early eleventh century. Oxford, St.
John's College, ms. 17. fol.7v. By permission.

Plate 2 *(left)*
Martin Puryear, *Timber's Turn,* 1987. Wood, 86 1/2 X 46 3/4 X 34 1/2."
Hirshhorn Museum and Sculpture Garden, Smithsonian Institution, Museum
Purchase 1987. By permission.

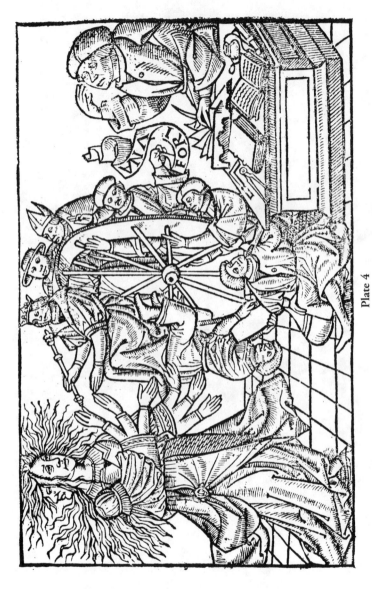

Plate 4

John Lydgate watching Fortune turn her wheel. Woodcut from the 1554 print edition of his *Fall of Princes*. By permission of the Folger Shakespeare Library.

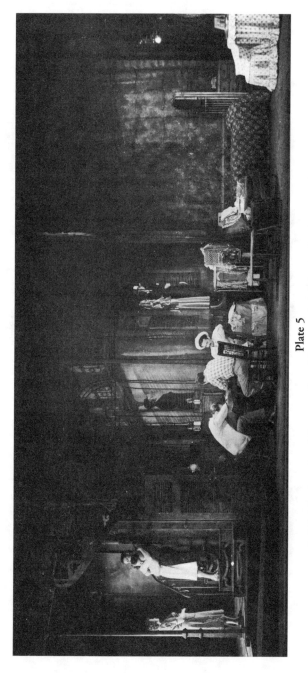

Plate 5

Jo Mielziner, set for *A Streetcar Named Desire* 1947. Photograph copyright Eileen Darby.

Plate 6

Ben Shahn, *Liberation* 1945. Tempera on cardboard 29 3/4 X 40." the Museum of Modern Art, New York. James Thrall Soby Bequest. By permission.

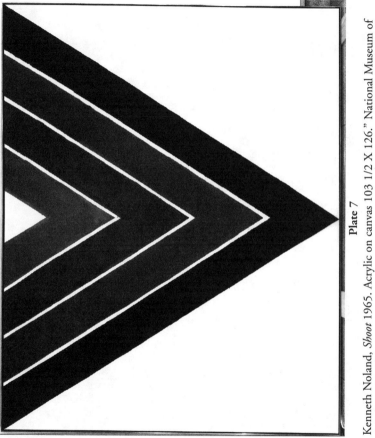

Plate 7

Kenneth Noland, *Shoot* 1965. Acrylic on canvas 103 1/2 X 126." National Museum of American Art, Smithsonian Institution, from the Vincent Melzac Collection through the Smithsonian Institution Collections Acquisition Project. By permission.

6

THE MEANING OF THE AUTHOR: ROBERT LOWELL AS IMAGE OF AN AGE

To what degree should the perceived nature of the artist enter into the meaning of the work? For the New Critics, in whose company William Wimsatt declared, "I care not what porridge John Keats ate," the personality of the author and his or her presumed intentions have no place in a determination of meaning. For those who follow a more Romantic ideology, the works may exist largely to express the personality of an author who, as a collation of physical presence, gossip, and the works as "spiritual autobiography," is the constructed signifier. In a crude but not unfounded dichotomy, we have the cold-blooded formalist holding for the work's autonomy while the humanist—in the majority position—insists upon the essential and defining presence of the human creator. The author makes the works, or the works make the author.[1]

Led by advances in women's studies in the last quarter of the twentieth century, attention has focused on authorial presence in the form of the many and subtle influences on discourse occasioned by the gender, ethnicity, and class of the author. With this new focus in the forefront, interpretations of literary works tend to provide information—taken to be the meaning of the work—that has mostly to do with the status of the given minority in the culture to which it is "other." Interpretation in this mode results typically in books and essays with titles in the form of "The Family in Chicana Fiction" or "The Self in Native American Poetry." For this critical school, the category prior to the "in" is the one on which research is presumed to focus.

There is no doubt that this is one valid and quite probably beneficial use of literature, a use that has been elaborately theorized and needs no

further justification here. In keeping with my examination of meaning in the arts, however, some attention must be paid to the way these author-centered meanings are signified and hence to the specific nature of the information so drawn. The greatest danger here is the knowing or unknowing transcendence of the literary work for the sociological knowledge of families, selves, sexes, etc. Two problems arise. On the one hand, literature as sociological data base is questionable on the very basis that it is literature, that is, counter-factual. On the other hand, its very literary qualities—linguistic matter and form—are given short shrift.

This dismissal is unfortunate for one of the very reasons that caused it: the interest in discovering in literature the nature of minority experience. Yet contemporary views of experience, such as that described by the social scientist Joan W. Scott, emphasize the *constructed* quality of experience rather than its assumed passive accumulation (Scott 1992: 22–40). If, as I have argued, artistic form gives expression to the way we shape experience, Scott's essay would certainly validate a close look at form in literary studies, a look that offers knowledge as important as—though different from—the perhaps dubious sociological knowledge. Of course, this construction—the clues for which, I am suggesting, we may find in the form of the text—is done *by* someone. This returns us to the author, but to a very different "author" than the one who, we assumed, had written our canonical works.

Since the time of Barthes's essay on the death of the author (Barthes 1968), the very notion of "author" has grown enormously more complex as the problems of race, class, and gender affect the reciprocal concepts of authorship and textuality. Current theory of the author coalesces around the question of "Who speaks?" From there it moves to questions concerning the selfhood of the author/speaker, the subject "I" who utters the text. The study of minority authorship has problematized the nature of this speaking self, especially where different cultural assumptions about selfhood or different positions—for example, speaking as woman—affect the meaning of what is said. Here certainly the perceived nature of the artist enters into some constructions of the meaning of the work.

A sense of the author—now problematized—also enters into a work's meaning when one considers whom this author "speaks *as*." Here we see the deconstruction of the traditional author, grandly assumed to be speaking *as* man to all mankind, conveying "the best that has been thought and said." This deconstruction of the "speaking *as*" touches also on the au-

thority of the speaker to represent a group and lies at the root of the question as to whether, for example, white feminist teachers or authors can speak *as* or *for* African American women writers.[2]

To be sure, rhetoricians have for centuries defined author and audience positions and acknowledged the effects upon meaning entailed when the hearer understood that one spoke as judge, as professor, as the accused, etc. We accepted, as a pragmatics of communication, the differences in meaning involved when the speaker eulogized a fallen soldier or when he or she gossiped one-to-one at lunch. On the other hand, an analysis of meaning-making—a semiotic—that considers the sign function in terms of its race, class, or gender throws quite new problems into the interpretive chain. It forces us, for example, to ask what semantic relevance can be truly accorded to the revelation that a previously anonymous narrative was written by a woman of color.

To clarify some of these new problems, I want to look back a generation to a time when race, class, and gender were not significant in weighing authorial meaning, to look back to the time of Robert Lowell, who was clearly white, upper class, and male. Lowell was very conspicuously in himself a sign: as "poet of the age," he defined the nature of poetry in a way that is no longer current. When we assess the qualities that people of the late fifties and the sixties brought to the fore to construct this author/signifier, we can discern a pattern of choices that may illuminate the nature and the consequences of today's chosen categories of authorial significance.

Robert Lowell was poet, political advocate, and psychotic. He was a Boston "blueblood" who spoke *as* such, even when he addressed President Roosevelt, reminding the president of their shared American ancestry.[3] Lowell produced a dozen volumes of poetry, was widely studied, analyzed, and reviewed. He also contributed to the notability of his persona some quite public escapades, the most conspicuous of which, his actions in the 1967 march on the Pentagon, is chronicled in Norman Mailer's *The Armies of the Night* (1968). We have, then, an especially well-documented test case for a semiotics of the author.

On the second of June, 1967, *Time* magazine devoted its cover to a kindly caricature of Robert Lowell crowned as king of poets. A five-page story lauded poetry, "a touchstone by which the spiritual condition of man may be tested," and honored Robert Lowell, who, it declared, "is, by rare critical consensus, the best American poet of his generation" (*Time* 1967:

67).[4] This was an age of poetry and, Lowell was the poet of the age.[5] This tall, gawky descendant of Puritan forefathers and writer of something called "confessional poetry" stood to someone for something: he had become a sign.

In Lowell we find a very complex sign function in which a physical signifier, the man or woman so chosen, stands for a cluster of meanings attributed to but certainly not inherent in the actual person. Mention of the Elizabethan era, F. Scott Fitzgerald and the Jazz Age, even, say, Lindbergh or Marlene Dietrich, can give a sense of the phenomenon at issue. The case is particularly interesting when the signifying figure is an author, since we must deal not only with the meanings that accrue to this person through his or her class, race, gender, or actions but with that particularly difficult relationship of author to his or her fictional works. I propose that semiotics can help us understand *how* such a man or woman can be used to signify the spirit of an age and *what* this can tell us about our construction of ourselves in our culture.[6]

In the case of the "poet of the age," the material signifier, the locus of the sign in all its collected meanings, is the person of the poet. Yet we know what "Lowell" means—or "Dickens" or "Shakespeare"—not from direct contact but through some various mixture of the works and biographical reports, themselves complex and treacherous signifiers of that thing we would call "the man himself." I want to treat this collection of signs appended to the author as interpretants in the sense in which Eco defined this Peircean term (Eco 1976: 68–72). I argue that the general meaning of the author as sign is developed from a selection and focusing of these interpretant signs.

An article by Rosemary J. Coombe on the legality of marketing the signifying properties of the celebrity personality throws an intriguing light on the case I am attempting to make for Lowell. Coombe distinguishes the celebrity person him or herself from what I have called its various interpretants: she cites examples such as singing style, car, mannerisms, etc. (Coombe 1994: 103). These items, which define, for example, Elvis Presley or Madonna, are considered under the law to be properties *owned* by the artist and worth considerable money. In this way, use by another artist of, say, the celebrity's identifiable clothing style could be considered theft. Legal codification of the rights to what I am calling interpretant signifiers lends an interesting tangibility to what may have seemed very abstract qualities. Coombe also describes

the way in which the audience itself aids in constructing the celebrity image, when the "fans" find "in stars sources of significance that speak to their own experience" (106). Such an image a perhaps more sophisticated audience found in the poet Robert Lowell.

To survey very briefly the interpretants that defined Robert Lowell, I will concentrate on those whose signifieds fall within four areas of meaning: 1) politics; 2) ancestry; 3) mental illness; 4) poetry. These categories will be seen obviously to overlap and to merge into the realm of the poet, which Lowell supremely was. It would be convenient to draw the signifiers for each of the above meaning clusters simply from the poems, from such famous lines as "Tamed by *Miltown,* we lie on Mother's bed" (from "Man and Wife," *LS*).[7] However, I want to argue that concepts of the first three aspects of Lowell's personality—his political protests, ancestry, and mental breakdowns—directed the audience in their interpretation and the author in his composition. There was a sense, too, in which signifiers that came into being after the publication of a poem would retroactively affect the meaning of the poem and the public's sense of its author. Lowell's 1967 participation in the March on the Pentagon, for example, inevitably influenced the meanings people placed on the 1960 author and his political poem of that year, "For the Union Dead" (*FUD*).

Before we look at the interpretants, it is important to take up the sign that these associated signs work to define. The immediate physical sign in the case of Lowell was the man himself: tall, handsome, and obviously patrician. He cut a very imposing figure in the many public or semi-public occasions he graced (and sometimes disgraced). His personality was displayed and molded in the poetry readings that were gaining popularity at the time, his occasional stints as a teacher, and in the many dinner parties in which he mixed familiarly with the literary and political elite, including Jackie and Robert Kennedy.

To the physical man and the poems as material for the complex sign that was Robert Lowell must be added the political acts. It was in the age of Lowell and of the Vietnam War that we learned how every act, the attendance at a dinner, the writing or reading of a sonnet, was a *political* act, but no Foucaultian interpretation was needed to understand Lowell's clear and deliberate stands against his government and his president, though biographical data show how the meanings of the acts were less clear in Lowell's own mind than they appeared to be to the general public. There may be some doubt about the extent to which Lowell's poetry is truly political

(Procopiow 1984: 187–194), but there is no doubt that this man, who was always a poet, was also a self-consciously political figure.

Probably Lowell's two most famous protests, hence important signifiers of his political meaning, were those in which he took his concerns, with typical assurance that he was addressing an equal, to the presidents of his country. In 1943, when he was 26 years old and when any recognition of the Lowell name would have depended upon his ancestors' accomplishments rather than his own (his first book, *Land of Unlikeness,* would appear a year later), Lowell wrote familiarly to Franklin Delano Roosevelt explaining to that man, who, as Lowell put it, shared with him the same long and patriotic American background, that he [Lowell] must refuse induction into an unjust war. In 1965, when a later president had contacted him as now one of the elite of American artists, Lowell blatantly and publicly—with a copy of his letter to the *New York Times*—turned down an invitation to Johnson's White House Festival of the Arts as a protest against that president's policy toward Vietnam. (Johnson seems to have considered the festival as something that "would particularly please the ladies" [Hamilton 1984: 321].)[8] Two years later, in September 1967, Lowell's meaning as symbol of the age broadened as he joined Dr. Benjamin Spock, Noam Chomsky, and Norman Mailer in that archetypal act of the period: the protest march, this time to the Department of Justice and the Pentagon (Hamilton 1982: 363–367 and especially Mailer 1968).

Writers and politicians mixed and merged at this brief moment in a way that was almost European. There were, of course, the ubiquitous antiwar poetry readings and the various protests up to and including those held at the Chicago Democratic convention of 1968, which pointedly featured literary artists. This was the time when a man, Senator Eugene McCarthy, who wrote and published poetry, ran quite effectively for president, buttressed by his fellow poet and two-time Pulitzer Prize winner, Robert Lowell.[9] Whether Lowell helped or hindered McCarthy, the point at issue here is that a senator and serious contender for the nation's highest office welcomed into his official entourage a well-known writer of complex poems, a writer who was at the time thought of by the intelligentsia, not the *vox populi* of the pollsters, as the greatest in America. Culture studies can be well served by a comparison of Lowell to the artists officially selected to celebrate the second inauguration of Bill Clinton in January of 1997.

Hovering about Lowell and his poetry were always those interpretant signs that bespoke his patrician ancestry. The very sound of this poet's name

connoted tradition, even when not accompanied by any accurate knowl-
edge of the Lowell line. Indeed, Lowell defined himself in his poetry—and
was consequently so defined by his critics—as a Bostonian of ancient lin-
eage, the descendant of "Mayflower screwballs" ("Waking in the Blue," *LS*).
He visited the "Boston Public Garden" (*LS*) and lived on "hardly passion-
ate Marlborough Street" ("Memories of West Street and Lepke," *LS*).
Though he frequently rebelled against tradition, he maintained a thor-
oughly conservative stance in which contemporary improvements, such as
the parking garage under the Boston Common, were tawdry signs of a "sav-
age civility" while the broken-down old South Boston Aquarium and the
St. Gaudens statue of Colonel Shaw's Civil War regiment signified a better,
more patriotic time ("For the Union Dead," *FUD*).

In the uneasy period following World War II, when a newly enfran-
chised veteran or war-worker class elbowed into the precincts of the upper-
middle class (and "anybody" could get into the Stork Club), Robert Trail
Spence Lowell IV, unlike a notoriously wealthy Vanderbilt or Mellon, en-
shrined a spartan, "old money" American tradition quite appealing to
many—even the not so fortunate—who saw themselves threatened by a
postwar vulgarity. This Boston Lowell was thus the perfect nexus for a cul-
tural content anxiously seeking focus. That such a content was seeking and
finding expression may be witnessed in the popularity of Tennessee
Williams's plays in which figures of gentility—however corrupted—were
threatened and destroyed by the "common" power of a Stanley Kowalski.

Mention of Tennessee Williams's characters can lead our discussion of
Lowell to that area of interpretants that referred to the aura of mental ill-
ness. Williams's characters and the playwright himself are in most ways
quite unlike Lowell, but the latter's northern, more heterosexual, anxieties
"tamed by *Miltown*" resounded familiarly at this time when psychoanalysts
still had full schedules. Recognized as descended from the American Puri-
tan gods and appropriately marked with a touch of lunacy, Lowell pos-
sessed not only the Romantic credentials of a mad poetic genius but was
Freudianized for that group of the intelligentsia who thought of psychoses
as the signs of due response to a world only they could see as too vulgar.
Indeed, the general subject matter of "confessional" poetry, and part of its
gossipy attraction, was the confession of madness. That such announce-
ments were well based can be gleaned from the fact that the central group
of confessional poets[10] all suffered from severe bouts of mental illness seri-
ous enough to require extended institutionalization.

The most important interpretants of this "poet of the age" must obviously be the poems. As Ehrenpreis put it (in a comparison of Lowell with Baudelaire) "the true biography of them both emerges not from a tale of their friendships or families or external careers but from their works alone. The real Lowell . . . is met with in the poetry to which he has given himself altogether" (Ehrenpreis 1965: 36). The matter for the expression plane from which Lowell would construct his poems consisted of a modern English language elaborately codified by the modernist poets and theorized by the prominent New Critics with whom he studied at Kenyon. Lowell's particular immersion in the materiality of language took on different meanings as he moved away from the strict forms and regular rhymes of the early volumes to *Life Studies* (1959), yet the sense of an educated American speech deeply involved with the aural repetitions possible in it remained constant. Though he certainly defined one palette of the speech of the day, Lowell himself realized that his prosody never attained to the plain speech he admired in William Carlos Williams and that the poetry of the "Beats," who were emerging in the late fifties, gave a quite different sense of language, hence of the ultimate meaning of the ideas expressed therein, than his own did (Hamilton 1882: 241).

Lowell was the consummate professional, extremely well read in the tradition, both ancient (B.A. *cum laude* in Classics) and modern. He maintained throughout his life close professional and personal relationships with contemporary writers. He was intimately acquainted with John Crowe Ransom, Allen Tate, and Randall Jarrell. He corresponded prolifically with other poets, including William Carlos Williams and T. S. Eliot, whom Lowell addressed as "Tom" (Hamilton 1982: 337). The solid position of this author as *poet* can never be shaken, no matter what the final evaluation of his work turns out to be.

Consideration of Lowell's poems as interpretant signifiers is complicated by the wide differences in style and subject matter they embody, from *Land of Unlikeness* in 1944 to *Day by Day*, published in the year of his death, 1977. However, Lowell is probably best known, and was certainly considered in the period of the *Time* apotheosis in 1967 as the "confessional" poet of *Life Studies* (1959) and *For the Union Dead* (1964). Most critics have agreed that Lowell's strength lay in placing his personal struggle poignantly in lines like "These are the tranquillized *Fifties,/* and I am forty" ("Memories of West Street and Lepke," *LS*). Here the greatest care for rhythm, alliteration, and light ironic tone let us easily take them up as

our own "life studies." These poems in Part 4 of *Life Studies,* moving from grandparents to his own parenting (in "Home After Three Months Away"), compress in a vivid and saddened way the times of memory and the scene of remembering. So Lowell defined, from the unmarked anxieties of cold-war America, the familial and neurotic states in which we then lived.

To touch on one of the best known of the "public" poems that support—and modify—Lowell's political significance, we may look at "For the Union Dead" (*FUD*), mentioned above for its mixture of radical and conservative positions. This poem, composed to be read at the Boston Arts Festival of 1960, employs a stricter formal structure than most of the *Life Studies* poems. Flowing through the typographical regularity of strict five-line stanzas is a compelling image pattern of old and new Boston, of fish and finned cars, of Civil War memorials and the Mosler safe that survived the atomic blasts that ended World War II. In these images, three times are evoked and contrasted: 1) Lowell's childhood delight in the old South Boston Aquarium; 2) the present in which the poet says, "I often sigh still/ for the dark downward and vegetating kingdom/ of the fish and reptile"; and 3) behind these, the days of the Civil War when the Massachusetts 54th Regiment gave up all to serve their country.[11] Lowell's highly praised poetic "ear" is particularly effective in this poem, especially where, evoking the scene of the first stanza in the final stanza, he displays the loss and disgust his generation felt:

> The Aquarium is gone. Everywhere,
> giant finned cars nose forward like fish;
>
> a savage servility
> slides by on grease.

In terms of semiotics, I want to stress the importance of the availability of the matter of the expression plane to the meaning that will accrue to it. Robert Lowell was physically endowed with an imposing presence, a keen if tragically disturbed mind, and extraordinary linguistic talents, both inherent and meticulously cultivated. This man, this poet, was available to signify something that his very nature would in part define and that certainly would have been different should another of the gifted writers of the time, say Allen Ginsberg or Adrienne Rich, have been so selected.

Why did Lowell's status as poet or sign of an age so markedly fade? Of course Lowell as person and poet can still be used to represent that aspect of American postwar culture that accentuated the conservative sensibilities of a beleaguered gentility, yet this seems no longer central to our concern. As we look back at the symbols of the period, Tennessee Williams's Blanche du Bois—no matter how "refined" or "artistic"—now appears essentially neurotic and consciously duplicitous, certainly not a central image for today's gender issues. Our present qualifications for president of the country hardly include the kind of friendship with a notably wayward and esoteric poet relished by Eugene McCarthy. Cultural attention shifts and with it the nature of those interests and anxieties that call for representation. Lowell remarkably engulfed a moment of our cultural history. The moment passed, and new signs were called into service.

This chapter has taken us slightly off the course I had set in limiting discussion of artistic signifiers to the works themselves while bracketing the contributions to meaning of the author and audience. This was a decision taken for concision and clarity, not because I assumed that these pragmatic dimensions of the making of meaning were of no importance. However, the current attention to the author, especially in his or her race, class or gender, has, as I described at the beginning of this chapter, swayed the focus of reading toward a view that interprets the text for its information on the author's ethnicity. Though this tendency is most apparent in the processing of literary works, it appears as well in considerations of women's painting, African American music, queer performance, etc.

The many dimensions of authorship discerned in current theory make the artist's contribution to textual meaning extremely complex. It will be helpful, though, to return to semiotic basics to get a sense of where authorship enters the hermeneutic frame. To do this I borrow a familiar example.

Let us say that, on a sunny morning after a storm, you are strolling down the beach to survey the damage. Amid the seaweed thrown up by the waves, you perceive a tangled pattern of shreds that appear to spell the word "help." Does the signifier, this awkward tangle of storm-tossed seaweed, have meaning in the total absence of any intelligent intention toward expression?[12] You decide no: without intention, the seaweed "word" is not a word and lacks meaning. You continue down the beach, where you come upon a remarkably textured and twisted piece of driftwood (another favorite war-horse of aesthetic theory). The driftwood you take home and

mount on your mantle. This you claim for a piece of "found art," whose virtues and meanings you extol to a sculptor friend.

Have you not been inconsistent in your willingness to grant or refuse meaning in the cases of two objects, *both* lacking any human intention in their physical construction? Here the third point of the triangle of signification, which includes author, work, and audience, turns to you, the audience. You could, to give the first signifier its rightful place in the canon, have photographed the seaweed /help/ and published it as a one-word novel. Not very promising, but not outside the bounds of avant-garde art. With the driftwood, you assumed "authorship" since you perceived the interesting qualities of the wood and decided to exhibit the piece as expressing these qualities. In both the seaweed novel and the driftwood sculpture—when they are *exhibited by you as art*—there is ostended meaning of the kind I have described in previous chapters: a meaning quite slight and minimally determined, but a meaning nevertheless.[13]

When we return from the beach to the library, we acknowledge that Lowell's poems have a very palpable human intender as author: the man Lowell, interpreted by the signifiers that are his poems and the poems interpreted at least in part by the more amorphous construction that was "Lowell." Thus, in the 1960s the complex significance of the poet Lowell to "For the Union Dead," or in the 1990s the even more complex significance of Rita Dove to *Thomas and Beulah* must be seen as a factor in the interpretation of the materials and the forms these poets chose to express themselves.

In an important sense, communication in words is a privileged medium. In whatever form an author uses this medium, whether in poem, novel, or biography, the root figure of a flesh-and-blood speaker stating or asking something underlies the whole pragmatics of the speech act. Thus the personhood of the author—the poet, the bard—normally contributes more meaning to his or her works than does that of the artist who works in the nonlinguistic media. The artist of our next chapter, the scene designer Jo Mielziner, as "author" probably commanded little more than vague name recognition from 75 percent of the audience at a Tennessee Williams play, yet I will claim that Mielziner's sets defined, in a way the purely verbal arts could not, a sense of the space in which the postwar population played out their lives.

7

SIGNS OF SPACE:
JO MIELZINER'S STAGE SETS

In this chapter I will argue again for an aspect of artistic meaning frequently overlooked or deliberately avoided as obscurely "formalist": that component—the ostended meaning—contributed by the very matter and form of its physical manifestation. I do this here through the example offered by a group of stage sets designed by Jo Mielziner for plays by Tennessee Williams and Arthur Miller. Mention of such plays as *A Streetcar Named Desire* and *Death of a Salesman* rightly brings to mind such literary and conceptual themes as brute pragmatism versus a decayed—or simply false—idealism. Yet it is easy to forget that the plays' original meanings were inseparable from the spatial meanings of the stage sets in which these themes were played out. This was in large part a "meaning of matter," a meaning not symbolized but ostended and, as such, physically present to the viewer.

These same stage sets, chosen to exemplify certain formal features, help as well to expand that side of my argument which has proposed that the ostended meanings I put forward, like all meanings, are culturally driven. Concepts of space were particularly troubling in the period of the Williams-Mielziner collaboration. They existed in an atmosphere of postwar readjustment the anxieties of which fed into the social atmosphere discussed in chapter 6 as an influence on Robert Lowell. The arguments put forth here for both formal and cultural meanings are about a semiotics of meaning, about meaning as created in an historical and cultural context. The examples used are, I hope, supportive of my main semiotic position. I have not tried to develop a complete theater semiotics, nor, despite my references to history in contrasting ideas of stage design both before and after the *Streetcar* set, have I tried to write a history of stage design.[1]

Poem, novel, picture—each of these has a certain autonomy, a certain assumed relation to the bit of reality it is taken to portray. Semiotic analysis of such art objects may be complicated in itself, but the nature of the object under discussion is relatively clear. To talk about a semiotics of the stage set, which exists only as part of the total "performance text," is to consider a much more amorphous object. Yet the particular challenges to semiotics that this subject entails can help define and enlarge the discipline as it moves beyond both strictly linguistic definitions and strictly iconic representations to consider the representation of that essential context of all experience that is the spatial dimension. This space of our actions is defined in the drama—Aristotle's "imitation of an action"—by the stage set. When most successful, these settings provide a compelling image of a culture's physical context, a sense of the lineaments of our significant moments. Jo Mielziner (1901–1976) was supremely successful in providing such an image.

The stage set as artifact is essentially architectural: a construct that defines the nature of the spaces it fills. Yet most stage sets are not, like the buildings an architect produces, the thing itself, for the construction of canvas and wood propped up on stage is not a room or a castle. However, this construction, in its own true dimensions and those dimensions suggested by the scene painter's art, does offer what the ordinary room or castle does not: a plasticly compelling sign of the kind of spatial object that a culture identifies, for example, with the idea of a room. I will suggest below that one of Mielziner's achievements has been to define so many compelling models of what the concept "room" can be, even when he does away with the solid walls that compartmentalize our real life rooms.

These particular conceptual meanings are the products of the artist's culturally driven choices of materials and form. Beyond the traditional wood, canvas, and paint, the most important material for the twentieth-century stage designer has been light. This is the material that had transcended its use as mere illumination to create the mood effects of Appia's Wagnerian mists and Belasco's naturalistic "western sunsets."[2] It was the essential material for Mielziner's fluid spaces.

The materials taken up, in their intrinsic qualities and connotations, have obviously a great effect on the designer's formal choices for their use. Light, for example, which in a darkened auditorium could illuminate one part of a setting while another was made dim—something impossible at Shakespeare's Globe—allowed for a much more flexible formal emphasis.

Balance, as formal feature, shared in this flexibility, and settings for the most serious plays, like modernist paintings, avoided strict symmetry. (See the placement far stage right of the important main entrance—the circular staircase—in the *Streetcar Named Desire* set, plate 5.)

As potential subject matter for the content plane of this designer's work, the traumatic experiences of Americans in a devastating war and an uneasy peace lay open and demanding. World War II populations were stunned by an explosion of space in both distance and height, and threatened by the awful power of the missiles that descended from that space. Following the war, society was caught between the nostalgic space of the past—so recent in this relatively short war, yet irretrievably lost to the hastening future haunted with the memories of war, but promising to the "new men" who were creating it. The kind of signifying spaces created by a Mielziner thus would answer well to Norberg-Schulz's definition in *Existence, Space and Architecture,* "Space may be understood as a concretization of environmental schemata or images, which form a necessary part of man's general orientation or 'being in the world'" (1971:7).

As Jo Mielziner adapted to this spatial sense, his settings for the Williams and Miller plays reflected the ambiguities of the late forties and fifties.[3] The space created was fragile, cramped, raffish, old-fashioned while at the same time open, threatening, brutal, and vast. Technically the changes of mood were accomplished through Mielziner's cleverly designed and lit transparencies; conceptually these changes were the product of an uncertain, protean age lived in a space in which the relics of the old—as in the skeletal remains of buildings fallen to the air war Blitzes—contested the raw power of an emerging pragmatism. The Mielziner settings defined for Williams the space in which Stanley Kowalski, master sergeant in the 241st Engineers, raped the faded southern belle, Blanche Du Bois. It was the kind of space in which Senator Joseph McCarthy, tail gunner wounded in action—as he claimed—routed out what, in a saying of the time, were the "pinks, queers, and other Unamerican crud."[4] It was the kind of space to which Thomas Wolfe had told us in 1938, *You Can't Go Home Again.*[5] It was an emotionally volatile space in which a charming shelter—Blanche's refuge in her sister's Latin Quarter flat—could, with a change of mood or of Mielziner's lighting plan, become an ominous trap.

A primary fact about such theatrical space is that it is shared by the audience and the actors: a situation different from that experienced by movie audiences. Typical of Broadway theaters of roughly 1920 to 1960, the Ethel

Barrymore provided *A Streetcar Named Desire* with the standard proscenium arch stage. Despite the two-dimensional quality this might imply, theatrical space, even though distanced and "framed," remains a part of the same space occupied by the spectators, and the structures and movement within that space would be seen as modifications of it. Of course, the total space of a play, and hence the total meaning of that space, would have to include the space of the auditorium—in the case of *A Streetcar Named Desire,* the Ethel Barrymore Theater. Indeed, the space of the New York theater district, the narrow cross streets of Broadway in the forties, crowded with taxis and set with restaurants and the gleaming marquees of competing theaters was, at the time, effectively the space of American drama just as the streets of medieval York or, in Shakespeare's time, London's South Bank were the space of their drama.[6] In this chapter, however, we must restrict ourselves to the space of the stage set proper, with the consideration that despite the sometimes mystical claims for the qualities of some favorite theater, most Broadway houses of the period were roughly similar and the choice of a particular auditorium was more a result of availability and finances than of aesthetics (see Little and Cantor 1971: ch. 5).

Though the way in which Mielziner created the images of space mentioned above will be examined here principally in Mielziner's design for *A Streetcar Named Desire,* his sets for *The Glass Menagerie* (1945), *Summer and Smoke* (1948), and Arthur Miller's *Death of a Salesman* (1949) expand and define the essential elements of the image. Each set offered a modest family dwelling contained within the impression of a potentially threatening environment: the brick walls and fire escapes framing the Wingfields' St. Louis apartment (*The Glass Menagerie*), the visual and auditory Mardi Gras sweeping around Stanley and Stella's New Orleans flat (*A Streetcar Named Desire*), the small-town Southern sky overhanging the gothic traceries of Miss Alma's parsonage home (*Summer and Smoke*), and the scrim of apartment facades dwarfing Willy Loman's house (*Death of a Salesman*).[7] The significant design feature of each set was the use of transparencies, which allowed an interaction between the space of indoors and outdoors, of intimate family living and the larger physical environment that conditioned it. This interpenetration created quite a new and different sense of theatrical space than that afforded by even the most elaborate devices of backings and cycloramas that would allow the audience glimpses of "sunlight," "trees," etc. through the open door or window of the traditional naturalistic set.

Turning now specifically to Mielziner's set for *A Streetcar Named Desire,* I must, as a first step, note what has been represented. I will return after this to consider the specific ways, that is, the semiotics in which this representation has been accomplished, a move that, I hold, will give a much fuller account of the meaning of Mielziner's set and of the play it accommodates. At this first level it is impractical to distinguish between those items of the Latin Quarter apartment represented by real objects— an actual window, for example—and those objects only suggested—the "windows" that were painted on the backdrop.[8] Any useful description of the signified architectural features must include their implications for the nature of the actions permitted or encouraged within them. Even though the inclusion of such implications goes beyond strictly iconic and denoted meanings, I take the liberty to add them to the description below.

Mielziner's set for *A Streetcar Named Desire* provides a long narrow interior with entrance/exits at either end. (See plate 5.) In this set the main entrance to the Kowalski apartment, with its spiral of New Orleans grillwork, had a very rakish and open charm. It could be immediately perceived, however, that once inside this narrow apartment, especially if one penetrated to the more intimate spaces of the bedroom and bathroom, escape could easily be blocked, as Blanche's escape was blocked by Stanley in the rape scene. The bathroom door, stage left, though deemphasized, was significant as spatial instrument. It was clearly established as affording no access to the outside while still affording some temporary refuge as a space in which Blanche could bathe and primp before making her entrances to the hostile scenes in the apartment proper. This was especially true as she prepared her entrance to her abortive birthday party (scene 7) and in the last scene, in which she was led off to the asylum.[9]

The main doorway, stage right, was emphasized in two ways. The level on which characters would enter from the stage-right wings (as from the nearby streets of the New Orleans Latin Quarter) was built up on platforms, providing a two-step descent into the apartment. Rising from these platforms and outside the apartment door was a handsome circular staircase that set up a very strong playing area framed above by the convex curve of the upper staircase and below by the enclosing curve of the railing. Actors playing on this staircase were further emphasized by their height from stage level and by the strong vertical—the strongest on the set—of the center pole of the stair unit. It was precisely in this position

that the two major reconciliations between Stanley and Stella were staged—reconciliations that froze out the third party, Blanche.

Inside the apartment, one entered a small dining/living area dominated by the round table, which served as the locus of the "Poker Night" game (scene 3) and Blanche's birthday-party dinner (scenes 7 and 8). This table held the important center stage position, making it especially effective for climactic scenes such as the above, though the fact that the apartment itself was offset to the left mitigated the kind of formal rigidity such placement could have caused.[10] Blanche's trunk, which contained the incriminating papers on the sale of her home, Belle Reve, and her collection of imitation furs and the cheap jewelry which Stanley later taunted her with was located here as well as a telephone stand and a cabinet containing plates and liquor.

The bedroom, stage left, was separated by a curtain hung from a frame whose curve repeated the curves of the staircase and the window tops. The room contained, beside the bed, a dressing table and chairs and a small chiffonnier. The properties that filled out these rooms—the "practical" pieces such as tables, chairs, trunk, etc.—were real enough though often scaled down or specially built for the set. This was, however, a strictly selective realism. There was no sink, refrigerator, or stove in the Kowalski "kitchen."

The meanings just derived, of "staircase," "bedroom," "table," etc., are largely iconic. The signifier /staircase/ is "read" as a staircase because it looks like a staircase.[11] As usual with any but the simplest signs, the mode of signification is never unmixed, and the symbolic mode with its learned and conventional codes operates not only to help us identify the iconically represented objects even when they are considerably abstracted, like the windows and shutters painted on the scrim, but in attaching the connotative meanings. It is such connotative references that attach the meanings "Southern architecture," "open," "hot" to the shuttered windows and iron grillwork.

Stage props, those everyday items used as part of the stage business, tend to carry a large burden of symbolic meaning and have thus been a favorite subject for theater semiotics.[12] I want to examine one such prop here because of the relevance of its symbolism to the themes of the play and its involvement through its material in the ostensive meanings I describe below. On the *Streetcar* set an interesting case may be made for the meanings of the paper lantern that Blanche asks Mitch to place over the

bare bulb in the bedroom (scene 3).[13] This specially constructed stage "prop" represented for the audience a common article: frail, cheap, and "arty," used to conceal the real source of power—the bare electric light bulb. As such, the connotative properties of the lantern obviously suggest the qualities of Blanche herself, as did the makeup table below the bulb, a table at which Blanche would again attempt cosmetically to hide certain less attractive realities.

I have argued throughout this book that to stop the search for meanings at the level of the iconic and symbolic cuts off an important part of the meaning that artworks *qua* artworks possess. Here come to the fore meanings by what I have called ostention, in which the material and formal properties of the signifier have content. First, the quality of the materials used, the paper of the lantern (though in this case, imitated on muslin) and the thin open-weave cloth of the backdrop have a sensory meaning made more complex when they are used alternatively to hide, to display, and to transform the light that can pass through them. This fluid and partly transparent quality affects the sense of spaces large and small, which open and close with the changes of the light plot. The same sensuous quality was seen in the insubstantial curtain that provided the only privacy—or shelter—between bedroom and living/dining room. This comment on the qualities of the cloth used could certainly be extended to cover the material and drape of the dresses created for Blanche by the play's costumer, Lucinda Ballard. As Mielziner said of his *Streetcar* set, "This kind of designing . . . deals in form that is transparent, in space that is limited but has the illusion of infinity, in light that is ever changing in quality and in color" (Mielziner 1965:141).

The distribution of masses, with the weightiest, most opaque, and tallest mass located far stage right, asymmetrically balances the long, low, and horizontal sweep of the apartment. Not only does this exemplify the architectural concept of entrance versus interior space, but it gives a dynamic to the placement of the actors so that each would relate spatially to the dominant vertical mass at the staircase, both in relation to its symbolic meaning of entrance and to the relative spatial weights this asymmetry gives to the breadth of the stage. The physicality of the placement of this dominant entryway is particularly effective in spatializing the drama of Blanche's first entrance alone and frightened into a dark, empty apartment and her final exit walking all the way from the bathroom far left past her rapist, Stanley, and the poker players. (See plate 5.)

Line—in the sweeping curve of the stairway, in the tops of the windows, and in the frame for the room divider and in the hatched lines suggesting the shutters—unifies the set with a meaning of completeness and integrity, which tells us that this mood of tacky decoration is central to the meaning of the drama that it houses. In the material and form of these we *feel* the fragility and the voluptuousness symbolized in the story of the play. Though the idea that a sense of unity is ostended by the repetition of certain qualities throughout the set—and theoretically in a modernist production in all the other physical aspects of the performance—may seem trivial, consider the deliberate effort in postmodern productions, described at the end of this chapter, to contravene any such semiotic hegemony.

A brief look at late nineteenth-century stage design offers, by contrast, a clearer definition of the changes in cultural semiotics that summoned forth designs like those of Jo Mielziner. Settings in this earlier period carried the heavy burden of realism but a realism that was in essence pictorial or illusional. In semiotic terms, late nineteenth-century sets focused their signifying powers on the iconic and symbolic modes, representing what was not there—a palace ballroom or the cramped quarters of a hovel—rather than what was—an architectonic construction in the real space of the theater itself. The effect of this pictorialist tendency was most felt in those plays of epic proportions such as Shakespeare revivals or the early Ibsen and Strindberg plays. When the curtain descended and rose again, the audience was transported to a new and different space, as the battlements at Elsinore or the adjacent churchyard of the *Hamlet* "gravediggers scene" (5.1). Modernist practice, while symbolizing the locale of the action, tended to focus on the space of the stage itself, which could be altered by lights and set pieces but which remained the stage of the Ethel Barrymore, the Martin Beck, or whatever theater had been engaged.[14]

Nineteenth-century sets enclosed their illusionistic scene, carefully masking it off from any view of the actual stage on which it had been constructed. You did not "see through" anything, as you did with the skeletalized roof of Willy Loman's house in *Death of a Salesman*. Walls were opaque and even the views through windows or doors presented only further carefully masked illusionistic backdrops.

Yet as the appetite for illusion—either of the gay or the grim—weakened and designers more and more accommodated realism with effective spatial design, the nature of interior spaces as totally enclosing lingered on. While

the structures that sheltered Blanche Du Bois and Willy Loman were no-
ticeably fragile way stations planted in the larger cube of stage space, the
Bergers' Bronx apartment, as created by Boris Aronson's set for *Awake and
Sing* (Odets 1935)[15] was convincingly solid. In this set, despite the exigen-
cies of the depression and the disorientation of the family around a weak
father and strong mother, the image is of enclosed, sheltering, even (espe-
cially for the protagonist) claustrophobic space. This set represents a space
not yet fractured by the physical and psychological dispersions of America's
entrance into World War II.[16] The action of *Awake and Sing* is visualized as
interior; it is the sociological struggle that transpires in *rooms* and suggests
a very different kind of space than that visualized in Mielziner's notes for
The Glass Menagerie, which he said was "a play of influences that were not
confined within the walls of a room" (1965:124). The point is not that no
one used exteriors or transparencies prior to Mielziner,[17] for this is very
clearly not the case. There were many expansive vistas shown on earlier
stages, but they tended to represent a particular space: Central Park, the
Forest of Arden, etc. The Mielziner sets are constructed in a more general
space, which is frankly the space of the stage itself.

Having proposed a set of signifiers and their presumed meanings, I am
obligated to provide evidence that these signifiers and signifieds had some
currency at least among the metropolitan population. I draw this evidence
from three areas. First I examine a kind of spatial experience that would
have been shared by most of the generation who lived through World War
II, an experience for which common images could be met in everyday life.
In the second place, I look for a kind of intertextuality of such images in
the arts of the time, specifically in a poem by Robert Lowell and a paint-
ing by Ben Shahn. Finally, I offer some evidence that an exploration and
expression of space in much the same terms that I have described was on
the minds of the architectural and design community.[18]

To focus the sense in which art both represents and defines our experi-
ence, we must consider how the years of war spatialized the American con-
sciousness to an extent not previously considered, an effect made poignant
in *The Glass Menagerie* by the figure of Tom dressed as a merchant marine
presenting this "memory play" from the great distance that the war had
taken him. Not only were the theaters of operations remarkably expansive
(crossing the Atlantic to Europe, crossing the Pacific to the Philippines,
Japan, and China) but the new importance of the air war and of air trans-
port added another dimension to our consciousness of space. While the

fighting men and women personally experienced the expansion, both they and the home audience were satiated by images of space in photographs, newsreels, and the many war movies of the period. Within this larger space, the old shelters, both ideological and physical, seemed fragile, local, and temporary. One senses the influence of pictures or actual experiences of buildings bombed out in the Second World War (Richards 1942). In the war's aftermath, space seemed especially impermanent and shelter a matter of life or death—as in the bomb shelters. Where the bomb or wrecking ball had done its work, buildings and even cities that had seemed rooted and permanent could be seen on any morning walk as literally as transparent as Mielziner's stage roof lines. The openness of such a space was threatening, and the appeal of the old, even—or especially—as partially destroyed gave a temporary and sentimental anchor to a time past in an uncertain time present. It was a moment in which the Romantic passion for ruins took hold again and the transparencies of skeletal walls or roofs played the strangely contradictory role of Victorian ruin *and* modernist transparent plane.[19]

The images of a fragile older culture propped up against the new that Mielziner had given us tactually were evoked by Robert Lowell in his poem "For the Union Dead" (1959). "The old South Boston Aquarium stands/ in a Sahara of snow now. Its broken windows are boarded," while on Boston Common "yellow dinosaur steamshovels were grunting/ as they cropped up tons of mush and grass/ to gouge their underworld garage."[20] As Laura, Blanche, and Alma intrude their glass menageries into a steamshovel world, the St. Gaudens Civil War Relief of Colonel Shaw and his soldiers in Lowell's poem must be propped up by a plank "against the garage's earthquake."[21] In another intertextuality, this poetics of destruction—early reviews of Williams stressed the poetic quality of his plays[22]—shared a link with some of the best American art, especially with some of the contemporary works of Ben Shahn, then a very popular painter showing at galleries within a few blocks of the theaters that housed *Streetcar* and *Death of a Salesman*. A number of Shahn's paintings of the time (*Reconstruction* [1945], *Cherubs and Children* [1944], and *Carnival* [1946], for example) display figures whose very presence challenges the vastness of the space surrounding them while fragmented traceries of their physical world still define a temporary locus for a moment's enjoyment. Shahn's famous *Liberation* of 1945 (plate 6), places three children in sticklike figures swung wide on the thin lines of their swings and

all placed in front of the shell of a building, itself set against the openness of a washed-out eternity.

Certainly Shahn's typically flat and abstract figures are unlike the more fully rounded psychological portraits of Williams or Miller, yet the fine linearities, the visual patterns from a fragmented past set raw and brave against a vast surrounding openness recall the feel of Mielziner's sets of the period.[23]

The clearest evidence for a shared spatial concept may be found in the design community itself. By mid-century this community had absorbed the ideas of abstraction and expressionism as well as the focus on material, its nature, and the design potential to which this nature seemed intrinsically to lead. As specifically a *stage* designer, Mielziner had inherited a tradition that descended from Adolphe Appia and Gordon Craig. It was passed on through Lee Simonson and Robert Edmond Jones, whose apprentice Mielziner had been (Mielziner 1965:3). On the other hand, modern commercial design of this period was heavily influenced by the teachings of the Bauhaus, a number of whose faculty members had fled to America after the school had closed in Germany in 1933. Thus Mielziner's "form that is transparent," "the translucent walls . . . made to appear by the skilled use of light" (1965:141) had one indirect source in Bauhaus philosophy, which, if it may seem too geometric to suit scene design, was, we should recall, influenced by the hardly mechanistic Kandinsky and Klee. Such interpenetrating planes as could be seen in Mielziner's sets were visible in the architecture of Mies van der Rohe as well as in industrial design, advertisements, and Fifth Avenue store windows.[24] This spatial openness and interpenetration culminated, for those New Yorkers who were also our potential playgoers, in Philip Johnson's much discussed glass-walled house in New Canaan, Connecticut (1949).[25] Man had become accustomed to "seeing through," to moving in an open and abstract space that could be defined and momentarily redefined, as Mielziner's walls were, with a change of light. Yet the new architectural space of Bauhaus origin was clearly too machine-oriented for the inherent romanticism of the American stage on which futurism and expressionism softened to the more wistful fantasies of musical comedy. The transparent planes of a Mielziner set were defined not in the geometric lines of Philip Johnson's glass walls but in Victorian traceries.

Art, in this case that of the stage designer, has done its semiotic work, defining by its ostended image a vital experience of a historic moment's

"being in the world," an image of the space in which that being was lived. It is in such a space: open, cosmic, tactile, and exciting, that the plays we have referenced are set. Laura, Blanche, Alma, and Willy act in an arena that is real and vast, challenging and vital but frightening in its openness, for this space can belong to the new men, the destroyers of the dream: Jim, the Gentleman Caller; Stanley Kowalski; Dr. John; and Young Howard. So our protagonists take shelter in the old and quaint, in the delicate and transparent charms of a glass menagerie, a New Orleans flat, a Southern parsonage, a small Brooklyn house whose outlines flaunt their eccentricities against the rigid backdrop of impinging apartments. Playgoers in these late years of the forties experiencing Mielziner's transforming linearities very likely remembered pictures of the gothic tower of England's Coventry Cathedral sundered by bombs in 1940 or Ben Shahn's stunned children swinging before the ruins of their home. In the delicate beauty of these ephemeral, transparent, yet heroic traceries we can feel the spatial image of faith, humanity, and tradition standing bravely in a changed and threatening world.

It might be well, in conclusion, to explore, in Jim Carmody's semiotic analysis of a postmodernist production (Carmody 1992), how theatrical signifiers define the cultural concerns of their age. I want to make two different points about the kinds of significations Carmody finds in a 1989 production at the La Jolla Playhouse of Molière's *The Misanthrope* (1666): the first about the kinds of meanings that the production staff has identified in the contemporary American—specifically Southern Californian—culture, and the second about the devotion to iconic, indexical, and symbolic meanings to the exclusion of what I have been calling the ostended meanings of the matter and form of the artefact.

As the article states, the La Jolla Playhouse production as "performance text" is designedly postmodern in its elements: a translation in colloquial English alexandrines of a quintessential seventeenth-century story; a set modeled on Madonna's Hollywood Hills house; properties and performance styles that often contradict rather than complement each other. The production is also postmodern, according to Carmody, in its penchant for quotation in a purposefully jumbled mix of references. The director and designer have given a nod to Molière's France with a guillotine blade, and a Jacques Brel tune; to contemporary Hollywood with an exercise machine, Evian bottles, the reference to a star's home, etc.

Carmody has chosen three elements of the production as synechdoches for the many signifiers that make up the "text": the exercise machine, the leading lady's curtain-call bow, and the program notes mailed to subscribers at Chicago's Goodman Theater where the play was next performed. (Actually in the article these notes got relatively little attention while, fortunately, Neil Bartlett's translation of the play was very informatively handled.)

The elements of the production chosen by Carmody are analyzed as Peircean symbols in that their signifieds are determined by cultural associations: the exercise machine, sneakers, gym towel, etc. signify the Southern California fascination with physical fitness. The bow, a combination of curtsy and showing off of arm muscles, was seen as a self-deconstructing signifier in which the leading lady's traditional demure acceptance of applause was contradicted by her gesture of feminine strength and victory over a husband, Alceste, whom she has just sent off to a desert island.

I have no quibble with the analyses of these signifiers as basically symbolic. Both their descriptions and the subtle interpretation of their meanings were very well handled. My point is that both the methods of the semiotic analysis by Carmody *and* the methods of the typical postmodern creators of such artistic texts are bent toward a primarily symbolic mode of meaning-making. As I remarked in the case of postmodern poetry (see chapter 5 above) this tends to support an ironic and intellectual artistic experience in which signifiers, like a word on a printed page, propose transcendent and referential meanings that they themselves do not embody. In addition, postmodernism as a directorial creed can be seen here to produce a *mise en scène* distinctly different from that desired in a modernist production. In this latter, as I noted of the unity of design in the *Streetcar* set, an organic feeling, a sense of oneness, is called for. In the postmodern world of contradictory "partial truths," the styles of performance and even the leading lady's bow deconstruct rather than unify any one governing idea.

Now meaning is meaning, however signified, and I would argue that the very dominance in postmodernism of a symbolic mode of reference is a sign of a cultural appetite for a wealth of references distanced by end-of-century irony yet appropriately multicultural not just ethnically but historically. Cultural fear of hegemony can perhaps be seen in the postmodern refusal to bring the elements of the given art sign under one dominant thematic. Yet art goes on: postmodern works are often

materially and formally quite exciting. Indeed the set for the La Jolla Molière, judging from the photographs reproduced in Carmody's article, appears to be a striking and massive spatial construction certainly meaningful in a contemporary architectural sense. I ask only that we acknowledge the ostensive qualities.

8

CAN NONOBJECTIVE ART MEAN?

Most of the art works previously analyzed have contained conventionally coded references to things, events, or ideas not present in the work itself. Shakespeare's Sonnet 4 refers to a young man and to usury; Mielziner's very abstract stage sets refer, through a few iconic touches, to the dwellings that Tennessee Williams's characters inhabit. The ultimate step in a semiotics that claims that art possesses a meaning through the ostended values of its matter and form must be a consideration of meaning in nonobjective painting and in music. Since my limitations unfortunately preclude doing the kind of technical analysis of music that could support the meanings I have been claiming, I will restrict my examples of the nonobjective realm to those found in the abstract painting of the twentieth century. Thus, nonobjective painting must stand in here not only for music but for the numerous and multiplying abstract works in sculpture, architecture, dance, and mixedmedia.

To keep a complex argument as straightforward as possible, I have selected a test case whose means are unrelentingly nonobjective: four chevrons forming a triangle contained on an almost square canvas. Most important, this work, Kenneth Noland's *Shoot* (1964), is to me and presumably to the staff of the National Museum of American Art who purchased it a very beautiful painting—that is, it counts here as art. Since I have held that the meaning of an artwork is not autonomous but functions in a culture of meanings, it is important also that we are dealing here with the work of a major abstract artist of the later twentieth century, one frequently exhibited and published, one in close contact with the major critics and artists of the school.[1] Let me turn, then, to an analysis of *Shoot* (plate 7).[2]

Semioticians have long since given up the attempt to provide a description that would be both exhaustive and neutral, but for an experiment that seeks to establish the ways in which an art object can mean, there is value in a consideration of the aspects of the signifier prior to any leap to denotational or connotational content. We proceed in this with the acknowledgement that even the features chosen for description are culturally determined. We learn to exclude the wall, the title card, and the stretcher from consideration. We learn as well, from experience with other modern works, a method of construing the shapes and colors that we find on Noland's canvas. There is no pretense that the following description is innocent, that it is not the product of finding in the object the kind of pictorial structure the brain has learned to see there. (Nor do we pretend that this "seeing" is done in any but human terms that make the canvas "large," not simply 103 x 126 inches.)

Shoot is a rectangular canvas (103 x 126 inches) crossed diagonally from the upper corners to the bottom midpoint by four chevrons of equal width and separated by one-inch bands of unpainted canvas. The chevrons leave right-angled triangles of unpainted canvas at either side with bases half the width of the canvas and sides equal to its height. At top a small unpainted equilateral triangle separates the arms of the uppermost chevron.[3]

The chevron colors are generally dark and intense against the pale buff color of the raw canvas. Moving from the outermost to the innermost chevron, these colors present successively a heavily saturated dark green, magenta, a medium blue, and a medium red. Color saturation generally decreases a little as we move inward. Each chevron is painted in one uniform flat color that seems to impregnate the canvas. The blue band, third from the bottom, shows some local variation of hue and texture as, to a lesser degree, do its neighbors. Close inspection reveals a degree of imprecision at the edges of the bands—index of a freehand, "painterly" quality. The four dark bands set against the raw canvas display a striking set of contrasts and similarities contained, as they all are, within the "cool" half of the color circle between the complementaries red and green.[4] The colors of the chevrons move inward through the blue area of the color circle but start well on the cool side of their primaries. The movement is that of alternation rather than a chromatic progression since the green band is followed by a magenta band (a mixture of red and blue), which in turn is followed by a turn back to blue, then to red.

Colors seem inseparable from the shapes that display them and seem to share their boldness. The effect is that of a direct exposure to the play of color that appears to surround one, spreading, as we point out below, above one's head and beyond one's reach. Any set of sequential color bands such as Noland utilizes can make iconic reference to the familiar color spectrum, an effect Noland carefully avoids by his choice of colors and their sequencing in bands that do not follow anything like "rainbow" order. Again, choice, sequence, and spacing of the colors—as in *Shoot,* the separation of the colors by thin lines of bare canvas—foils the kind of depth perception that might otherwise be present. In this way the bright colors, as well as the forcefully arbitrary shapes, are blatantly artificial and maintain the sense of direct experience of the signifier, defeating any attempt to "naturalize." On the other hand, the slight imprecision of the chevron's edges gives *Shoot* and most of Noland's paintings a personal and painterly quality lacking, for example, in the "squares" of his one-time teacher Josef Albers.

In addition to the shapes and colors employed, the sheer size of the painting constitutes a vital aspect of the physical signifier. *Shoot* is eight feet high and ten feet wide. In ordinary museum mounting, as at the National Museum of American Art, the base of the color triangle would stretch the width of the top border, that is, further than the arm span of the ordinary man or woman and well above the viewer's head. Presentation of simple shapes in striking color in so large a format ostends a particular meaning different from that expressed by the relatively small paintings of Mondrian. That the very format of the physical picture had become an expressive element can be seen in the great size of the works by a number of the period's artists—for example in the "unfurleds" of Noland's close friend, Morris Louis, whose *Beta Kappa* of 1961 measured eight and a half by fourteen and a half feet. Noland himself has continued to work in a very large format and, from the mid-seventies, to experiment in large shaped canvases.

Having described at some length the physical signifier, I want to step back to consider this semiosis from the point of view of a cultural process in which the artist *bricoleur* cuts out from the spectrum of undifferentiated matter the physical means to define some area of the spectrum of undifferentiated content.

To say that Noland was deeply involved in the material aspects of his craft is to say no more than that he was fully and intensely an artist. Diane

Waldman's essay on Noland for his 1977 Guggenheim retrospective catalogue (Waldman 1977: 9–37) lays out in detail Noland's own statements on his craft, his training at Black Mountain College under Josef Albers and Ilya Bolotowsky, and the experiments in technique he shared with his artist friends. In this account, attention is continually drawn to Noland's "sense of materials and the materiality of paint" (Waldman 1977: 17). From his youth through his later experiments with the new acrylic paints even with the kinds of canvas to which the paint would be applied, Noland was intensely and physically involved with his medium. Working in several series of many paintings each, he explored the effects of the format that would display his colored circles, chevrons, and lines, trying out squares and diamond shapes, then the very long horizontals of the late sixties, and the shaped canvases from the mid-seventies. The following, from the critic—and friend—Kenworth Moffett may give some feeling for Noland's approach:

> Toward the end of the horizontal series . . . he stretched and hung in his studio a bare, vertical canvas. Obsessed with the idea of painting vertical pictures, he wanted to study how one *sees* a vertical surface. Someone suggested that he hang one of his horizontal pictures vertically, but Noland said that would be "too easy"; verticality had to be achieved, not imposed. It was as if he wanted to get at verticality itself, its essence. (Moffett 1977: 72, italics in original)

The idea of expressing "verticality itself, its essence" may get us some way from the plane of matter to that of content, but something must, in the meantime, be said about the cultural context in which these experiments with matter were taking place. Noland's study with Josef Albers and Ilya Bolotowsky at the very experimental Black Mountain College (1946–48) brought him in contact with the ideas and techniques of European abstract painting from Mondrian to Kandinsky and Klee.[5] Albers, as head of the art department at Black Mountain, had set that department's curriculum very much in the tradition of the German Bauhaus from which he had come to Black Mountain in 1933. Fundamental to Bauhaus art pedagogy was the belief in the central role of the materials in the nature of the product to be made from them, a philosophy widely shared, without need for direct influence, by most schools of architecture and design at the time.

I have held throughout that the making of meaning is, at its best, a group work with many artists exploring aspects of the formal and conceptual areas of expression. Noland was a man very lucky in his group. He had gained, through Albers's and Bolotowsky's Bauhaus philosophy, a common language with many of the design-trained artists of the postwar years. Through friendships made at Black Mountain and since, he absorbed the thought and techniques of the most important of the second generation of American abstract artists. He met and/or shared exhibition space with most of them, but among his deepest friendships were those with the sculptor David Smith, with whom he shared an intense preoccupation with materials; the painter Morris Louis; and Clement Greenberg, the principal theorist of abstract expressionism and, on the practical side, the man who introduced both Noland and Louis to so many artists and dealers.[6] In terms of a cultural semiosis, this kind of loose collaboration helped to broaden and define the expressed content of abstract art at the time. This worked both for the artists and for an audience who could gather, from the various exhibitions and critical statements, a set of effective Peircean "interpretants" for the contents of these artistic signs.

The kinds of interpretants just suggested form the same kind of interpretative web that functions in literary art as "intertextuality." A comparable play of similarities and differences can be seen to operate in the visual arts where our understanding of what a picture means depends in part upon our sense of pictorial echoes—affirmed and denied—from the long history of painting. The meaning of Noland's *Shoot* depends on the definitions of visual experience offered by Noland's predecessors and contemporaries from Kandinsky, Mondrian, and Matisse through Frankenthaler, Louis, and Olitski. In her paintings of the late sixties, Helen Frankenthaler defined her space by pushing large monochromatic forms toward the borders of her rectangular canvases. In the large "unfurleds," Morris Louis deserted the center of the canvas—the area of Noland's greatest concentration—while balancing the composition with poured and stained diagonal bands of color. Olitski has stressed the interior and exterior of verticality by moving the largely uniform color of the interior shapes almost to the containing borders of his rectangles.[7] In comparison with the painters just mentioned, Noland's work probably displays more sheer play of color and a much stricter geometry, but Noland's meanings must be seen intertextually with those who were helping to define a contemporary view of space. *Shoot* would not necessarily be meaningless to a viewer who

did not know the kind of works just mentioned, yet experience of its generic context goes a long way toward informing us how the signifier is to be "read." Viewing *Shoot* without such intertextual knowledge could be compared to reading William Carlos Williams's "This Is Just to Say," with no balancing knowledge of Williams's other poems or those of Whitman, Eliot, and Pound.[8]

Turning, then, from the description of the physical signifier—the painting *Shoot*—and the context in which it would be interpreted, it is time to define the signified of this nonobjective work. Since the concepts ostended are visual not verbal, this will be difficult, but "the nature and dynamism of color as a part of strict geometries" should come close as a statement of the meaning. Let me hasten to respond to some of the issues raised by the ascription to a painting of a meaning quite unlike that of "a house" "a sunset," etc. It might be said that any crude drawing in colored crayons of a triangle, a circle, or a square would have the same content—"the nature and dynamism of color"—as the Museum of American Art's *Shoot*. However, the size and the magnificence of Noland's painting signifies this content in such a striking way that, unlike the crayon-drawn triangle, we sense the geometry and color in an exciting and lasting way. In *Shoot* color and form have been "made strange," released to stand as example in the way the Prague School formalists described.

To refine a bit further the meaning of *Shoot* stated just above, I would add a few more specific meanings, such as "rectangularity" and "triangularity." Another aspect of the meaning expresses the force of diagonal movement (as the contained color triangle, stretching the total ten feet of the top border, declines to a dimensionless point at the exact middle of the lower border). With the two right-angled triangles of unpainted canvas at the sides markedly set off against the darkest colored paint band, *Shoot* defines with startling clarity the concept "equilateral triangle." The precision of the shapes, mitigated somewhat at close inspection by the evidence of freehand painting, reinforces the ostended quality of geometricity, while the strength and intensity of the colors and the fact that their chosen hues, clearly avoiding the rigidity of pure primaries, play subtly with one another to give a very lush painterly quality to the work which contrasts with the kind of geometrical meanings produced by Mondrian.[9]

I have claimed throughout a kind of meaning signified by the choice and use of materials. Here we have first Noland's choice of canvas for a support. Painting, cutting, and stretching this canvas in the large sizes he

chose determined a basic meaning, for despite their size, these were paint-
ings, not murals: to be hung on a wall, not to be a wall. Second, Noland's
intense involvement with the paint itself—mixing dry pigment, experi-
menting with various acrylic bases to replace oil—gave his works the kinds
of colors and treatments that differentiated them from the kinds of visual
statements made, not only through Mondrian's imposed limit to primary
colors, but to Josef Albers's more academic experiments with colors in his
Homage to the Square series.

Group μ, the school of Belgian rhetoricians following in the tradition
of Saussure, Hjelmslev, and Jakobson, has defined the plastic signified of a
circle in ways that bear interestingly on my definition of meanings for
Noland's huge triangle (Group μ 1979: 173–92). At the end of an ex-
haustive analysis of the structure of a visual sign into a signifier and a sig-
nified and further into plastic and iconic aspects of both, the authors
define the denotational and connotational plastic signified of a graphic cir-
cle as respectively "circularity" and "formal perfection" (180). Thus, the
sense of what the authors take to be a proper signified of a nonfigurative
visual form agrees with the nature of the content we perceive in *Shoot*. In
both Group μ's example and Noland's painting, we are dealing with a sig-
nifier that gains its signifying force neither from convention nor from
iconicity.[10]

The materials and forms that artists pick up or borrow have a kind of
intransigence that determines the meanings that will be made with them.
Certain visual means exist and certain special problems confront them.
The problems are never completely solved—we never *fully* understand
space and color—and painting, fortunately, continues. The found and
constructed signifier, a huge inverted chevron, or, with Louis, perhaps a
trace of thin paint poured down an eight-by-twelve-foot canvas (the "un-
furleds"), presents itself as a tool for making meaning. Here the viewer or
user enters, taking this signifier-without-assigned-signification and "read-
ing" it as Jonathan Culler has shown how we read a verbal text (Culler
1975: 175). Not *any* meaning can be made from a given painting. In the
inexact terms of verbal description, *Shoot* will, as we said, confine its mean-
ings within a class defined by boldness and geometricity, but within the
play of signifieds possible here one could include, for example, a significa-
tion of the bold angular architectural experience effected by the New York
office buildings that surround the gallery area where the works of such
painters as Noland are usually displayed. Clearly, as well, signification of a

class of spectral color relations is also offered. Aspects of progression, important both in spatial and temporal terms, are signified through the alternation, already noted, of colors from the natural order of the spectrum as the bands of *Shoot* move from green to red. (This aspect will be heightened by rhythmic variation in the width of the bands—which then become thin stripes—when Noland turns to the horizontal paintings of his next period.)

Finally, in attempting to state the meaning of *Shoot,* I turn to a critic, Kenworth Moffett, whose perception of the content of Noland's paintings may profitably be added here since it defines and extends the spectrum of plastic signifieds which a "competent" viewer, equipped with the kind of intertextual references we have been claiming, will find in Noland:

> One might characterize the content of Noland's paintings as the tension between the splendor of color and its taut control, or between clarity and immediacy of presentation and the pictorial indeterminacy that results. In the horizontals, for example, the viewer relates colors vertically against the repeated horizontality, which pulls everything taut. . . . Tension, presence, openness, and ungraspability are the very structure of subjectivity, feeling and personal contact. (Moffett 1977: 85–86)

It has been the thesis of this book that the very matter and form of the artwork have meaning, that these elements mean even where no iconic signs refer to a content in the natural world. Now in this late chapter and in the presence of a purely nonobjective art work, it is imperative to confront the traditional objections to such claims. Many persons, both inside and outside the artistic community, will not accept the proposition that a nonobjective work such as *Shoot* can mean in anything like the commonly accepted sense of that term. Even Clement Greenberg, theorist and advocate for abstract art, had grave doubts about any specifiable content for such works (Greenberg 1967).[11] Michael Fried, who did one of the important early books on Noland and his compeers at about the time *Shoot* was painted, refused to name a specific content for this nonobjective school but did sum up his analyses with the note that the aspirations of the painters represented "are not toward purity, but toward quality and *eloquence*" (Fried 1965: 48, my emphasis). Of those who might grant meaning to the formal and material levels of art, many would not agree that such meaning would be of the kind that I have proposed.[12]

The arguments against ostended or "formal" meaning usually fall into the following categories. 1) No meaning is generated by a sign that is purely self-referential. 2) No meaning is generated by a sign whose reference is completely open, that is, a sign that can "mean anything." 3) If despite the above objections, meaning of some kind is generated, that meaning is so general as to be of little use.

To be clear about what it is that means, let me set out those aspects of the signifier that I take to function in the production of ostended meaning. First would be the nature of the material medium as that material has been worked by the artist: the shaped wood of Martin Puryear, the bodily movement of Martha Graham, the trumpet tone of Louis Armstrong. Following from this would be the formal relationships of the elements set forth in these materials: the relationship of the central triangle of Noland's *Shoot* to its enclosing rectangle, the relationship of the first six lines—the sestet—of Shakespeare's Sonnet 4 to its concluding octet. These ostended qualities and relations do, I claim, have meaning, meaning of the general kind of the "triangularity" ostended by *Shoot*.

The meaning I am proposing is not propositional, as such a statement as "Triangularity is good" would be. My proposed meaning is not symbolic in the sense in which Peirce distinguishes symbolic meaning from iconic and indexical meaning. In Peirce's trichotomy of sign functions, one would say that the word "triangularity" symbolizes the quality it specifies but does not ostend it, because the word, in its graphic or oral manifestations, is not triangular. This distinction is addressed by Eco in terms of "conventionally coded" and "intrinsically coded" signifiers. In the ostensive act, the qualities I have listed as parts of the signifier are "intrinsically coded" (Eco 1976:209–11; 226–27). That is, the large size of *Shoot,* the chevron shapes, the colors, etc. are themselves present. They are to be taken "as the intentional description of the properties recorded by the corresponding sememe" (Eco 1976: 226).

To take up the first objection listed above, that meaning cannot be ascribed to signs that are purely self-referential—as in the attempt to say that a triangle represents triangularity and a stone represents stoniness—I would argue as follows.[13] First, the eight-by-ten-foot triangle in *Shoot* is different from the concept of triangularity and hence functions as a genuine sign with a meaning, just as Mielziner's set for *A Streetcar Named Desire* is different from the concept of space that it signifies and that can be found in other sets and other visual expressions. Second, the example of

the stone is misleading. As in all "found object" aesthetics, the stone *could* be offered as an example of stoniness and, with some goodwill, be found to signify this quality. On the other hand, an artwork that has been carefully and intentionally crafted to present some affect ostends this in such a way that the artwork is both especially attractive and an especially well-developed example of its kind. Thus the objection that proposed formal meanings simply refer back to the individual work may be countered by instancing the recognizable and shared concepts that different tokens of a type of formal sign can be shown to ostend.

As regards the second objection, that no meaning is generated by a sign whose reference is completely open, it is certainly justifiable to claim that if a text—verbal, visual, gestural—cannot command a reasonable amount of agreement as to its meaning, then in fact that text has no meaning. Thus the notorious evidence of popular disagreement about meaning in art is taken to nullify any claims to its presence in that realm. One aspect of such apparent disagreement can be effectively countered by separating ideas of meaning from those of significance. This is a simple distinction, demystifying the fact that persons would agree on the meaning of "Flight 115 has been canceled" even though, in its personal significance, the text may cause either frustration or relief.[14] Thus personal significance or affective reaction is certainly a psychologically real aspect of the experience of an art work, but significance is not meaning in the sense I have been arguing for ostention, and its variousness does not count as a refutation of ostended meaning.

A different kind of disagreement used as evidence that formal meanings can "mean anything" hence effectively meaning nothing occurs when persons attempt to figure out what real-world item an abstract painting "represents." Despite its aggressive purity, *Shoot* could be thought to represent a line of speedboats and their wakes or geese in flight. Actually, I feel, these "representations" do, in an interesting way, direct us toward verifiable meanings. I take it to be the power, not the weakness, of the conceptual meanings ostended by artworks that *as basic conceptual metaphors* they get at the essence of meanings that find specific manifestations in sometimes contradictory categories. *Shoot* could be seen as a plunge to extinction—as the huge triangle descends to the lower border—or, if our gaze moves from the bottom upward, a rising and spreading of spirit. Although the meanings just expressed may seem to contradict and thus, in a verbal logic, to negate each other, the basic spatial/geometric perception that underlies the

metaphorical plunge or rise is the same. George Lakoff (1987) and Mark Johnson (1987) have described basic bodily concepts of space such as the concept of inside and outside, which, clear and precise on their own, can yet be meaningfully extended to support seemingly very different meanings. Though the inverted chevrons in Noland's *Shoot* do not, in a primary way, mean or represent "speedboats and their wakes," in their precise spatial determinants they will support—and clarify—such a manifestation of the experience of a spreading wave pattern. Thus I would say, in response to objection #2, that one would find agreement on the meaning of the basic formal concepts ostended *and* on the meaning of that seme in metaphorically extended examples, even though the literal meanings of the extensions may differ.[15]

A critic might go along with us so far as to acknowledge the possibility of ostended meaning, might allow that it commands the agreement of "competent readers," and yet hold, as in the third objection listed above, that such meaning by its nature is so vague as to be of little use. "Triangularity" can hardly run in the same communications race as even such a simple verbal text as "Tomorrow's performance will be canceled because of scheduling problems." The temporal relationships of "tomorrow" and "will be," the idea of cause, even the nature of "scheduling problems" are beyond the powers of the purely visual media. But as was clear above in the attempt to state a meaning for *Shoot,* the resources of the natural languages are themselves hard put to express what *Shoot* expresses. Further, the contents of paintings are not as imprecise as their translation into verbal terms would suggest. Even among the closely associated artists mentioned in this chapter, Noland, Louis, Olitski, and Frankenthaler have each contributed, as I noted above, a specific refinement to the spatial definitions being worked out at the time. They each cut out from the spectrum of geometric meanings certain distinct themes, just as, say, Hemingway, Faulkner, and Wharton each cut out distinct though related definitions of modern experience as recognized "themes" of their oeuvre.[16]

Such ostended meanings, as I have suggested for Noland's art, are essential to our conceptualization of experience, to understanding intellectually and physically the space we live in and the rhythm of the events of this living. As I sketch out in the next chapter, cognitive science is paying close attention to the way our neural networks are trained up in pattern recognition, a training in which the forceful and rich patterns of the arts play an important part. The neural biologist Semir Zeki, for example, has

found in visual art, and especially in the work of Mondrian, a direct reflection of the basic conceptual patterns used in visual comprehension.

It is one thing to argue epistemology with critics and philosophers; it is quite another to argue with the artists themselves that their paintings do not mean what they think they mean. However, in order to support the idea of formal meanings as based upon the work itself, I must differentiate ostended meanings from certain very appealing, wished-for meanings that, I argue, cannot be supported by any objective qualities of the visual text. I refer particularly to the kinds of claims made by abstract artists from Kandinsky to Rothko that their works express "spirituality." My remarks concern *kinds* of claims and *kinds* of possible meanings; they do not represent the specific claims of any one artist, for these varied widely from artist to artist, and even from one artist, the claims varied considerably over time. Rothko, for example, both encouraged and denied the ascription of religious meaning in his art (Chave 1989: 194).[17]

I will hold that whatever emotions may be aroused by an artwork, these affective reactions are not part of the *meaning* of the work. Thus I have no complaint when anyone says of a painting—as has frequently been said of the late works of Rothko—that such and such painting gives him or her a religious or spiritual feeling.[18] I do vigorously maintain, though, that such paintings do not have in themselves a religious or spiritual *meaning*.

The case of Rothko—along with Barnett Newman and Adolf Gottlieb—is particularly interesting for semiotics because it involves a shift from a symbolic art to an ostensive art. In the 1940s these men, who all believed that their works had some kind of "deeper" significance, found that their biomorphic forms, such as the suns, snakes, animals, etc., which they had incorporated as archetypal symbols, were failing to communicate the supposedly basic and universal meanings that the surrealists had banked on.[19] Thus Rothko, Newman, and Gottlieb deserted the failed symbols and gradually worked toward a nonobjective art where their intended expressions of spirituality culminated in Barnett Newman's series *Stations of the Cross* (1960) in the National Gallery of Art, Washington and Rothko's 14 paintings commissioned for the *Rothko Chapel* in Houston, Texas (1965–66).

It has been said by the artist and others that Rothko's late dark paintings express a tragic and violent religious struggle (Chave 1989: 180–82), yet nothing in the signifier, relentlessly stripped of the figural, can give such a meaning. To invest these canvases with a valid religious meaning, some working symbol must be introduced: some suggestion of a crucifix,

a mountain, a dove, etc.[20] Once the symbol is in place, we have a ready connection to a system of meanings that can be read back onto the formal qualities of the picture, for example in the late Rothkos: death, sin, redemption, fallen man. These are themes of a faith basically transcendental in its doctrines and developed outside the realm of plastic visual relations, hence impossible to be signified by them in any iconic way.[21] If some group accepted the rectangle with its four sides as a symbol of a Pythagorean religion involving the magic of the four elements, four seasons, and other such numerical doctrines, as we discussed in chapter 3, then, *to those people,* Rothko's great mysterious rectangles would definitely have a religious meaning. Without this symbolic reference, the paintings may in some way inspire the kind of feeling—awe, perhaps—that contemplation of the profundities of a religious creed inspire, but they do not convey a religious *meaning.*

If instead of transcending Rothko's lushly painted signifiers—the great classic canvases—we explore their material and formal values, the meanings concretely ostended there will fully make up for any loss of the dubious "spiritual" messages and lend clarity and definition to the conceptual structures that underlie such doctrines. At the level of material and the technique of its use, Rothko has continued the painterly approach of the 1950s abstract expressionist school. Especially in the kinds of overpainting on his rectangles and the feathered-out brushstrokes through which he blurs their borders, Rothko achieves an effect of glowing color spaces special to him, an effect sometimes seen in light-against-dark cloud formations. It ostends with great power the beauty wrought by technique from material—in this case, paint pigment. It is not, and was not intended to be, a copy of cloud formations; it does not mean "cloud formations." The meaning at this level lies in the glorification of the material components of our world. Such a proposition may or may not concur with the beliefs of some religion, but that would be a concern external to the picture itself.[22]

Using these materials, Rothko brushes in two or three large rectangles, one darker and larger or smaller than the other, that fill the space of the canvas except for a small border of what appears to be the background color. Formally these rectangles are delicately balanced by various relations of their size, their color, and the intensity of the paint. In the very late dark canvases, into which only blacks, grays, and some browns enter, the balance of these large "heavy" rectangles ostends, as formal relationship, a very powerful juxtaposition of dark and light plastic forces. This

juxtaposition of plastic forces, I would say, is the meaning of such a Rothko painting. It is a meaning powerful in itself, a new definition of dark and light. It is also a powerful basic metaphor for conceptualizing struggles of dark and light in ethical or religious terms: of gods and devils, death and life, as Rothko himself liked to think (Chave 1989: 182). But to transcend the painting to these *different* meanings is not to go from the "superficial" and "aesthetic" to the "real" and "meaningful" but to shortchange a basic meaning that could have clarified the supposedly greater meaning for which it supplied a springboard.

I have stressed that art succeeds upon its usefulness in conceptualizing aspects of the cultural continuum, adding that those concerns need not be the most obvious—"the noisiest"—of current discourse, nor need these be conceptualizable primarily in verbal language. In our century, nonobjective painting grew up exploring visual concepts of a technological and materialist environment, attempting in its "purity" to transcend the technological to the conceptual meanings of pure form, as with Kandinsky and Malevich, or to celebrate it, as with the devotees of the Bauhaus. Whatever may have been in the minds of the artists and their audiences, the freedom from figural content inevitably forced them to consider material and formal meanings. Now, roughly ninety years after its introduction and on the eve of a new century, two recent books, both expanded editions of exhibition catalogues, help to define what at the end of the century seem to be the means and the meanings of nonobjective or, less radically, simply abstract art. The first, *Repicturing Abstraction* (High et al. 1995), surveys current abstract art through linked exhibitions in three Virginia galleries and in essays—introduced by Arthur Danto—on the artists there presented. The second, Mark Rosenthal's 310-page, folio-sized *Abstraction in the Twentieth Century: Total Risk, Freedom, Discipline,* published by the museum, the Guggenheim, that introduced abstract art to America in 1939—lays out and sumptuously illustrates the history and theory of the movement.

In Rosenthal's "Conclusion" to this second book (Rosenthal 1996: 234–36), several of the concerns of the present chapter are touched on. On the positive side, Rosenthal remarks the apparent acceptance of nonobjective art as a recognized genre of painting, like the landscape or the still life. On the negative side, he reminds us of the objections raised in the name of various ideologies to an art in which any recognizable human subject matter is repressed. He also notes postmodern qualifications placed on the

"universality" supposed of primitive symbols, or simply "natural form," by artists down through Gottlieb, Newman, and Rothko. These qualifications are raised not only for philosophical reasons but in consequence of the nature of a viewing audience radically diverse in cultural background.[23]

As to the art of this present moment, both Rosenthal and the essayists in High describe its changes from the abstraction of the fifties and sixties as attempts both reverent and irreverent to deconstruct the paintings of the past, including the classics of the abstract school itself. They note postmodern gestures in which crude drawing and deliberate lack of "finish" alternate with the most elaborate and technically difficult appropriation of bits from older paintings, sometimes, as in the work of Joel Carreiro (High et al. 1995: 16), so disoriented as to provide a textural effect in what appears to be a nonobjective work.

To consider this scene briefly from the point of view of a semiotics of art, I would recall my point that abstract or nonobjective art, indeed the formal aspects of all art, do have meaning, certainly "human meaning," in that they are "about" those basic perceptual categories long known but now, as we shall see in the following chapter, being more and more clearly defined in the work of the cognitive scientists. Finally, complaints that nonobjective art is elitist and obscure are oddly answered by postmodern deconstructions whose usually parodistic "quotations" from past art, like any parody, require a knowledge not only of the art being quoted but of the cultural assumptions surrounding it. Surely this added level of symbolism must make such paintings more, rather than less, elitist. All that has changed is the composition of the elite group.

9

COGNITIVE SCIENCE AND THE SEMIOTICS OF ART

Study of the arts—literary, visual, aural, etc.—has always had some recourse to a notion of the creating/perceiving mechanism through which the aesthetic object is enjoyed. Now, at the end of the twentieth century, a burst of activity in the cognitive sciences seems to promise an experimentally verifiable picture of the mind/brain that, along with the regulation of heartbeat and the calculation of a slam dunk, creates for artist and audience the perceived artwork.[1] If we assume, in post-Kantian fashion, that our perceptions are not a simple mirror or window on the outside world but have been shaped by the apparatus that observes them, such shaping, such construction of the sign as perceived, must become of the greatest concern to semiotics and especially to a semiotics of the arts.

Two areas of art theory seem particularly dependent on a theory of cognition: those that involve some notion of deep structure and those that propose a learning function for artistic experience. I attempt here to outline three cognitivist schools—from what might be called the soft sciences to the hardest—whose doctrines weigh heavily upon these two areas. In this I progress from generally anthropological linguistics to the biology of brain architecture itself. In a study so structured, it is obvious that we enter a complex interdisciplinary area in which semiotics, as a study of the way in which we make meanings, occupies an ideal position to mediate the vast collaborative enterprise of cognitive studies and the study of the artworks that are the products of this cognition.

The idea of deep structure, taken as some organizing principle prior to the "surface" manifestation that is the everyday commerce of our perceived world, has intrigued the imagination from Platonic Ideas, to structuralist

langue and *parole,* to Chomskian grammar. As applied to art, the notion of deep structure evokes a vision of something that is more "natural," more "real," and thus more "true" than the vagaries of our changing world. Part of the mystery and the power of deep structure is the belief that it is innate to us and universal in our species. Though these roughly Platonic views have been countered by the belief that the so-called universals amount to no more than useful generalizations, recent cognitive studies have favored the Platonists, supposing some important basis of innate knowledge even while acknowledging the essential contribution of experience to fill out (or "train up") these very abstract innate structures.

It is in this notion of a training-up process that art can lay claim its educative power. Even those cognitive theories that assume a substantial endowment of innate knowledge take this to be more a pattern for learning than learning itself and therefore require some experiential stimuli to shape up the abilities we possess. (For example, feral children presumably endowed with an innate "mental grammar" never learn to speak properly if they have been deprived of linguistic experience in the early years [Jackendoff 1994: 120–22; see also Zeki 1993: 212–16 on visual deprivation].) Artworks, by their nature both highly patterned and so "distanced" from ordinary communication that these patterns are foregrounded, would appear to be ideal providers of the kind of stimuli needed for concept formation. Especially in neural network theory, we will see how this works out right down to the biological level. We will also see that not all new light is shining from the sciences down upon the arts, but that current art theory, particularly in its discrimination of cultural influences, has much to say about the learned versus innate problem, which the typically synchronic tendency of science tends to ignore.

Theorists have frequently turned to a basis in the human psyche for the patterns they detected in art. The American aesthetician Susanne Langer spent the last twenty years of her life seeking a source for her "symbolic forms" in an avowedly materialistic study of the mind (Langer 1967, 1972, 1982). C. G. Jung proposed his archetypes as an explanation for the patterns of death/rebirth, virgin/whore, etc. that seemed to pervade literature (Jung 1928). Moving from psychology to anthropology, we note the historical theories of scholars like Jane Ellen Harrison and Gilbert Murray (of the Cambridge Anthropologists) early in the century and the structuralist theories of the later century when anthropology met with linguistics producing on the one hand the work of Lévi-Strauss and on the other hand

that of Roman Jakobson. All had ultimate recourse to some kind of universal patterns of thought.

To bring this fascination with deep structure and its relation to a mind/brain processor down to the present moment, I have chosen three notable fields of cognitivist inquiry: structural semantics, as represented by the Paris Circle and its mentor, A.-J. Greimas; that American school of linguists like Ray Jackendoff, Ronald Langacker, and George Lakoff generally known as cognitive semanticists; and finally a group I loosely call neural network theorists like Gerald Edelman, Antonio Damasio, Semir Zeki, and Patricia Churchland (actually a philosopher with medical training). The most important theoretical formulations for these groups have appeared historically in the order in which they were just cited, from Greimas's *Structural Semantics* in 1966 to the works of the neural network group, who may be said to be pioneers in an enterprise only just evolving. As we shall see, these three approaches have at each advancing stage a more specific dependence on a knowledge of actual brain architecture and less to do with the cultural—specifically aesthetic—productions of the brain. All persons cited here would consider themselves to be scientists, though some might withhold this title from others on the list. Anyone familiar with the works I have abstracted from will realize how radically I have simplified their positions.

Of all our representative figures, Greimas was least concerned with a biological account of mental activity. The "Explanatory Note" prefacing his "The Interaction of Semiotic Constraints" describes his more Platonic concept of the mind's part in semiosis; "[W]e can imagine that, in order to achieve the construction of cultural objects (literary, mythical, pictorial, etc.), the human mind begins with simple elements and follows a complex trajectory, encountering on its way both constraints to which it must submit and choices it is able to make" (Greimas 1968: 48). This "generative trajectory," a process that lies at the center of Greimas's system, takes semantic material (in Greimas's system this material is strictly prelinguistic and indeed may not be linguistic at all, but may be previsual, pregestural, etc.) and combines it with the syntactic primitives of relations. As these primitives descend, they take on what Greimas calls "actorialization, temporalization, and localization"—that is, they take on the aspects of agency and placement in some kind of time/space context. In developing this trajectory, Greimas included the manifestation of values (axiology) and modes, explaining that, "ethnic literature . . . is often characterized by a

rigid moralization in which the *positive* versus *negative* opposition is invested with *good* versus *evil* contents, thus giving rise to the pairs of *hero* versus *traitor, helper* versus *opponent,* etc." (Greimas 1973: 108).[2]

The generative trajectory will get us from what we might—but Greimas would not—call the "idea" to the lexical manifestation, but it lacks any dynamic principle. This Greimas supplies with his "semiotic square." Here again we have an appeal to innate patterns of thought, though these smack much more of the logical than the neurological.

Working through his own studies in semantics and the analyses of Russian folk tales by Propp and of myth by Lévi-Strauss, Greimas expanded the structuralist binary opposition to the four-pole figure of the semiotic square. Thus the two-place relationship of contraries (male/female, life/death) is extended by adding the contradictions of the positive contrary pair, giving us "not-male" and "not-female." Filling out the logical relations represented in the square, we have, on the vertical axes, the relation implication, where male implies not-female. These relations are diagrammed in the familiar form below.

The true Greimasian analysis is a subtle and complex affair, as his own book-length analysis of Maupassant's short story "Two Friends" (Greimas 1976) will bear out. Here Greimas posits a square whose axes contain the contraries LIFE and DEATH, coupled with their respective contradictories NOT-LIFE and NOT-DEATH. Implication, on the vertical axes, is fulfilled with LIFE implying NOT-DEATH. The narrative dynamic launched by the square's logical force does seem to fit Maupassant's story

in which two middle-aged friends defy the German siege of Paris (the story is set at the time of the Franco–Prussian War in 1870–71) to hazard once again their prewar ritual of the Sunday trip. At the end of a pleasant day of fishing, the two are caught by the Germans, interrogated as spies, and killed for refusing to divulge a password, which in fact they did not know.

Given the logical scheme proposed, the opening paragraph seems the perfect manifestation of just such a deep structure, "Paris was blockaded, famished, a death rattle in her throat. The sparrows rarely appeared on the roofs, and even the sewers were being emptied of their regular tenants. People were eating—no matter what" (in Greimas 1976: xxix). With a slight Greimasian nudge, one senses right away the not-life in siege-struck Paris conflicting with the real death of the two noncombatant Frenchmen. One senses the constriction of surrounded Paris and the openness of the fields where the "two friends" fished. Of course war and not-war (static siege); plus before and during all leap to mind as structuring forces. In terms of the generative trajectory, one can easily see the "actorialization" in Maupassant's creation of the two friends as heroes and the Prussian officer as antagonist. It seems to work splendidly. Is it wrong or simply beside the point?

Behind the details of the journey: the fishing; who caught the first fish, a gudgeon; even a snatch of conversation in which Mr. Sauvage deplores the siege conditions with the comment, "Such is life" and to which his friend replies, "Say rather, such is death" (Greimas 1976: xxxii), the logical dynamics of the square seem to leap out forcefully. There is, I believe, useful knowledge to be gained from such an analysis. The structural understanding not only heightens the enjoyment of the story, giving, for example, much more subtle weight to the opening lines quoted above, but also, as I have held throughout this book, a sense of our patterns of understanding. We learn not primarily about Prussian soldiers and French civilians or about fishing, that is, not primarily about subject matter. What we learn is the way in which experience makes sense because we construct it in patterns similar to but not limited to the contraries and contradictions of not-life (Paris under siege) leading to the death that was a not-death, when the two very ordinary Frenchmen triumphed over the Prussian officer. We will return to consider some of the wider implications of this cognitive approach, but first I must complete my sketch of the three approaches.

Thus I want to move from Greimas, whose references to brain architecture appear respectful but distant, to the hard-core brain scientists by

way of a group of American linguists generally referred to as cognitive semanticists, or, with Langacker, cognitive grammarians. It would seem indeed that such cognitive linguists with their notion of a *constructed* mental representation would cast a particularly interesting light on a semiotics of art by helping us get at the ways in which the art object embodies the deep structure, the basic constructive principles of our human vision. Such, however, does not seem to have been the outcome. Despite a vast and interesting output of linguistic data, and with two notable exceptions described below, there is little that can be extended from the sentence-level linguistics of these scholars to the structure of the poem, the novel, or the dance. Greimas has certainly dared more.

Though there are significant differences among them, Ray Jackendoff, Ronald Langacker, and George Lakoff seem to pursue similar goals with similar instruments in works cross-referenced to each other. (In none of the works I have consulted, however, have these writers cited Greimas.) These "cognitive semanticists" are much more self-conscious about the new brain science than Greimas was—and of course have much more information on brain functioning than was available when Greimas was forming his theories in the 1960s—but they generally opt for theories that are "psychologically real" without pressing for confirmation in terms of the machinery that would run their programs.[3]

As far as the "cognitive" in cognitive semantics is concerned, the title of chapter 14 in Jackendoff's *Patterns in the Mind* states the goal baldly: "Language as a Window on Thought."[4] Since there is a good deal of evidence for the belief that mental representations differ from the objects that motivated them, linguists attempt to find in language the "mental grammar," the partly innate, partly learned structures forming these representations. The task for the cognitive linguist is to figure out what these mental representations are like and what effect the mental grammar has had on their construction (as, in a very crude analogy, our mental picture of a sunny landscape might have been constructed as "sunny" by a yellow tint in our glasses). The chosen source for researching this task is the study of our natural languages.

Such mental representations are described by Jackendoff as concepts, which for now we may simply call thoughts. The infinite number of concepts we might entertain must, for Jackendoff, be built up from a limited and innate number of "conceptual primitives" combined in patterns according to a "conceptual grammar." Thus, though the number of concepts

may be infinite, their nature can only be such as can be built with these blocks and in these combinations (Jackendoff 1994: 188, 191). It would obviously be of great importance to semiotics if these essential tools could be found. Unfortunately, Jackendoff is sometimes skittish when it comes to defining them. In his chapter entitled "What Is a Concept that a Person May Grasp It?" he offers as primitives the "ontological categories": Thing, Event, State, Place, Path, Property, and Amount (1992: 34). A function that involves these categories, such as a Change of Place, will be modeled according to the "Semantic Field" in which it is employed. Thus in the semantic fields of Spatial Location, Possession, and Ascription of Properties, "go" the common English verb that manifests the concept of Change of Place—in both the physical and nonphysical senses—would produce "John went to China"; "The painting went to the highest bidder"; and "The light went from red to green" (Jackendoff 1992: 37; 1983: 188–211). In this we are to consider sentences in which three Things, three Events (the "goings") and three Places all participate in a change identical at the cognitive level but, on the surface, differentiated by the Semantic Fields in which the Event took place.

As can be seen even from this brief sketch, the system is complex, with its seven primitives and its fields. It is also very language-bound and in language, strictly taken at the sentence level. There is not much here that can be extended to a semiotics of art (and perhaps that is as it should be). However, Jackendoff has, on other occasions, taken his theory of a mentally constructed universe into the fields of visual, social, and musical perceptions.[5] Jackendoff's work on music theory would obviously be of the greatest interest here, and I turn to this as a demonstration of the strengths and weaknesses of his position vis-à-vis the arts.

In *A Generative Theory of Tonal Music* (1983), Jackendoff, a gifted amateur pianist and Fred Lerdahl, a professional cellist, set out their theory of our musical experience as constructed through the intervention of an at least partly innate "musical grammar." They hold that, given an input of noises, this "musical grammar" will parse these into pleasing groups (that is, musical phrases) in terms of melody ("grouping structure"), metrics ("metrical structure"), and a sort of melodic-harmonic overall pattern ("reduction structure"). In this book the authors have presented a convincing and detailed refinement of traditional (Shenkerian) musical analysis based upon psychological theories of an innate mental grammar that Jackendoff has attempted to demonstrate in natural language perception. The process

assumes two psychological givens: a gestaltist tendency that operates in making pleasing groupings and a parallel processing brain that can make in real time the complex decisions about which patterns are operative in the heard piece (for example, what key should we be assigning to the notes just heard?). With this resort to parallel processing, Jackendoff has crossed into a realm of brain architecture we will be discussing in the next section.[6] An analytic technique thus cognitively grounded could presumably be extended to other arts, but Jackendoff has not, to my knowledge, attempted such analyses even in the linguistic realms of poetry or story. We are left, then, with a content of good gestalts with no reason, no meaning. As Jackendoff himself says, "it [music] only makes us feel good."[7] I have suggested elsewhere that the arts, including music and nonobjective painting, *do* mean and do instruct. I can only suggest here that musical gestalts such as "progression," "departure and return," etc. are meaningful contents of musical pieces and by their effective ostention in such pieces do instruct us in the subtle discrimination of these patterns as we struggle to make sense of our daily experience. I will in a moment call upon a neurobiologist to buttress my claim.

In the meanwhile, I want to look briefly at a kind of linguistic deep structure that might be more useful. George Lakoff's vision of the "embodied mind" locates basic and constructive concepts in bodies that experience balance and unbalance (falling), symmetry and asymmetry (in left and right hands), etc. (Lakoff 1987; Johnson 1987). Lakoff then develops a metaphorical system in which such basic-level concepts as "containment" give rise to conventional expressions like "being *in* love," "falling *out* of love" etc. Together with Mark Turner, George Lakoff has extended this cognitive exploration to metaphor in poetry (Lakoff and Turner 1989).[8] This is certainly interesting in its unpacking of common metaphorical uses (as in a detailed examination of what the authors call the life is a journey metaphor in Emily Dickinson's "Because I could not stop for Death" [Lakoff and Turner 1989: 1–11]), but as a specifically cognitivist approach it dwells too much in the realm of learned or applied metaphor, thus sidetracking the exciting possibility of getting at the very structure of poetry itself.

As we pass on to the neural network group, we reach that level of concept processing by the actual brain "stuff" that the previous scholars have sidestepped. Here I have focused on the strictly naturalistic or "reductionist" school—those who have reduced mental functioning to "It's all just

neuron firings"—in an attempt to ground deep structure and a possible learning function for art at the most basic level. From MIT in the East to the University of California at San Diego in the West, new techniques for brain imaging and modeling have increased our knowledge of this organ a hundredfold yet left us ignorant on some of the most basic questions. In a hotly contested field, some agreement seems to have collected around the following general points.

1. The hardware matters (Sejnowski 1995: 215–30). Unlike the computer/brain analogy proposed by early Artificial Intelligence theorists in which the brain was compared to computer hardware, which could indifferently run any software programs, the present feeling is that the biological architecture of the brain very much influences the form of its output. Thus, I would presume, the way in which the brain is set up to perceive, arrange, store, and put out information will influence the kinds of poems that get written, dances that get danced.

2. The brain, probably running as a parallel distributive processor (PDP), processes input—aural, visual, tactile, etc.—by comparing this input against a set of preexistent patterns both innate and learned. The fact that the brain seems to be a parallel processor accounts for the remarkable speed with which it, for example, recognizes faces—a task that would take the ordinary serial computer a very long time (Churchland and Sejnowski 1990: 232–33). Referring back to Jackendoff's theory of music, it also allows the brain, in the "real time" of hearing a concert, to compare and accept or reject the possible musical patterns of the ongoing composition. The brain is a "distributive" processor in the sense that input information is divided up and distributed to various locations where, for example, verbs, nouns, and the syntax which relates them are processed in different areas (Damasio and Damasio 1992).

3. The patterns the brain uses have a basis that is both innate and learned. In the first place, the kind of information we get from the world depends upon the nature of our cognitive faculties. We do not, for example, get the kind of sound-wave information that the bat gets. Here, again, the hardware matters. In the second place, "wired-in" knowledge appears to be more a program to learn in certain ways than a complete preexistent content. This program is in some sense "presemantic," a ground for arranging and using the semantic content that may arrive.

4. Whatever the mix of innate and learned—and no one now seems willing to go back to a behaviorist model in which no innate knowledge is supposed—experiment indicates that the neural networks by which we learn to understand language or even to see must be "trained up." They require both the wired-in propensity and the feedback from the real world, which, through back propagation of the new information, can correct choices in the process, thus strengthening those synaptic connections that allow us to prosper in our environment.[9]

5. Michael Arbib's schemas can provide a good picture of the way in which a connectionist parallel distributive processing network might search out the disbursed memory stores in the brain to form concepts of, for example, rectangularity, at the microcosmic level, to concepts of tragic drama at the highest level. It is important in Arbib's account—and missing in most descriptions of the much-used schema idea—that the author shows how these schemas could be instantiated *at the biological level* and grouped—or "connected"—for employment at higher levels (Arbib 1995).[10] Schemas are collections of data about things or ideas that would be called up to explain sensory stimuli (What is that rectangular thing out there?) or to develop an internal thought process (Do I need to go to the grocery store?). In the instance of the "rectangular thing," the schema for table, as one of the schemas that might be searched in the brain's parallel processing, would include straight lines and corners, flat top, legs, used for holding objects, etc. The thousands of schemas instantiating an experience of the tragic pattern would certainly involve, among many others, schemas of death, agency, and will.

As I discussed Greimas's Paris Circle and the American cognitive semanticists, I explored ways in which their approach had been applied to the arts. I find it interesting that the most extensive and specific application so far can be found here in the most "scientific" of the cognitive sciences. Semir Zeki, professor of neurobiology in the medical school at University College, London, has extended his very technical study of vision (*A Vision of the Brain,* 1993) to understand the nature and function of visual art. In doing so, Zeki has advanced a scientific basis for the existence of both an innate "deep structure" and a learning function for art. Zeki emphasizes again and again that seeing consists not of the passive reception of a scene but of the active construction of that scene. Specifically,

the brain "sorts" the input from the retina, screening out the vagaries of shifting illumination or points of view to give us what the scene itself does not—a fixed concept of—for example, a green chair. The brain, in Zeki's words, gives us "the essential," a view, he unblushingly admits in his Woodhull Lecture, that is deeply Platonic (Zeki 1996: 7). Zeki proposes that what the visual brain does is to present us with these constant and essential qualities, which other parts of the brain will categorize on the basis of their stored information as seeing a chair, a sofa, a horse, etc. From this point of view, what the painter does in his or her turn is to act as a kind of "super seer" using a brain—and hand!—more experienced and more trained but basically the same as that of the rest of us.

What we have so far leaves us stalled in a pseudo-Platonism fixed upon ideas of chairs, sofas, and horses: types easily derived from tokens. Zeki's greatest contribution, and the one most supportive of my argument, establishes the true visual essences as formal. Zeki's drive for visual "realism"—in the Platonic sense—follows the Cubists, Suprematists, etc. in shucking off the object for pure and universal Form. Thus he finds in Mondrian's squares those visual essentials that are visual essentials because they are the specific stimuli to a set of cells "considered by physiologists to be . . . the essentials of form perception" (Zeki 1996: 17).[11] If the formalist painters have ostended so effectively these formal essentials, can we not justifiably say that they are "teaching us to see," to see not just lines and cubes of course, but, through sharpened sensitivities in the basic pattern recognition cells, to see and understand the visual world at large?[12]

I have sketched very crudely three cognitivist approaches to knowledge. On the basis of this, what might we expect to gain for a semiotics of the arts from a further exploration of any of them?

Greimasian semantics—simple on the surface, very complicated in its interstices—is appealing in its theory of oppositions as narrative or dramatic basis, not a new idea, of course, but very effectively worked out *as a cognitive scheme* prior to experience. Fredric Jameson has effectively championed and demonstrated the approach in *The Political Unconscious* (1981). The manifestation of these oppositions in a set of characters (Greimas's "actantialization"), though it could be tidied up a bit from its too literal basis in Propp, works wonderfully in examining any "cast of characters."

On the negative side, the strengths mentioned above suggest that Greimas's is predominantly a narrativist vision that does not work as well

outside that genre. I feel, for example, that it has not served Eero Tarasti well in his study, *A Theory of Musical Semiotics* (1994). Further, the narrative oppositions, when extended onto the "Square" with contraries, contradictions, and implications, not only strain the imagination but run against current cognitive studies indicating that the brain is not a logical operator in the sense that Greimas's theory requires. Some modification of these patterns along the lines of the "embodied" conceptions advocated by Lakoff, Johnson, Damasio, etc. could help here. Finally the "generative trajectory," which is a wonderful way of imagining the Idea becoming text as it descends through various levels of materialization is, again, running into trouble with more recent conceptual theories such as those of Eleanor Rosch, which see conceptual categories as growing out from a middle or "prototypical" term like "dog," then moving both upward to the more abstract category, like "animal," and down to the more concrete, like "poodle"(Rosch 1978 and Lakoff 1987: 39–57). It is unfortunate that the Paris Circle and the American linguistic community have not had more contact.[13]

The American cognitive semanticists have established a scientific theory of language through a close examination of the lexicon and the grammar of natural languages taken at the sentence level. This has stressed both some sort of innate and possibly universal "mental grammar" and experience in some particular natural language to fill it out. One of the most frequent demonstrations of this hypothesis has been taken from the study of child language acquisition in which, according to the "poverty of the stimulus" idea, children could not perfect their speaking ability without the innate grammar as guidance, or, indeed, without the stimulus of language use, however poor it might be (Lightfoot 1990). Looking toward the arts—at least the literary arts—we get some support for the notion of a syntactic deep structure and at least the implication that literature as linguistic experience might help in training up our language capacities. Certainly these semantic/syntactic theories do not go nearly as far toward our understanding of story and drama as Greimas's theories do, though the Americans are probably on much firmer experimental ground. (It should be emphasized here that the scholars we have been dealing with are not operating the only language game in town.)

Where the cognitive semanticists move out to concept formation, schemas, and metaphor, as Lakoff and Turner have done, much greater promise awaits. Certainly the literary arts are built around thematic or imagistic clusters that might be thought of as vastly expanded schemas. A

thorough examination of the basis of such schemas in literary works would be a valuable undertaking. What literary theory does not need, however, is a duplication of its own considerable work on metaphor at the cultural level. It is no trick to figure out that "where the rubber meets the road" is a mapping—with alliterating *rs*—from the automotive semantic field onto some field in which a difficult task is about to begin. Where the cognitive scientist can help is to show how and with what possibly embodied and innate concepts such metaphors can meet the road in the first place.

The scientists working at the neuronal level of cognition have tantalizing yet incomplete information for us. We can accept with some certainty the accounts of concept formation as the brain checks input against the widely dispersed neuronal patterns that make up memory. The importance of this "thinking by pattern recognition" may well suggest a learning role for art as that sort of "information" that is most richly patterned.[14] But just as linguists have been leery of pushing beyond the sentence level of language study, we must be wary of "scaling up" from the level of immediate perception to that of the novel, the dance, or the symphony.

Semir Zeki's bold advance from the biology of vision—an area much better understood than that of language processing—to a theory of visual art is most welcome, and obviously so here in that it supports the major thesis of this book, that form is an essential *and* meaningful part of art. Such welcome news must be accepted guardedly, however, as we await the sure-to-come rebuttals to a view so Platonic and formalistic in an age that does not hold those qualities in high regard.

Finally, I think I can say that the fields of cognitive study reviewed here give at least tentative support to a form of innate deep structure and to a learning function for art. This tentative support, tempered with some much needed clarification, is most useful to a semiotics of art when it encourages those areas of analysis that the art historian has previously been barred from: the innate, the biological, bases of perception. On the other hand, contemporary theory of the arts does much better than cognitive science on the "learned" aspects of knowledge. Such "culturalist" theories may be seen here to restore the historical and cultural determinants of art's form and meaning. I would want then, to balance Zeki's valuable account of the determination of Mondrian's abstract style in the nature of brain circuitry with an account of the cultural determinations that, in early twentieth-century Europe, influenced that "purification" of art that made Mondrian feel his paintings could somehow knit up the chaos brought on by fascism.

CONCLUSION

Along with the signs that a culture produces to store its history and to carry on its daily commerce, it typically produces a set of signs considered to be works of art. Semiotically speaking, these latter signs occupy a very ambiguous place since it is possible to argue that if they have no meaning other than their own attractive being, they are not in the true sense signs at all. A red street light is a sign of considerable importance because it means "stop," a concept essential to the smooth flow of traffic on our crowded highways. In contrast, a Beethoven quartet or a Shakespeare sonnet are thought to have only their intriguing selves to recommend them. While some would credit poems and novels—but not quartets—with meaning, others—including poets and composers—would say that art should not mean but be, to paraphrase the lines from Archibald MacLeish's "Ars Poetica" cited earlier in this book.

The preceding chapters have argued that art works *do* mean and that these meanings are of a special and important kind, offering genuine knowledge. It even appears possible that the nascent cognitive sciences will prove that the experiential and cumulative knowledge provided by the arts "trains us up" in understanding those very cognitive patterns that recognize "stop and go," the spatial configuration of highways, etc.

My conceptualization of an argument for a meaning in art has depended on the body of semiotic analysis developed and honed by many hands but in my case dependent largely on the work of Peirce, Saussure, Hjelmslev, and Eco. While, in general, notions of a form/content split or of "aesthetic distance" have been around for a long time, the distinctions necessary to argue that form *means* were established convincingly for me only in recent work in semiotics. Looking ahead to what might be done with the system of analysis presented in the previous pages, I think that besides the fundamental and commonly accepted distinction between the sign's dual strata of signifier and signified, the concept of an unmediated continuum of matter and of content and the Peircean triad of icon, index,

and symbol have been the most useful. I have employed the continuum concept to support a creative and dynamic cultural sign production. Peirce's triad, especially the symbolic mode of signification, served as a basis on which I defined, in contrast, a kind of meaning making called "ostensive," a meaning by exemplification *in* the work, not external to it. This, I believe, is the kind we find not exclusively but most distinctly in the arts.

I have emphasized the culture's definitions of itself through its creation of art signs and, to highlight the diachronic nature of this process, have used examples taken from periods long enough in the past for us to sense the historical differences which gave those signs their special character. Following Clifford Geertz's warning against the purely formalist or the purely functionalist analysis, I have regarded artworks as materializing, in his words, "a way of experiencing, bringing a particular cast of mind out into the world of objects, where men can look at it" (Geertz 1976: 99). Here, in the Conclusion, I want to use the semiotic categories just described to offer some notes on the situation in which the American culture and its arts find themselves at the end of a century during which society and art have both changed so radically.

The initial explication of these semiotic categories was accomplished with examples of works of art like poems and nonobjective paintings that foregrounded the formal rather than the referential nature of their message. On the other hand, in most artworks, and probably in the most popular of artworks, the content would be prized before the form if indeed the form was recognized at all. The kind of content conveyed in the symbolic mode weighs heavily on us, as indeed it should, for civilization depends on this mode's powerful ability to instruct, to record, and in effect, to "get us to the church on time." Faced with a rapidly expanding and, in its expansion, more and more differentiated world, we seek information at a time when information technology, as in the case of the sorcerer's apprentice, heaps on us more information than we can possibly handle.

An important part of the information that has been taken up in the arts and by those institutions that exhibit and study the arts has to do with a new kind of "otherness" that the availability of so wide a spectrum of information on different people has made available. Here, I feel, the notion of an undifferentiated continuum of content is effective in locating a great sea of ideas from which the inevitable—and probably quite healthy—conflicts of different peoples, in closer contact and in greater numbers than

ever before, stimulate the creation of signs that define and hence deal with these important forces in our culture. As everyone reading this book will recognize, this kind of information has been categorized informally but effectively as dealing with that new person called "the other," and otherness has been neatly categorized by its place in race, class, and gender.

I have no problem with this; the categories have been elaborately defined and theorized in a large and interesting body of works. Where I would want to enter the discussion would be in that area where the arts serve as subject matter—primarily, that is, in museums and in classrooms. Here my quarrel would be with the tendency to let the obvious symbolic content that tells us of discrimination, persecution, and poverty—bad things, indeed—drown out a consideration of the material and formal meanings these works possess; in brief, I address the "tyranny of the subject." I would look for meanings not in place of the very important information on discrimination, but meanings along with that information that can suggest narrative shapes, linguistic devices, even—where the work is in another language or in a colonialized English—in the meaning of the very verbal matter itself. I feel sure that such meanings are being taught, but descriptions in book catalogues and a skimming of contemporary journal articles foster doubt.

As the institutional interpreter goes in a search of the signs that will tell us of this diversity, this otherness, he or she naturally turns to the novel rather than the string quartet, for the novel—as *verbal* discourse—means easily and literally in the symbolic mode, which ordinarily gets us to the message without overmuch concern with the medium. (Actually many language and literature departments now go beyond the novel to film, advertisements, performance art, etc., but these signs tend also to be explored primarily for their symbolic meanings, which turn out to be much the same as those found in the novel.) Since artworks come with no warning against the use of the product in a manner inconsistent with its labeling, novels may be mined for whatever minerals might possibly be sought there. This amounts in many cases to the literal information they offer on the social psychology of the race, class, or gender represented. This information then is refined in discussions, articles, and books on "The Construction of the Self in the Chicano Novel" or "Sexism as Constraint in the Novels of . . ."

These novels, films, travel books, etc. are complex signs in which the persons, events, and ideas symbolized may be analyzed in many ways,

including that which describes the fortunes of, let us say, ethnic minorities in some sociopolitical paradigm of the power structure. That is, they are analyzed for their literal content as accounts in which a woman becomes conscious that her selfhood has been sacrificed to conventional family life (*The Awakening*) or an African American finds that, in relation to the dominant culture, he is The Invisible Man. These accounts, and many both older and newer, provide the material for sociological hypotheses, that in turn guide the interpretation of the stories that had suggested and now support them. The *meaning* of the novels is taken as and generally limited to the exposition of the sociopolitical forces that subjugate the minority in question. The novels become case histories. The linguistic signs have done their job, providing interesting and persuasive evidence for a complex, closely reasoned, and absolutely essential theory of otherness. The "crossing of boundaries" from literature departments into the realm of the sociologists, historians, and political and economic scientists is not necessarily bad, for the disciplinary sophistication the human sciences can bring is welcome.

My point here, and in this book generally, is that consenting to sole concentration on the symbolized, literal meanings by those departments devoted to the study of the arts is to let pass a meaning not "formalist" and abstract, as, indeed, the sociopolitical meanings are, but redolent with the material and patterns through which any human understanding is generated. The kinds of meanings I am arguing for are not easy to describe, since they are not represented in the symbolic mode of classroom instruction, which the literal content of the novels share. But they make the difference between understanding and knowledge.

The kinds of meanings I have in mind include the meanings of the very materiality of the language from which the novels are created. Not only are novels now being written in such indigenous languages as Tagalog and Urdu, but grounds for the study of such linguistic matter present themselves in novels in a "colonialized" English by persons whose native tongue may have been Spanish or an Asian language. Again, at the level of the meaning of the matter, interest in an *écriture féminine* has ebbed and flowed, but continual complaints about phallic, linear, aggressive styles must imply the existence of some other linguistic means, and, to a feminist *écriture* must be added the possible material bases of a black or queer writing. Although the materiality of the linguistic material is hard to analyze and convey, especially where, in so many cases, translations must be

used, the move mentioned above to film, performance arts, etc. brings in a very rich materiality pregnant with ostended cultural meanings. (The sculptures of Martin Puryear discussed in chapter 2 are an excellent example of such meanings.)

Turning to the content side of the semiotic system outlined in chapter 2, the meaning of the form of the novel—a second-level meaning dependent on the first-level decoding of the meaning of the words—is probably most obviously and most valuably located in narrative form: the way the story is told, the way events and characters are constructed by author and reader from the raw content material of agency and action. Here the postmodern uncertainties undermine the linearity of plot and blur the identity of the narrative voice. Years after historians, nudged by Hayden White, began to consider that histories are not found but constructed, literature departments, whose theories enabled such thoughts, are still instructing workers in the human sciences. We cannot let these formal meanings be dissolved in the obvious lure of formless accounts of the fascinating sins of the world.

Considering the last formal meaning described in chapter 2, the meaning of the form of the content itself, it would be valuable to point out the currently popular use of satire, in which the content plays upon and mocks an understood intertextuality of "classical" elements in the way that postmodern architecture "quotes" classical columns, peaked domes, etc. Such an ostended content must deeply qualify the literal signified content of any story. A culture needing to signify its concepts in this manner seems to be expressing the anxieties of diversity in the constant satiric references from text to text, from the high point of "modern" times to an equivocally remembered tradition.

In concluding, I want to turn away from the novel and to turn back in time, back to the work of Ben Shahn, whose painting *Liberation* (1945) I cited in chapter 7. Shahn is useful here because he is thought of as a painter of content, a painter whose political involvement in the 1930s and 1940s inspired his Sacco-Vanzetti series, labor union posters, and WPA murals, all featuring a humanity of clearly mixed ethnicity. These works represented in his time the discourse on race, class, and gender I have just been talking about. Shahn, who described his views of art in Harvard's Charles Eliot Norton lectures, had little faith in pure abstraction and held firm for a deeply human expression, not "general" but in some way "universal" (Shahn 1957: 45, 55–58). Yet he reverts again and again to the

matter, for there the work begins: "The painter who stands before an empty canvas must think in terms of paint. . . . his inner images are paint images, as those of the poet are no doubt metrical word images and those of the musician tonal images" (1957: 49). Turning to form, Shahn says, "For form is not just the intention of content; it is the embodiment of content" (1957: 70). Certainly no one could be thought less a dilettante than Ben Shahn, no paintings less empty than his paintings of coal miners and cotton pickers or of the war's devastation in his beloved Italy. But *Liberation* (plate 6), beyond its content, is certainly a "paint image" achieved with a very sure handling of the tempera medium, which yields the textures of the walls of the bombed-out apartment building, the dark figures of the children against the scrubbed-in stretches of sky, and the rubble that provides a contrast and a ground to the rest. The "paint image" constructs the content of the form ostended by the spacing of the child on the right, swung way out from the pole and set high against the textures of the building. This quality of lift and flight created by the formal placement of the figures on the canvas means for us the essence of the liberation that its title signifies. If we leave the material and formal values behind for the signified content—the end of the war—how empty and abstract this painting becomes.

NOTES

INTRODUCTION

1. This familiar example is borrowed from Jakobson's famous statement at the Bloomington Conference on Style. See Jakobson 1960: 357.

 Though I have tried to avoid terms whose meanings are not reasonably common to the contemporary discourse on theory, I have kept *ostention* as the name for a special kind of production of meaning by exemplification. Since a considerable part of my argument hangs on the proposal that ostention is a particular kind of sign process, the very unfamiliarity of the term will, I hope, enforce the idea that there is something about meaning in the arts that has not been covered under the customary approaches. The term will be widely discussed and demonstrated in the chapters to come.

2. In the Whitney catalogue for this show, Lisa Phillips notes that "formal invention has taken a backseat to the interpretive function of art and the priorities of content" (Sussman et al. 1993: 55).

3. For material on the "new formalism," see *A Formal Feeling Comes: Poems in Form by Contemporary Women* (Finch 1994). A critique of the National Museum of American Art's show—censored even by Congress—may be found in "Political Correctness: Art's New Frontier" (Ringle 1991). The Guggenheim show of abstractions is elaborately documented in its catalogue (Rosenthal 1996).

CHAPTER ONE

1. We seem to be in even deeper trouble when a musician himself says, as Stravinsky does, "Music is, by its very nature, essentially powerless to *express* anything at all . . ." (Stravinsky 1936: 53). The argument that music means only itself may be pursued in Kivy 1990, while Treitler 1995, as described below, holds for expressive content *in* the music.

2. A convenient summary of this structuralist doctrine of the functional and the nonfunctional aspects of the signifier may be found in Culler 1975: 8–12.

3. Goodman's "exemplification" strikes a little closer to the meaning I wish to convey than does Eco's "ostention." For further illumination of Eco's meaning of ostention as the exhibition of a token of its type, see his discussion of the "drunk" exhibited at Temperance meetings (Eco 1977: 107–17).

4. In a strictly Peircean scheme, no addition of a *fourth* sign mode would be possible, since his categories—always in triadic sets—are based on notions of firstness, secondness, and thirdness.

5. On this same ground, I take issue in chapter 5 with the ambiguities involved when Michael Shapiro claims that a high proportion of open vowel sounds in a Shakespeare sonnet is iconic of a verbal content of freedom (Shapiro 1998).

6. The traffic light as example of sign systems has served in many instances. Two interesting and different usages may be cited. Edmund Leach employs the example in his monograph on Lévi-Strauss (Leach 1974: 16–21). Harald Haarmann uses traffic signs of a more complex kind to demonstrate the cultural embedding of even such supposedly universal symbols (Haarmann 1990: 7).

7. Though his early work, especially the *Elements of Semiology* (Barthes 1964a) and *Empire of Signs* (Barthes 1970), aligns itself carefully with semiotic distinctions and terminology, this is much less the case as the work progresses.

8. Critics of this important article by Barthes from *Communications* 1964 include Alain Picquenot (1983), who criticizes Barthes's "linguistic imperialism" but does not consider the possible semiotic significance of the plastic values themselves and Jean-Marie Floch (1985: 14), who criticizes Barthes's failure to deal specifically with the meanings of the plastic forms. Floch deals extensively with such meanings in a chapter devoted to advertisements (1985: 139–86).

9. Mondrian's most explicit comments on this subject may be found in the article "Liberation from Oppression in Art and Life," started in London during the Blitz of 1939 and finished in America in 1940. It was first published in Mondrian's *Plastic and Pure Plastic Art* of 1945 (Holtzman and James 1986: 320). Some of the tone of this passionate argument may be gleaned from its first sentence: "In the present moment, oppression is so clearly evident that everyone must regard it as one of the greatest evils," followed later in the essay by "Art is the aesthetic establishment of complete life—unity and equilibrium—free from all oppression. For this reason it can reveal the evil of oppression and show the way to combat it." A hint at the way Mondrian sees abstract art working toward his goal follows: "Plastic art establishes the true image

of reality, for its primary function is to 'show' not to describe" (Mondrian 1945: 322–23). For Mondrian's "show," I would substitute "ostend" in the present context.

David Carrier raises some of the issues of abstract art as political in "Piet Mondrian and Sean Scully: Two Political Artists" (Carrier 1994: 255–67).

CHAPTER 2

1. Where the technical nature of the discussion requires a clear distinction, between 1) a word or phrase designating a sign vehicle, 2) a word or phrase designating the content of that sign vehicle, and 3) the object which corresponds to both the cultural unit and the sign for that cultural unit, I have resorted to the graphic conventions used in Eco's *Theory* (1976: xi). Thus /stop/ with the use of single slash marks designates the sign printed, spoken, gestured, etc. {stop}, with curly brackets, indicates the concept signified, that is, the idea of coming to a halt. //stop//, with double slash marks, indicates a referral to an actual physical instance of the halting. (Roughly put, curly brackets indicate designation of a type, while double slash marks indicate a token of a type.)

 In the following, the appropriate graphic marks have been used to designate the usage categories:

 a. The word /cat/ has three letters.
 Little Nancy's /cat/ is very crudely drawn.
 b. The {cat} is a very proud animal.
 c. Get that //cat// off the sofa!

 Since absolute consistency in the use of this convention throughout the manuscript would be awkward, I use it only where the distinctions it enforces are of special importance.

2. European analyses in the structuralist tradition of semiotics, motivated by the desire for a scientific methodology, depended heavily on such "complete" and presumably objective tabulations of every feature of the text. Examples may be found in Greimas's *Essais de sémiotique poétique* (1972) and in the early issues of the French journal *Communications,* which from 1964 published much of the work in this area.

3. These just mentioned paraphrases for /help/ would count as Peircean "interpretants": such approximations to the signified meaning as narrow, but never quite close, the gap between signifier and signified. See Eco 1976: 68–72.

4. Both Greimas and Eco derive a good part of their theory of sign production from Hjelmslev. While both authors mention Hjelmslev frequently,

sections referring specifically to the matters under discussion here may be found in Greimas 1966: 27–28 and Eco 1976: 51–54.

5. In form/content schemes that follow Hjelmslev, even at a distance, the usual term for the signified on the content plane is substance. To address someone who is not necessarily enmeshed in the Hjelmslevian kind of semantic arguments, it seemed easier to say /meaning/ when I meant {meaning}.

6. I have reverted here to the example cited in the Introduction, Jakobson's "Closing Statement: Linguistics and Poetics" for the 1958 conference on "Style and Language" arranged by Thomas Sebeok. See Jakobson 1960: 357. Eco quotes the example but does not attempt to put a meaning to its formal qualities (Eco 1976: 309, n.39).

7. The relationships among signifieds exploited by the New Critics were typically found in image schemas. Cleanth Brooks, for example, suggests a relation of paradox between the unexpected strength of the "Naked . . . babe/ Striding the blast") and the weakness of Macbeth's false "cloak of manliness" (*Macbeth* 1.8.21–22). ("The Naked Babe and the Cloak of Manliness" in Brooks 1947: 45).

8. This description of the level at which meanings such as {tragedy} are produced may be compared to the famous phenomenological description of the "strata" provided by Roman Ingarden (1965). René Wellek describes these strata in the *Theory of Literature* (Wellek and Warren 1949: 152, 157), an interpretation renounced by Ingarden in his 1965 preface to the third German edition of *The Literary Work of Art* (Ingarden 1965: lxxviii–lxxxiii).

9. This motivation to work out cultural problems in all sorts of sign-making enterprises—widely explored in anthropological studies—was at the center of Lévi-Strauss's mythology from the time of his work on the Oedipus myth (Lévi-Strauss 1955).

10. This idea and its continental sources are summarized in Culler 1975: 26–31).

11. I have described elsewhere (Barry 1960) the pedagogical techniques used and the different kinds of improvisations favored by Stanislavsky Method training in acting studios of the period. The deep psychic structure of Method improvisations owed a great deal not only to such American phenomena as racism and red hunts but to the memory of European fascist persecution. I witnessed many improvisations in Manhattan studios in which the "plot" involved émigrés and border guards attempting to carry off—or to thwart—a flight from terrorism to freedom. Tennessee Williams's *Camino Real* reflected just such a cultural anxiety in its prominent "Flight of the Fugitivo" sequence.

12. I maintain with deep belief that such a museum is of incalculable value to every age *but* that the meaning of its objects, profound as this may be, is first of all the meaning of another time.

13. The "somehow crippled" female—literally crippled in Laura Wingfield's case (*The Glass Menagerie* [1945]), emotionally crippled in the case of later heroines such as Blanche Du Bois in *A Streetcar Named Desire* (1947)— was compelling enough in its meaning to become a theatrical type known as the "character ingenue." The emergence in those years of such a definable type from the scripts of Williams and his imitators, combined with the specifically trained and cultivated physical characteristics of actresses like Julie Harris and Geraldine Page, offers a perfect example of the creation of a cultural unit.

CHAPTER 3

1. Use of the word "emblem" in the context of sixteenth- and seventeenth-century studies plunges us into a sea of contested definitions. In these special fields, the technical sense of "emblem" was usually tied to the so-called emblem books, collections, like those of Geoffrey Whitney's *A Choice of Emblemes* (1586) in which appeared a picture, as of Fortune turning a wheel, together with a motto and a verse or short prose text explaining the motto and its visual presentation. For our purposes "emblem" will be used much more loosely and will refer to those kinds of visual signs presented either visually or described in words and which are, like the Wheel of Fortune, conventionally related, usually metaphorically, to the moral concept involved. Our concern is not with the history of the emblem, but with the fact that these popular devices could be so useful semiotically to communicate the culture's notion of the nature of life. For a well documented discussion of the nature and use of emblems in the sixteenth and seventeenth centuries, see Daly 1979.

 Though I do not develop it in this chapter, one must always keep in mind that tradition of iconography applied to medieval and Renaissance visual symbols in the works of the Warburg and Courtauld Institutes. E. H. Gombrich summarizes much of this material on Renaissance attitudes toward the interpretation of visual symbols in an appendix "*Icones Symbolicae:* Philosophies of Symbolism and their Bearing on Art" to his *Symbolic Images: Studies in the Art of the Renaissance* (1972).

2. Three books have been especially helpful in gathering material, supplying detailed documentation, and providing illustrations of the Ages of Man: Chew 1962, Burrow 1986, and Sears 1986. Chew's examples date from the mid-fifteenth century through the seventeenth and are frequently

much more artistically sophisticated than the earlier examples found in Sears or Burrow. Sears's heavily annotated book deals with materials from the early medieval period up to the age of printing. Burrow's treatment is a more literary/cultural one, particularly interesting for its section on Time. In addition, Patch (1927), whose book is really about Fortune, does have a very interesting chapter on the goddesses' wheel. Of Patch's thirteen illustrations—most not repeated by Chew, Burrow, or Sears—all but two show her with a wheel.

3. In *Henry V,* Act 3, scene 6, the soldiers Pistol and Fluellen (a captain) discuss Fortune's wheel, and the latter furnishes a quite detailed description of the icon and its meaning.

4. A relatively rare example of an ages scheme spelled out in the life of a woman is supplied in a four-ages scheme by Dante, *Convivio* IV, canzonne terza; quoted in Sears 1986: 103.

5. The fascination with great wheels and their quadrants appears in modern times in W. B. Yeats's *A Vision* (1925).

6. A section from Ptolemy (second century A.D.) describing the seven planets and their seven ages may be found in the appendix to Burrow 1986.

7. Burrow cites a study of nineteenth-century French peasantry to support his point about the arbitrariness of counting age by birthdays (Varagnac 1948). Philippe Ariés, a French demographic historian, makes the same point about the existence of societies in which persons have very imprecise knowledge of their age (Ariés 1960: 15–18). Ariés's comments on the problems of translating the Latin names for the ages supports, with French examples, the same difficulties described by Burrow (Ariés: 25–29). The Latin *puer* and *adolescens* do not, for example, find any ready equivalents in the French *bébé* and *enfant* (the latter of which is used even for soldiers, as one can note in any French military cemetery).

 The heated controversy that has followed Ariés's claim that childhood, in anything like our own sense of the term, was absent from the medieval mind is effectively chronicled in Schultz 1995: 1–20.

8. For verb tenses and phenomenological time, see Ricoeur 1984: 2.61–77. The marking by grammatical forms, such as Latin inflections, of the universal experience of temporal differences was much on the minds of the medieval, linguistically oriented philosophers (see David Herman's *Universal Grammar and Narrative Form* (1995: 5–7).

9. Lydgate's manuscript (ca. 1438) was sent to his patron Humphry, Duke of Gloucester "Voide of picture and enlumynyng" (Lydgate ca. 1438: Book 9, line 3591).

10. The identification of Fortune and hence of her motivation for the particular turn of the wheel was a consideration carrying considerable teleolog-

ical concern for those whose fate lay in her control of the wheel handle. W. R. Elton in *King Lear and the Gods* (1966) describes, with many citations, the principle positions that Shakespeare's contemporaries would hold toward the intertwined notions: Fortune, Nature, Chance, and Providence. Rolf Soellner, writing eighteen years after Elton, describes the thematic implications for *King Lear* of several Wheel of Fortune emblems he had collected (Soellner 1984).

11. Material on Boccaccio's and Laurent's texts as a basis for Lydgate may be found in Henry Bergen's Introduction to the Early English Text Society reprint (Bergen 1924: ix–xxvii).

CHAPTER 4

1. Some authors as late as the end of the sixteenth century saw the wheel as appropriate to the form of tragedy while still grappling for a way to incorporate a larger degree of self determination into the genre. Evidence of this may be found in Thomas Storer's three-part division of his *The Life and Death of Thomas Wolsey Cardinal* (1599): "*Wolseius aspirans,*" "*Wolseius triumphans,*" and "*Wolseius moriens.*" As Farnham comments, "Thereby he marks sharply the outlines of that pyramid of tragic ambition, or of tragic embracement of the world which even so early as Boccaccio is indicated as the most naturally effective structural form for *de casibus* tragedy. There is first the incline upward, then the apex of triumph, then the slope downward to calamity. The traversing of the pyramid corresponds to progress around the circle of Fortune's wheel" (Farnham 1936: 329–30).

2. The quotation is from Campbell's introduction to her edition of the *Mirror*. She describes there the very complicated history of the gathering and printing of the stories. Suffice it to say that for many of the stories the dates of composition and the author are not definitively fixed.

3. In this Protestant time, the problem of where these ghosts were when they talked with Baldwin raised no little concern. See the prose link on page 346 of Campbell's edition.

4. Sackville, the highest placed of the *Mirror* authors, had bitterly denounced the traitorous mob in the fifth act (presumed, on the evidence of the title page, to be his, not Norton's) of the Sackville-Norton, *The Tragedy of Gorboduc* (1561–62).

5. When rule depended on genealogy, not election, readers of the *Mirror* and later, spectators at Shakespeare's *Richard III,* would have been acutely aware that their ruler, Elizabeth I, was the direct descendant of characters depicted there. Thus these stories as well as those in the various chronicles—Fabian's, Hall's and Holinshed's particularly—had an

important semiotic overcoding of the documentation of divinely or-
dained power. This was so much a recognized meaning that in the mid-
dle of the book, the *Mirror* authors reaffirmed their specific purpose of
offering examples to dissuade from sin and warned, on the other hand,
that no man should "thinke his title eyther better or wurse by any thing
that is wrytten in any part of thys treatyse" (prose link 20, Campbell
1938: 267).

6. For the history of the *theatrum mundi* concept, Curtius 1948: 138–44 is
frequently cited, though in his rapid survey from Plato to Hofmannsthal
the actual physical referents of *histrionem, scena, comoeda,* etc., when used
by such writers as Augustine or Boetheus, are much more questionable
than in the time of Shakespeare. See also Anne Righter 1962: 59–62 and
Julia Briggs's *This Stage-Play World* (1983: 195–96). The histrionic basis of
life has taken on a new importance with the publication of Stephen Green-
blatt's *Renaissance Self-Fashioning* (1980).

7. I am not concerned to argue for these wheel stories as possible sources for
Shakespeare's works; Fortune's Wheel was, after all, a commonplace of the
time and as such is scattered through the works. Spevack's Concordance
(1968) lists eleven explicit references to a Wheel of Fortune; many more
references in the works are implied, as in the sections of *Richard III* we ex-
amine below.

 Clemen (1957: 184) cites R. Chapman "The Wheel of Fortune in
Shakespeare's Historical Plays," (1950) as claiming a central role for the
wheel. Clemen himself is more cautious, as am I.

8. In his note on Margaret's first two lines (4.4.1–2), Hammond (1981) re-
marks on the contrast of this autumnal image with Richard's "glorious
summer" in the second line of the play.

9. Clarence's fortunes in the play have a just claim to wheel- story status and
were so treated in Tragedy 18 in *The Mirror for Magistrates*. I have, some-
what arbitrarily, not considered the Clarence story, since Clarence had no
real high point in the play itself and because the long scene of Clarence's
death (1.4) depends more on dream-vision form than on the wheel.

10. Essex's speech is quoted in G. B. Harrison 1937: 323. See also J. A.
Sharpe, "Last Dying Speeches: Religion, Ideology, and Public Executions
in Seventeenth-Century England," *Past and Present* 107 (1985), 144–67.

11. An especially interesting glimpse into the life of a woman in somewhat the
same circumstances as the Duchess of York exists in the letters of her
granddaughter-in-law, the Viscountess Lisle. In these letters, the Vis-
countess, second wife to the bastard son of Edward IV, gives a very lively
account of how she managed not just the logistical details of a grand es-
tablishment but the intricate political details of the placement of her chil-

dren in the great homes of others and the management of other aristocrats' children in her own court (Byrne 1981: I.26–37 ff.).

12. Material on the historical persons represented in *Richard III* has been drawn from Clemen 1957: xv–xxiii.

13. The laments of the women in *Richard III* gain signifying power for the more literate in the audience by their echoes of the laments of the women survivors of the Trojan War as depicted by Euripides and especially by Seneca in his *Troas.* Hecuba would equate to the Duchess of York and Andromache, Hecuba's daughter-in-law to Elizabeth, daughter-in-law of the Duchess. Anne corresponds to Polyxena, and the foreigner Helen to the French Lancastrian Margaret. In both cases a long and devastating war has left widows and mothers lamenting three generations lost. The Trojan episodes would have been familiar to the Elizabethans not only from their classical education but from their belief that they themselves descended from this stock through Aeneas, whose descendants, notably Brute, were thought to have inhabited England. Seneca's tragedies were readily available in Latin and, from about 1560, in a somewhat adulterated translation by Jasper Heywood. For the details, see Harold Brooks (1980).

14. Background and precedent for the laments in *Richard III* are provided in "The Dramatic Lament and Its Forms" in Clemen 1955/61: 211–80.

CHAPTER 5

1. The present sketch for a semiotics of poetry must acknowledge, among all the previous work done, from the Russian formalists through the Anglo-American discourse analysts, the work of the Paris School centered on A.-J. Greimas. This intensely analytic method given to taxonomic tables and algebraic formulas probed deeply into the relations of poetic signifier to signified. The method prescribed an intense focus on generative principles—especially those that projected a binary opposition—from deep structure to complete textural manifestation. The collection of ten essays gathered and introduced by Greimas (*Essais de sémiotique poétique* [1972]) may be considered the classic casebook for the school. My account here presupposes the analytic techniques of these "structuralists" and, in general, the theory on which they were drawn up, though the pervading emphasis on binarism seems, in light of recent cognitive science, to be too rigid. (See chapter 9 of this book.) In short, something like these Greimasian analyses could profitably support the points I make in the present chapter, but to achieve some reasonable compression, I eschew the complete textural analyses for a few examples of formal devices that seem best to make my points.

2. See Eco 1976: 163–68 for one semiotically oriented analysis of the relationship between the word "cat" and the supposed real-life referent.

3. Louis Montrose's essay, "'The Place of a Brother' in *As You Like It:* Social Process and Comic Form," is very informative about the importance of inheritance to the life of the young male, especially, in Montrose's piece, to the younger brother, who ordinarily found himself with very little after the first son got his share (Montrose 1981).

4. Thomas M. Greene's essay, "Pitiful Thrivers: Failed Husbandry in the Sonnets," examines the economic concerns underlying especially the young-man sonnets. "The procreation sonnets display with particular brilliance Shakespeare's ability to manipulate words which in his language belonged both to the economic and the sexual/biological semantic fields" (231). After citing many of the words cited here, Greene adds the key word "husbandry" (Greene 1985: 230–44).

5. Joel Fineman's *Shakespeare's "Perjured Eye"* is of interest here because he draws on both Renaissance concerns with the breakdown of linguistic realism and the works of modern theorists—he cites Jakobson, Greimas, Derrida, and Lacan—to define Shakespeare's fixation with the subject of utterance and his or her relation to language and its object.

6. The idea here may be underlined by one of the main concepts in Harvey Gross's *Sound and Form in Modern Poetry:* "The function of prosody is to image, in a rich and complex way, human process as it moves in time" (1964: 14).

7. In frequency of occurrence, the word "use" is listed within the first 100 of 86,700 words in the *Word Frequency Book* (Carroll, Davies, and Richman 1971). "Usury" is from the Latin "usura," derived from "usus," the past participle of Latin "uti." Latin derivations, even those later proved false, would have been very close to the ear and mind of any literate Elizabethan.

8. Technically speaking, the realist-nominalist dispute involved the mode of existence of universals. It posed the question: was the term "man" simply a verbal expression that gathered the observed similarities of individual men (nominalism), or did it have an existence above and apart from the individual things it linked (realism)? A brief description of this dispute, as enunciated in its *locus classicus* by Abelard (1079–1142), may be found in Leff 1958: 104–14. The idea that language itself had the power and authority of the Real in its words ("abracadabra," "G-d," etc.), was popular among the more mystic Neoplatonists of the Renaissance, especially when combined with Cabalistic lore (Kristeller 1961: 60). For a vivid picture of realist metaphysics at work, see the conjuring scene (iii) in Marlowe's *Dr. Faustus* (ca. 1592).

9. See chapter 3, "Poem as Literary Microcosm" in Heninger 1974 for an extended treatment of this concept and for the sources of statements by these and earlier writers. Alastair Fowler's *Triumphal Forms: Structural Patterns in Elizabethan Poetry* (1970) goes into further and more questionable speculations on the mathematical relevancies of Elizabethan poetry. In Fowler, the presumed pyramidal structure constructed upon the number—153— of Shakespeare's sonnets (the number of sonnets in the 1609 edition minus 1 for sonnet 136, which Fowler wishes to remove) seems particularly questionable (Fowler 1970: 183–97).

10. Though mention of fourteen would automatically suggest 2 x 7 to the numerologically sensitive, few sonnets actually divide that evenly. A rare example may be found in the first fourteen lines of the King's speech in *Love's Labour's Lost,* which make up a very neat unrhymed sonnet in two balanced seven-line sentences. See Barry 1983 for an analysis of the sonnets in the plays.

11. Heninger argues, with some justification, that his fours and threes are more "natural" than the highly conventionalized numerology of Fowler's *Triumphal Forms* (1970), which includes such esoteric connections as "666, the number of the beast and 108, the number of Penelope" (Heninger 1994: 6).

12. In this same chapter on the sonnet, Heninger moves his argument about formal meanings forward to twentieth-century abstract painting, as I have done in chapter 8. After an effective description of the nature and setting of Barnett Newman's *Stations of the Cross,* Heninger, not surprisingly, finds in this fourteen-picture series a parallel to the sonnet, enforced by such quite objective facts as that the format of the paintings changes at the ninth picture—the traditional point of the *volta* or change of subject matter in the sonnet—and that the last of the paintings resolves the series in "peace" by the elimination of all conflicting elements in an all-white surface (1994: 111–18).

13. To illustrate the difficulties surrounding this claim for a sound/meaning iconicity, consider a possible musical parallel. If one were to assert an iconic relationship of unobstructed vocalization to a semantic content of freedom, it might be held on the same basis that an iconic relationship obtains between high musical notes and a conveyed meaning of tension, on the theory that the trumpeter's embrasure or the violinist's string is more constricted the higher the note. There seems no evidence that this is the case.

14. It must be noted that line 9 of Sonnet 4, "For having traffic with thyself alone" suggests a self-imposed restriction on the young man's freedom, and the mention of "tombed" in the couplet is certainly restrictive. Otherwise this sonnet certainly speaks of free, if misdirected, prodigality.

15. I have gathered information on the "new formalism" mainly from the statements from the poets in Annie Finch's anthology *A Formal Feeling Comes: Poems in Form by Contemporary Women* (1994), and from the introduction by Finch herself; from Dana Gioia's "Notes on the New Formalism" (in McCorkle 1987); and Lynn Keller's article in Keller and Miller 1994: 260–86).

16. See Marilyn Hacker's statement in Annie Finch's interview with her in Finch 1996: 24.

17. This is mentioned frequently in the brief prefaces to their works provided by the women poets in Finch's collection. See, for example, Maxine Kumin's statement, "The joy of working in form is, for me, the paradoxical freedom form bestows to say the hard truths" (in Finch 1994: 143).

18. I have drawn heavily here from a long analysis of this sonnet sequence by Lynn Keller (Keller and Miller 1994), which places Hacker's work in relation to Shakespeare and to the new formalism. I am grateful to Norma Procopiow for introducing me to Marilyn Hacker's work and to the Keller essay.

19. Marilyn Hacker was 42 and Ray (Rachel) was 25 at the time of the romance (Keller and Miller 1994: 266).

CHAPTER 6

1. Though in her book, *Feminism and Poetry: Language, Experience, Identity in Women's Writing,* Jan Montefiore is concerned particularly with women's expression of their experience, she doubts, in any literary works, the importance for meaning of a knowledge of the author: "Even though the poet's personality may seem to validate and explain her work, it remains a hypothesis which we construct out of the poems themselves plus any information we may have about the poet" (1994: 5).

2. A convenient, brief essay that sets out these issues and offers abundant references to supporting readings may be found in "Let It Pass: Changing the Subject, Once Again" (Caughie 1997: 26–39).

3. Lowell's familiar "address" to President Roosevelt had taken the form of a 1943 letter explaining why he was refusing the draft for World War II.

4. A brief sample of critical opinion in the period of the *Time* article can be gleaned from Jonathan Price's *Critics on Robert Lowell* (Price 1972). John Hollander notes, "Robert Lowell is probably the most distinguished American poet of his generation . . ." (Hollander 1959: 66). Richard Poirier asserts, "Robert Lowell is, by something like a critical consensus, the greatest American poet of the mid-century, probably the greatest poet now writing in English" (Poirier 1964: 92). William Meredith calls Low-

ell, "one of our best poets—only Pound, Auden, and Berryman can be named in the company now" (Meredith 1969: 121). We can add John Thompson's *Kenyon Review* study, which claims, "perhaps alone of living poets, he can bear for us the role of the great poet, the man who on a very large scale sees more, feels more, and speaks more bravely about it than we ourselves can do" (Thompson 1959: 272).

5. Irvin Ehrenpreis designates the fifties and sixties "The Age of Lowell": "For an age of world wars and prison states, when the Faustian myth of science produces the grotesquerie of fall-out shelters, the decorous emotion seems a fascinated disgust. After outrage has exhausted itself in contempt, after the mind has got the habit of Dallas and South Africa, the shudder of curiosity remains. . . . Among living poets writing in English nobody has expressed this emotion with the force and subtlety of Robert Lowell" (Ehrenpreis 1965: 15).

6. For details of Lowell criticism and biography, I have depended throughout on Norma Procopiow's survey of Lowell criticism (1984) and Ian Hamilton's biography (1982). Actually, it is grist for my mill that Lowell's reputation has considerably shrunk, since this very transience of reputation testifies to the power of cultural forces in the process of sign formation. As a very rough gauge of current interest in Lowell compared to that in his contemporaries, we might note that the 1993 *MLA International Bibliography* lists only five entries for Lowell while his friend Elizabeth Bishop garnered seventeen and his student Sylvia Plath eighteen. Robert Frost, whom Ehrenpreis saw as being replaced by Lowell as the voice of the American spirit (1965: 33), was the subject of thirty-five studies in the 1993 volume.

7. Identification of the volumes from which Lowell's poems will be cited utilizes the following abbreviations: *LS* for *Life Studies* (Lowell 1959) and *FUD* for *For the Union Dead* (Lowell 1964).

8. Roughly 15 years after his letter to Roosevelt, Lowell referred to this stance as "my manic statement,/ telling off the state and president" ("Memories of West Street and Lepke," *LS*). Lowell's objection to this war, which most Americans had united in supporting, had mainly to do with our embrace of Stalin and our bombing of civilian populations (Hamilton 1982: 87–88).

 Lowell's protest against Johnson's festival was more ambiguous than it seems since he had at first accepted the invitation and changed his mind at the intercession of such friends as Philip Roth (Hamilton 1982: 320–27).

9. In the politically charged spirit of the times, the 1973 edition of *The Norton Introduction to Literature* published Eugene McCarthy's "Kilroy" along

with poems by Julian Bond, Larry Rubin, Etheridge Knight, Bob Dylan, and Joni Mitchell.

10. The "confessional poets" are given here as defined by Diane Wood Middlebrook (who cites Joyce Carol Oates as her source). These are Lowell and his sometime students W. D. Snodgrass, Anne Sexton, and Sylvia Plath (Middlebrook 1993: 632). The cultural fascination with psychoanalysis in the sixties and seventies reached a wider audience through Woody Allen's satirical treatment of it in his films of the 1970s.

11. The Massachusetts 54th was an African American regiment commanded by a distant relative of Lowell's, Colonel Shaw. Shaw and all his men were killed in a futile attack on a Confederate position. Lowell uses as epigram to "For the Union Dead," "Relinquunt Omnia Servare Rem Publicam" ["They give up all to serve the duties of the republic."] Lowell altered the third-person singular verb of the actual epigram on the St. Gaudens commemorative sculpture presumably to include the men of the Massachusetts 54th as well as just their colonel.

12. I wish to recall here my own example in chapter 2, where I imagined an endangered camper—a human author!—who scrawled the same word with charcoal from her campfire. What difference, if any, does the signifier /help/ have in the two cases?

13. A crucial distinction must be noted here between the driftwood sculpture and the seaweed novel. The driftwood, shaped as it is by the natural forces of sea and sand, is itself the signifier, whereas the "word" is a word only to a person who can discern in its presumed graphic representation a verb of the English language and secondarily—second-level semiotic system—a novel. A Chinese person with somewhat the same aesthetic tastes as we have could easily appreciate the "sculpture." He or she could not construct the "novel."

CHAPTER 7

1. Perhaps no task is as challenging as that of writing a semiotics of an art—theater—in which language, gesture, scenery, blocking, and sound all participate and in which their meanings are taken to be signified by a daunting list of semiotic "codes." Though there have been excellent studies before and since, Keir Elam's 1980 *The Semiotics of Theatre and Drama* is a convenient reference book because it offers a brief summary of the work of continental semioticians. My comments on the book and its subject may be found in Barry 1982.

For a history of stage design, two quite different books may be cited: *New Theatres for Old,* by a designer who worked in the same tradition as Mielziner, covers the European backgrounds and their American influence

(Gorelik 1940), while Orville Larson's 1989 book covers the American theater with a generous supply of illustrations.

2. A sense of the early fascination with light as design material may be gained from the chapter "Light as Setting" in Macgowan and Jones 1922: 68–80 and, for Belasco, see Gorelik 1940: 166–67. Robert Edmond Jones was Mielziner's mentor.

3. The dramatic consequences of the Tennessee Williams–Jo Mielziner relationship have been developed in two essays by Harry W. Smith. The first (Smith 1982) describes the effects the author-designer collaboration achieved in *The Glass Menagerie, A Streetcar Named Desire,* and *Summer and Smoke* stressing the ways in which Mielziner's lighting and transparencies reinforced the form of Williams's plays of struggling fragility. Smith 1995 describes what he takes to be a change in Williams's dramaturgy abetted by a change in Mielziner's stagecraft to move the characters of *Cat on a Hot Tin Roof, Sweet Bird of Youth,* and *The Milk Train Doesn't Stop Here Anymore* into a more abstracted, ritual confrontation with the theater audience.

4. Joseph McCarthy serves here as a type of "new man," like Kowalski, playing on a war record, that in McCarthy's case was partly false. (He had actually been an intelligence officer.) McCarthy did not achieve a national reputation as a red hunter until 1950, after *Streetcar* had closed. The senator did, however have active predecessors at the time of Williams's play, and Williams continued to write about deviants pursued by the forces of law and order throughout the period of McCarthy's prominence.

5. The manuscript, unfinished at Wolfe's death on 15 September 1938, was edited and published by Maxwell Perkins (Wolfe 1942).

6. For two very different treatments of performance space, see Fischer-Lichte (1983: 93–107) and two books by Marvin Carlson (1989 and 1990). Carlson presents a semiotic analysis (in historical perspective) of London's "Old Vic" " . . . considering some of the ways in which this theatre, whatever plays it may have been presenting, communicated various messages to its actual and potential publics . . ." (1990: 57).

7. For an earlier and particularly effective Mielziner set in which the protagonists' dwelling is dwarfed under a New York city scape, see the set for Maxwell Anderson's *Winterset* (1935). Anderson's romanticized extension of the Sacco-Vanzetti story has a very different feeling from the postwar plays we have been considering (Mielziner 1965: 88–89).

8. The phenomenological status of the "real" item used on stage is interestingly explored in States 1985.

9. All references to Tennessee Williams's plays are to *The Theatre of Tennessee Williams,* Vols. 1 and 2 (New York: New Directions, 1971).

10. The desire to avoid the kind of symmetry that had characterized the seventeenth- and eighteenth-century stages was very much in the mind of American directors and designers of the forties. See Dean 1941: 183–93. This book was essentially the text for Dean's Yale Drama School directing course and hence, whether accepted or denounced, an influence on Broadway.

11. There is a fine point here in the fact that the signifier /staircase/ is truly a staircase, which several members of the cast climb. Yet no item on stage escapes, in the magic of performance, its transformation into something that it is not. And indeed, this stage prop staircase, which could never serve a real building, leads not to the indexically indicated second-floor apartment but to a concealed escape stair.

12. For an interesting theoretical article on props see "What Do Brooks' Bricks Mean?" in the theater semiotics issue of *Poetics Today* (Avigal and Rimmon-Kennan 1981). In a piece I discuss at the end of this chapter, Jim Carmody gives a semiotic analysis of a remarkable exercise machine used in postmodernist fashion at the La Jolla Playhouse (Carmody 1992). Neither Avigal and Rimmon-Kenan nor Carmody go beyond the strictly symbolic meanings of these props to consider possible ostensive meanings.

13. The paper lantern as signifier is particularly interesting because this prop, for which the designer intended to use a real Japanese paper lantern from the store, had to be copied, largely to satisfy theater fire codes, "in flame-proofed wood and muslin, hand painted to simulate the paper original" (Mielziner 1965: 142). Here the iconic sign works better than the real thing.

14. A few set pieces on the fore-stage and a concentration of lighting created the Moon Lake Casino scene of *Summer and Smoke* and the New York City scenes of *Death of a Salesman* while the main set remained visible to the audience throughout.

15. A picture of this set may be seen in Bigsby 1982: 1,169).

16. The fact that I can cite a set with the indication of solid and sheltering walls before the war and a set with walls only lightly sketched in front of a threatening world after the war proves nothing in itself. The semiotic process that would provide for such meanings accrues only with the war and postwar experiences of space to be signified and with the whole complex artist/audience compound which made the Group Theatre production of *Awake and Sing* particularly important in the 1930s and the Williams–Mielziner–Kazan production of *Streetcar* important in 1947.

17. For a famous example of a set predating either of the above in which a house is—as is Willy Loman's—set against the open stage space, see the set for Eugene O'Neill's *Desire Under the Elms* (1924) by the man, Robert Edmond Jones, who had been Mielziner's mentor. Both the intertextuality of

the Jones set and a number of its details differentiate its meaning from post–World War II Mielziner–Williams sets in ways that cannot be considered here. For a picture, see Bigsby 1982: 1,65.

18. In assembling this evidence, I have in part utilized my own experience of the time and of the original productions of the plays involved.

19. See especially the beautifully illustrated chapter, "Fallen Shrines," in Macaulay 1964.

20. The visual theme of the "once elegant" building huddled beneath the scaffolding of the building for which it is to be demolished is literally present in Eldon Elder's design for Studs Terkel's play *Amazing Grace* (Brockett 1969: 448–54).

21. First published under the title "Colonel Shaw and the Massachusetts 54th" in *Life Studies* (1959). This poem, published twelve years after *A Streetcar Named Desire* opened, also contains references to the nuclear threat of the late 1950s cold war and the accelerating racial tensions in the South. Neither of these issues was prominent in the context of the plays we have been discussing.

22. In the opening night reviews of *Streetcar,* John Chapman called Williams "a young playwright who is not ashamed of being a poet," *New York Daily News,* 4 December 1947. Brooks Atkinson called him "a genuinely poetic playwright," *New York Times,* 4 December 1947, *New York Theatre Critics Reviews* 8: 23, 249, 252.24.

23. For illustrations see Soby 1963. Today the work of Ben Shahn is overshadowed by the explosion of abstract expressionism into the New York art world, an event that did not gain wide public recognition until the fifties. Shahn, with roots in the political protests of the Depression years, the times in which Mielziner and young Williams, Miller, and Kazan were gaining their artistic influences, was much closer to the hearts of the typical New York theatergoer than the generally apolitical work of Pollock, Rothko, Newman, etc. See the "chronology" in Auping 1987 and Sandler 1971: 51–52.

24. Testimony that designers of the time were conscious of the need to define the new space is forcefully presented in the preliminary materials to *Language and Vision* (1944) by Gyorgy Kepes, an American artist and teacher formerly associated with the Bauhaus. The writing has an interesting flavor of semiotics, speaking of "tools" for understanding and organizing our world, of a "grammar" and "syntax" of vision. This is not surprising when one takes into account the fact that both Hayakawa and Charles Morris read and criticized the manuscript (Kepes 1944: 4). Kepes's treatment was expanded and more elaborately illustrated in Laszlo Moholy-Nagy's 1947 *Vision in Motion.*

25. The *New York Times* Sunday magazine section had published on 20 February 1949 a cartoon on the building of the glass house (Section 6, p. 34) and an article with four illustrations of the finished house in the Sunday edition, 14 August 1949 (Section 6, p. 34).

CHAPTER 8

1. For information and illustrations, see the monographs by Diane Waldman (1977) and Karen Wilkin (1990). Both contain biographies, bibliographies, and lists of major exhibits.
2. Among semiotic analyses, most helpful here as models were Jean-Louis Shefer's analyses of late Renaissance painting (Shefer 1969) and Jean-Marie Floch's wide-ranging analyses in his *"sémiotique plastique"* (Floch 1985).
3. I examined *Shoot* at the National Museum of American Art, part of the Smithsonian Institution in Washington, D. C. Good color reproductions of Noland's "chevron" paintings of 1964–65 may be found in Waldman 1977 and Wilkin 1990.
4. This description of color in terms of the conventional "wheel" begs several questions in the psychology of perception. To what extent, for example, does our notion of color complementaries reflect an intuitive and universal perception of objective data and to what extent is this a cultural product? Entwined here is the whole problem of what certain artists and critics have taken to be the universal emotional qualities of colors, lines, and shapes. See Eco 1976: 203–4, Arnheim 1954, and Berlin and Kay 1969.
5. Noland actually studied with Josef Albers, later dean of the Yale Art School, only for one term. He felt Albers's approach was too mechanical and preferred to work with Bolotowsky (see Waldman 1977: 9–10). At Black Mountain Noland also studied with John Cage, who had joined a faculty that, in 1948 also included Elaine and Willem de Kooning, Buckminster Fuller, Merce Cunningham, and Richard Lippold (Waldman 1977: 38).
6. Dore Ashton, writing from close association with the scene she describes, offers an informative look at the ideology of the art scene just prior to the years in which Kenneth Noland and Morris Louis would enter it. See Ashton 1973.
7. Illustrations of the styles referred to may be found for Helen Frankenthaler in Barbara Rose ca. 1969: plates 162–68; for Morris Louis in the "Complete Works" catalogue 1985: plates 343–423; and for Jules Olitski in Kenworth Moffet 1981: plates 72–81. The many reviews of Noland's ex-

hibitions would offer a set of critical "interpretants" along with the artistic "interpretants" just mentioned.

8. Robert Scholes provides an especially appropriate parallel in his discussion of the intertextual knowledge of the great English elegies that affects our reading of W.S. Merwin's minimalist "Elegy" (Scholes 1982).

9. That experiment with the possible meanings of color combinations was a conscious goal, not only of Noland and Louis but of a group of Washington, D.C. artists in the 1960s, was recognized by their designation by the critics as a "colorist school."

10. Group μ does go on to speak of possible iconic aspects of both signifier and signified, but in doing so they have separated these aspects from the purely plastic aspects.

 Though my purpose here is to describe a kind of nonconventionalized meaning, I would never deny that conventional meanings do adhere to even nonfigurative works like *Shoot*. The huge chevrons obviously suggest the letter *V*, which, as graphic design and member of our alphabet, is described in a play of meanings many of which could hardly be denied to Noland's eight-foot grapheme. Certainly letters and numerals have been featured in otherwise nonobjective paintings from Jasper Johns to the postmodern abstractionist David Row. (For the latter, see High et al. 1995: 19).

11. " . . . 'content' remains indefinable, unparaphraseable, undiscussable . . . the unspecifiablility of its 'content' is what constitutes art as art" (Greenberg 1967: 38–39). In this much quoted article, "Complaints of an Art Critic," Greenberg finally opts for "quality" as content.

12. Susanne Langer did insist that artistic form was in itself meaningful, but her notion of sentient form as content is not the same kind of thing I am claiming. See *Feeling and Form* (1953). A concise statement of her position may be found in the essay "Expressiveness" (Langer 1957: 44–58).

13. A classic early statement of this objection can be found in Richard Rudner's "On Semiotic Aesthetics" (1951). My defense here is based largely on the attempt to counter Rudner's position.

14. The separation of meaning and significance in a text follows the discussion by E. D. Hirsch (1960: 470–79). There remains the cloudy issue of "significant form"—to be touched on below—in which major chords are said to be perceived by most people as happy, certain colors or lines to be perceived as joyous, etc.

15. Even many verbal texts, to which we would not deny a clear primary meaning, may be shown to have had similar seemingly contradictory metaphorical extensions. The wide use of such metaphors in poetry has been explored in Lakoff and Turner 1989.

16. On the point about the "ineffability" of artistic meaning, Leo Treitler quotes Felix Mendelssohn's 1842 letter arguing music's precision as greater than that of words. Treitler concludes, "It is not music's ineffability that makes for the difficulty of talking about musical meaning . . . but the ambiguities, vagueness, and inconsistencies that are inherent in the normal practice of language communication" (Treitler 1995:288–89).

17. Anna Chave's exhaustively researched book, *Mark Rothko: Subjects in Abstraction* (1989), is especially valuable in its exploration of the many and contradictory opinions about meaning in Rothko and in abstract art generally. In the last part of her introduction (pp. 33–39), Chave considers "Methods of Interpretation," among which she includes semiotics. Basing her argument on Peirce's categories, Chave decides that Rothko's classic pictures are iconic.

18. The concept of meaning in nonobjective art can be clouded by the use of words like "dark," "luminous," and "pure" which legitimately describe the physical qualities of a painting but too easily and inappropriately call in the nonphysical connotations they bear in ethical and theological discourse.

19. It is interesting to compare Newman, Gottlieb, and Rothko's beliefs with the belief in archetypal patterns and their symbols held by Eliot and Yeats and fostered by the fascination with "primitive" myth by anthropologists, classical scholars, and psychiatrists. That all this must have seemed dated by the 1940s confirms the importance of the painters' problem. See Chave 1989: 90 and 98–104 ("Mythmaking").

20. Kandinsky slipped some favorite symbols, such as the horse and the troika, into his early abstract paintings. Jean-Marie Floch has provided a thorough semiotic analysis of Kandinsky's *Composition IV* (1911) detailing the use of such symbols and their incorporation into the plastic narrative of the painting (Floch 1985: 39–77. Any discourse alleging the possibility of spiritual meanings in nonfigurative works must harken back to Kandinsky's 1912 *On the Spiritual in Art.*

21. David Clarke's carefully considered article, "The All-Over Image: Meaning in Abstract Art," describes an interesting example in which religious doctrine determines the formal design of an abstract painting. Here Clarke attributes Mark Tobey's abolition of a single center in the picture space to Tobey's attempt at an art that would express the Buddhist concept of creation in which each element is a center (Clarke 1993: 358, 361, 364).

22. Actually Rothko had declared, relative to attempts to transcend the painting, "I adhere to the material reality of the world and the substance of things" (statement made ca. 1945, quoted in Chave 1989: 103).

23. In response to this diversity, a social semiotics of the visual arts will need to explore the institutional providence of its display. Jean Umiker-Se-

beok (1995) has, for example, documented perceptions of discomfort with the formalities of art museum attendance that discourages significant numbers of the African American population from visiting the museum's galleries.

CHAPTER 9

1. The choice of a word for the human thinking organ has many resonances—including the theological. My preference would have been to use "brain" throughout the paper, but that would have given off incorrect resonances in talking about certain of the figures discussed. I have tried instead to use the word or phrase that would best characterize the sense each of the scholars had of our cognitive faculty.

2. To see what Greimas takes to be the relationship between his generative trajectory and Chomsky's generative grammar, consult Greimas and Courtés 1979: 132–33.

3. See, for example, "I am not going to be concerned with how concepts are instantiated by neurons in the brain; crucial as it is, I don't think we have any useful understanding of this issue at the moment" (Jackendoff 1992: 54). Lakoff 1995 suggests a more friendly attitude toward biology.

4. See Jackendoff's chapter, "Language as a Window on Thought," but note his warning that not all thought is linguistic (Jackendoff 1994: 184–203). For material on Ray Jackendoff, I have depended largely on *Patterns in the Mind* (1994), a very accessible summary of his position; *Languages of the Mind* (1992), a collection of lectures and essays arguing the main planks of the theory; and *Semantics and Cognition* (1983), which lays out in systematic form the premises taken up in the later books. It was in 1983 as well that Jackendoff published the extension from linguistics to music that I comment on below (Lerdahl and Jackendoff 1983).

5. See Jackendoff 1994 for summaries.

6. Experimental psychologists have verified a number of the assumptions made in the Lerdahl–Jackendoff study (See Butler 1989 and the journal *Musical Perception* generally). Since 1983 Jackendoff has used his argument for an innate mental grammar in music to buttress his argument for the same thing in language (Jackendoff 1992: 125–55; 1994: 165–71).

 In *A Theory of Musical Semiotics*, Eero Tarasti cites the Lerdahl–Jackendoff study several times to support his narrative concept of musical meaning (Tarasti 1994).

7. See Jackendoff's conclusion to the section on music in *Patterns in the Mind:* "Why should there be such a thing as music among our abilities? . . .

Aesthetic pleasure doesn't enhance survival of the species, it only makes us feel good" (Jackendoff 1994: 170).

8. Lakoff's "extension" of linguistics to semiotics and literature should be considered in light of his undergraduate work with Roman Jakobson at MIT, where he wrote a thesis on story grammar founded on Propp's *Morphology of the Folktale* (1928). Jackendoff, also associated with MIT, has had a long-running argument with Lakoff over the nature of metaphor as a basic operator in cognition. See Jackendoff 1983: 209; 1992: 177; and Jackendoff and Aaron 1991, a review of Lakoff and Turner's 1989 book on metaphor in poetry.

9. For an excellent brief account, not only of the theory but of the biological machinery that accomplishes the learning, see Churchland and Sejnowski 1990.

10. A somewhat similar and very illuminating description of the neurological instantiation of the concept "cup" may be found in Damasio and Damasio 1992: 94–95. Together with Mary Hesse, Arbib contributed an account of schema theory as a general epistemological mode.

11. Zeki here puts on a neurological basis the mid-century speculations of many nonobjectivist painters. The title of Hans Hofmann's book of such speculations tells the story: *Search for the Real* (1967).

12. Though Zeki's writings on the visual arts are distinguished by the fact that he is a biologist by trade, it is only fair to recognize that others have contributed important work on the psychological bases of these arts. Among many, Rudolf Arnheim deserves special mention.

13. Ronald Schleifer et al. (1992) find great value in a Greimasian narrative and rationalist cognitive science that would mediate a supposedly empiricist American science. In this view, motivated by a strong predilection for the "cultural studies" approach, American cognitive science gets very short shrift. None of the recent cognitive linguists or neurologists is cited.

14. An argument might be made that the most exciting art is that which *breaks* patterns. Here again, though, biology supplies an answer. In the evolutionary theory of brain development currently popular, stress is laid on the plasticity of brain circuits (Zeki 1993: 207–26), something that would accommodate and profit from the stimulus of experimental art as a way to form those new patterns necessary to survive in changing conditions.

REFERENCES

In keeping with the culture-specific focus of this book, all works are dated as of the time of first publication or performance. Where the particular reference volume is not the original, I have supplied the later date and publication information. General references to frequently reproduced works, such as those by Aristotle and Shakespeare, are not cited here unless a particular edition was the source of extended comment or quotation.

1993 MLA INTERNATIONAL BIBLIOGRAPHY. 1994. New York: The Modern Language Association of America.

Arac, Jonathan. 1988. "Hamlet, Little Dorrit, and the History of Character." *The South Atlantic Quarterly* 87: 311–27.

Arbib, Michael, ed. 1995. *Handbook of Brain Theory and Neural Networks.* Cambridge, MA: MIT Press.

Arbib, Michael, and Mary Hesse. 1986. *The Construction of Reality.* Cambridge: Cambridge University Press.

Ariés, Philippe. 1960. *Centuries of Childhood: A Social History of Family Life,* trans. Robert Baldick. New York: Vintage,1962.

Arnheim, Rudolf. 1954. *Art and Visual Perception.* Berkeley: University of California Press.

Ashton, Dore. 1973. *The New York School: A Cultural Reckoning.* New York: Viking.

Auping, Michael, ed. 1987. *Abstract Expressionism: The Critical Developments.* New York: Abrams.

Avigal, Shoshana, and Shlomith Rimmon-Kenan. 1981. "What Do Brook's Bricks Mean." *Poetics Today* 2: 11–34.

Barry, Jackson. 1960. "A Visitor's Notebook of Acting Classes in New York." *Quarterly Journal of Speech* 46: 383–90.

———. 1973. "Shakespeare's 'Deceptive Cadence': A Study in the Structure of *Hamlet.*" *Shakespeare Quarterly* 24: 117–27.

———. 1982. Review of Elam, *The Semiotics of Theatre and Drama. Journal of Aesthetics and Art Criticism* 40: 439–41.

———. 1983. "Poem or Speech?: The Sonnet as Dialogue in *Love's Labour's Lost* and *Romeo and Juliet." Papers on Language and Literature* 19: 13–36.

————. 1986. "Meaning, Being, and Ostention: Semiotics and the Arts." *American Journal of Semiotics* 4: 143–56.

Barthes, Roland. 1957. *Mythologies.* Selected and trans. Annette Lavers. New York: Hill and Wang, 1987.

————. 1961. "The Photographic Message," in *Image, Music, Text,* trans. Stephen Heath. New York: Hill and Wang, 1977.

————. 1964a. *Elements of Semiology,* trans. Annette Lavers and Colin Smith. New York: Hill and Wang, 1977.

————. 1964b. "Rhetoric of the Image," in *Image, Music, Text,* trans. Stephen Heath. New York: Hill and Wang, 1977.

————. 1968. "The Death of the Author," in *Image, Music, Text,* trans. Stephen Heath. New York: Hill and Wang, 1977: 142–48.

————. 1970. *Empire of Signs,* trans. Annette Lavers and Colin Smith. New York: Hill and Wang, 1982.

Benezra, Neil.1991. *Martin Puryear.* Chicago: The Art Institute of Chicago.

Berlin, Brent, and Paul Kay. 1969. *Basic Color Terms: Their Universality and Evolution.* Berkeley: University of California Press.

Bigsby, C. W. E. 1982. *A Critical Introduction to Twentieth-Century American Drama,* vol 1. Cambridge: Cambridge University Press.

Booth, Stephen. 1977. *Shakespeare's Sonnets.* New Haven: Yale University Press.

Briggs, Julia. 1983. *This Stage-Play World: English Literature and its Background 1580–1625.* Oxford: Oxford University Press.

Brockett, Oscar G. 1969. *The Theatre: An Introduction.* 2nd ed. New York: Holt, Rinehart and Winston.

Brooks, Cleanth. 1947. *The Well Wrought Urn: Studies in the Structure of Poetry.* New York: Reynal and Hitchcock.

Brooks, Harold J. 1980. "*Richard III,* Unhistorical Amplifications: The Women's Scenes and Seneca." *MLR* 75: 721–27.

Budra, Paul. 1992. "The *Mirror for Magistrates* and the Politics of Reading." *Studies in English Literature, 1500–1900,* 32: 1–13.

Burrow, J. A. 1986. *The Ages of Man: A Study in Medieval Writing and Thought.* Oxford: Clarendon Press.

Butler, D. 1989. "Describing the Perception of Tonality in Music: A Critique of the Tonal Hierarchy Theory and a Proposal for a Theory of Intervallic Rivalry." *Music Perception* 6: 219–42.

Byrne, Muriel St. Clare, ed. 1981. *The Lisle Letters,* 6 vols. Chicago: University of Chicago Press.

Campbell, Lily B., ed. 1938. *The "Mirror for Magistrates."* Cambridge: Cambridge University Press.

Carlson, Marvin. 1989. *Places of Performance.* Ithaca, NY: Cornell University Press.

————. 1990. *Theatre Semiotics: Signs of Life.* Bloomington: Indiana University Press.

Carmody, Jim. 1992. "Alceste in Hollywood: A Semiotic Reading of *The Misanthrope,*" in *Critical Theory and Performance,* ed. Janelle G. Reinelt and Joseph R. Roach. Ann Arbor: University of Michigan Press.

Carrier, David. 1994. *The Aesthete in the City: A Philosophy and Practice of American Abstract Painting in the 1980s.* University Park: Pennsylvania University Press.

Carroll, John B., Peter Davies, and Barry Richman. 1971. *The Word Frequency Book.* Boston: Houghton Mifflin.

Caughie, Pamela L. 1997. "Let It Pass: Changing the Subject, Once Again." *PMLA* 112: 26–39.

Chapman, R. 1950. "The Wheel of Fortune in Shakespeare's Historical Plays." *Review of English Studies* NS 1.

Chave, Anna C. 1989. *Mark Rothko: Subjects in Abstraction.* New Haven: Yale University Press.

Chew, Samuel C. 1962. *The Pilgrimage of Life.* New Haven: Yale University Press.

Chopin, Kate. 1899. *The Awakening.* New York: Avon, 1972.

Churchland, Patricia, and Terrence Sejnowski. 1990. "Neurophilosophy and Connectionism," in *Mind and Cognition,* ed. William G. Lycan. Cambridge, MA: Basil Blackwell, 224–52.

Clarke, David. 1993. "The All-Over Image: Meaning in Abstract Art." *Journal of American Studies* 27, 355–75.

Clemen, Wolfgang. 1955. *English Tragedy Before Shakespeare: The Development of Dramatic Speech,* trans. T. S. Dorsch. London: Methuen, 1961.

————. 1957. *A Commentary on Shakespeare's "Richard III."* English version by Jean Bonheim. London: Methuen, 1968.

Coombe, Rosemary J. 1994. "Author/izing the Celebrity: Publicity Rights, Postmodern Politics, and Unauthorized Genders," in *The Construction of Authorship: Textual Appropriation in Law and Literature,* ed. Martha Woodmansee and Peter Jaszi. Durham, NC: Duke University Press, 101–31.

Culler, Jonathan. 1975. *Structuralist Poetics: Structuralism, Linguistics and the Study of Literature.* Ithaca, NY: Cornell University Press.

Curtius, E. R. 1948. *European Literature and the Latin Middle Ages,* trans. Willard R. Trask. Princeton: Princeton University Press, 1953.

Daly, Peter M. 1979. *Literature in the Light of the Emblem.* Toronto: University of Toronto Press.

Damasio, Antonio, and Hanna Damasio. 1992. "Brain and Language." *Scientific American* 267–3 (Special Issue on Mind and Brain): 88–95.

Dean, Alexander. 1941. *Fundamentals of Play Directing.* New York: Rinehart.

Dickie, George. 1985. "Evaluating Art." *British Journal of Aesthetics* 25: 8.

Dove, Rita. 1986. *Thomas and Beulah.* Pittsburgh: Carnegie-Mellon Press.

Eco, Umberto. 1976. *A Theory of Semiotics.* Bloomington: Indiana University Press.

———. 1977. "Semiotics of Theatrical Performance." *The Drama Review* 21: 107–17.

Edelman, Gerald M. 1992. *Bright Air, Brilliant Fire: On the Matter of the Mind.* New York: Basic Books.

Ehrenpreis, Irvin. 1965. "The Age of Lowell," in *Critics on Robert Lowell,* ed. Jonathan Price. Coral Gables, FL: University of Miami Press, 1972.

Elton, W. R. 1966. *King Lear and the Gods.* San Marino, CA: Huntington Library.

Farnham, Willard. 1936. *The Medieval Heritage of Elizabethan Tragedy.* Oxford: Basil Blackwood, 1963.

Finch, Annie. 1996. "Marilyn Hacker: An Interview on Form by Annie Finch." *The American Poetry Review* 25: 3, 23–27.

Finch, Annie, ed. 1994. *A Formal Feeling Comes: Poems in Form by Contemporary Women.* Brownsville, OR: Story Line Press.

Fineman, Joel. 1986. *Shakespeare's "Perjured Eye": The Invention of Poetic Subjectivity in the Sonnets.* Berkeley: University of California Press.

Fischer-Lichte, Erica. 1983. *The Semiotics of Theatre,* trans. and abridged by Jeremy Gaines and Doris L. Jones. Bloomington: Indiana University Press, 1992.

Floch, Jean-Marie. 1985. *Petites mythologies de l'oeil et de l'esprit: Pour une sémiotique plastique.* Paris-Amsterdam: Editions Hades-Benjamins.

Focillon, Henri. 1934. *The Life of Forms in Art,* trans. Charles Beecher Hogan and George Kubler. New York: Wittenborn, Schultz, 1948.

Fowler, Alastair. 1970. *Triumphal Forms: Structural Patterns in Elizabethan Poetry.* Cambridge: Cambridge University Press.

Fried, Michael. 1965. *Three American Painters: Kenneth Noland, Jules Olitski, Frank Stella.* Cambridge, MA: Fogg Museum/Garland.

Geertz, Clifford. 1973. *The Interpretation of Cultures: Selected Essays.* New York: Basic Books.

———. 1976. "Art as a Cultural System," in *Local Knowledge: Further Essays in Interpretive Anthropology.* New York: Basic Books, 1983.

Gioia, Dana. 1987. "Notes on the New Formalism," in James McCorkle, ed. *Conversant Essays: Contemporary Poets on Poetry.* Detroit: Wayne State University Press, 1990.

Gombrich, E. H. 1972. *Studies in the Art of the Renaissance.* London: Phaidon.

Goodman, Nelson. 1968. *Language of Art.* Indianapolis: Bobbs-Merrill.

———. 1978. *Ways of World Making.* Indianapolis: Hackett.

Gorelik, Mordecai. 1940. *New Theatres for Old.* New York: Samuel French.

Greenberg, Clement. 1967. "Complaints of an Art Critic." *Artforum* 6–2: 38–39.

Greenblatt, Stephen. 1980. *Renaissance Self-Fashioning: From More to Shakespeare.* Chicago: University of Chicago Press.

Greene, Thomas M. 1985. "'Pitiful Thrivers': Failed Husbandry in the Sonnets," in Patricia Parker and Geoffrey Hartman, eds. *Shakespeare and the Question of Theory.* New York: Methuen.

———. 1996. "Introduction," in Douglas F. Rutledge, ed. *Ceremony and Text in the Renaissance.* Newark: University of Delaware Press.

Greimas, Algiridas-Julian. 1966. *Structural Semantics,* trans. Daniele McDowell, Ronald Schleifer, and Alan Velie. Lincoln: University of Nebraska Press, 1983.

———. 1968. "The Interaction of Semiotic Constraints," in *On Meaning,* trans. Paul Perron and Frank Collins. Minneapolis: University of Minnesota Press, 1987.

———. 1973. "Actants, Actors, and Figures," in *On Meaning,* trans. Paul Perron and Frank Collins. Minneapolis: University of Minnesota Press, 1987.

———. 1976. *Maupassant: The Semiotics of Text,* trans. Paul Perron. Amsterdam: John Benjamins, 1988.

Greimas, Algiridas-Julian, and Joseph Courtés. 1979. *Semiotics and Language: An Analytical Dictionary,* trans. Larry Crist et al. Bloomington: Indiana University Press, 1982.

Greimas, A-J., ed. 1972. *Essais de sémiotique poétique.* Paris: Larousse.

Gross, Harvey. 1964. *Sound and Form in Modern Poetry.* Ann Arbor: University of Michigan Press.

Group μ. 1979. "Iconique et plastique: sur un fondement de la sémiotique visuelle," in *Rhétoriques, sémiotiques [Revue d'esthétique]* 1: 173–92.

Gurr, A. W. 1987. *Playgoing in Shakespeare's London.* Cambridge: Cambridge University Press.

Haarmann, Harald. 1990. *Language in Its Cultural Embedding: Explorations in the Relativity of Signs and Sign Systems.* Berlin and New York: Mouton de Gruyter.

Hacker, Marilyn. 1986. *Love, Death, and the Changing of the Seasons.* New York: Arbor House.

Hamilton, Ian. 1982. *Robert Lowell: A Biography.* New York: Random House.

Hammond, Antony, ed. 1981. *Richard III,* Introduction and notes. London: Methuen.

Harrison, G. B. 1937. *The Life and Death of Robert Devereux, Earl of Essex.* New York: Holt.

Harrison, Jane Ellen. 1903. *Prolegomena to the Study of Greek Religion.* Cambridge: Cambridge University Press. Rpt. Cleveland: World, 1959.

Hayakawa, S. I. 1944. "The Revision of Vision," in Kepes, *Language of Vision.* Chicago: Paul Theobald.

Heninger, S. K., Jr. 1974. *Touches of Sweet Harmony: Pythagorean Cosmology and Renaissance Poetics.* San Marino, CA: Huntington Library.

———.1994. *The Subtext of Form in the English Renaissance: Proportion Poetical.* University Park: Pennsylvania State University Press.

Herman, David. 1995. *Universal Grammar and Narrative Form.* Durham, NC: Duke University Press.

High, Steven S., George Cruger, and Randee Humphrey. 1995.*Repicturing Abstraction.* Richmond, VA: Anderson Gallery, Virginia Commonwealth University.

Hirsch, E. D., Jr. 1960. "Objective Interpretation." *PMLA* 75: 470–79.

Hjelmslev, Louis. 1943. *Prolegomena to a Theory of Language,* trans. Francis J. Whitfield. Madison: University of Wisconsin Press, 1969.

Hofmann, Hans. 1967. *Search for the Real and Other Essays,* ed. Sara T. Weeks and Bartlett Hayes, Jr. Cambridge MA: MIT Press.

Hollander, John. 1959. "Robert Lowell's New Book," in *Critics on Robert Lowell,* ed. Jonathan Price. Coral Gables, FL: University of Miami Press, 1972.

Holtzman, Harry, and Martin S. James, eds. 1986. *The New Art—The New Life: The Collected Writings of Piet Mondrian.* Boston: G. K. Hall.

Ingarden, Roman. 1965. *The Literary Work of Art.* 3rd. ed. trans. George G. Grabowicz. Evanston, IL: Northwestern University Press, 1973. Originally written in Polish; 1st German ed. 1931.

Jackendoff, Ray. 1983. *Semantics and Cognition.* Cambridge, MA: MIT Press.

———. 1992. *Languages of the Mind: Essays on Mental Representation.* Cambridge, MA: MIT Press.

———. 1994. *Patterns in the Mind: Language and Human Nature.* New York: Basic Books.

Jackendoff, Ray, and D. Aaron. 1991. Review of Lakoff and Turner (1989), *Language* 67: 320–38.

Jakobson, Roman. 1960. "Linguistics and Poetics," in *Style in Language,* ed. Thomas A. Sebeok. Cambridge, MA: MIT Press.

Jameson, Fredric. 1981. *The Political Unconscious.* Ithaca, NY: Cornell University Press.

Janssen, Anke. 1981. "The Dream of the Wheel of Fortune," in Karl Heinz Goller, ed. *The Alliterative Morte Arthure: A Reassessment of the Poem.* Cambridge: D. S. Brewer.

Johnson, Mark. 1987. *The Body in the Mind.* Chicago: University of Chicago Press.

Jung, Carl Gustav. 1922. "On the Relation of Analytical Psychology to Poetic Art," in *Contributions to Analytical Psychology,* trans. H. G. and Cary F. Baynes. New York: Harcourt Brace, 1928.

Kandinsky, Wassily. 1912. *On the Spiritual in Art,* ed. and trans. Hilla Rebay. New York: The Solomon R. Guggenheim Foundation.

Keller, Lynn, and Cristanne Miller, eds. 1994. *Feminist Measures: Soundings in Poetry and Theory.* Ann Arbor: University of Michigan Press.

Kepes, Gyorgy. 1944. *Language of Vision.* Chicago: Paul Theobald.

Kernodle, George. 1967. *Invitation to the Theatre.* New York: Harcourt, Brace and World.

Kivy, Peter. 1990. *Music Alone.* Ithaca, NY: Cornell University Press.

Kristeller, Oscar. 1961. *Renaissance Thought: The Classic, Scholastic, and Humanistic Strains.* New York: Harper Torchbooks.

Lakoff, George. 1987. *Women, Fire, and Dangerous Things: What Categories Reveal about the Mind.* Chicago: University of Chicago Press.

———. 1995. "Embodied Minds and Feelings," in *Speaking Minds: Interviews with Twenty Eminent Cognitive Scientists,* ed. Peter Baumgartner and Sabine Payr. Princeton: Princeton University Press.

Lakoff, George, and Mark Turner. 1989. *More than Cool Reason: A Field Guide to Poetic Metaphor.* Chicago: University of Chicago Press.

Langer, Susanne. 1953. *Feeling and Form: A Theory of Art.* New York: Charles Scribner's Sons.

———. 1957. *Problems of Art: Ten Philosophical Lectures.* New York: Charles Scribner's Sons.

———.1967–1982. *Mind: An Essay on Human Feeling,* 3 vols. Baltimore: Johns Hopkins University Press.

Larson, Orville K. 1989. *Scene Design in the American Theatre from 1915 to 1960.* Fayetteville: University of Arkansas Press.

Leach, Edmund. 1974. *Claude Lévi-Strauss,* rev. ed. New York: Viking.

Leff, Gordon. 1958. *Medieval Thought: St. Augustine to Ockham.* Baltimore: Penguin.

Lerdahl, Fred, and Ray Jackendoff. 1983. *A Generative Theory of Tonal Music.* Cambridge, MA: MIT Press.

Lévi-Strauss, Claude. 1955. "The Structural Study of Myth." *Journal of American Folklore* 68.

———. 1962. *The Savage Mind.* Chicago: University of Chicago Press, 1966.

Lewis, C. S. 1954. *English Literature in the Sixteenth Century,* vol. 3 of the *Oxford History of English Literature.* Oxford: Clarendon Press.

Lightfoot, David. 1990. "Modeling Language Development," in *Mind and Cognition.* Ed. William G. Lycan. Cambridge, MA: Basil Blackwell.

Little, Stuart, and Arthur Cantor. 1971. *The Playmakers.* New York: E. P. Dutton.

Louis, Morris. 1985. *Morris Louis, the Complete Paintings: A Catalogue Raisonné,* ed. Diane Upright. New York: Abrams.

Lowell, Robert. 1944. *Land of Unlikeness.* Cummington, MA: Cummington Press.

———. 1959. *Life Studies.* New York: Farrar, Straus & Cudahy.

———. 1964. *For the Union Dead.* New York: Farrar, Straus & Giroux.

———. 1977. *Day by Day.* New York: Farrar, Straus & Giroux.

Lydgate, John. ca. 1438. *Fall of Princes,* ed. Henry Bergen, 3 vols. Early English Text Society. London: Oxford UP, 1924.

Lynch, Kevin. 1960. *The Image of the City.* Cambridge, MA: MIT Press.

MacCaulay, Rose. 1964. *Pleasure of Ruins.* N.p.: Thames and Hudson.

MacDiarmid, Lucy. 1994. "Augusta Gregory, Bernard Shaw, and the Shewing-Up of Dublin Castle." *PMLA* 109: 26–44.

MacGowan, Kenneth, and Robert Edmond Jones. 1922. *Continental Stagecraft.* New York: Harcourt Brace.

MacLeish, Archibald. 1926. "Ars Poetica," in *Collected Poems: 1917–1982.* Boston: Houghton Mifflin, 1985: 106–107.

Mailer, Norman. 1968. *Armies of the Night.* New York: New American Library.

Marcus, Leah S. 1992. "Renaissance/Early Modern Studies," in *Redrawing the Boundaries,* ed. Greenblatt and Gunn. New York: The Modern Language Association of America.

Marlowe, Christopher. ca. 1592. *The Tragical History of Doctor Faustus.* ed. Roma Gill. New York: Hill and Wang, 1966.

Meredith, William. 1969. "Looking Back," in *Critics on Robert Lowell,* ed. Jonathan Price. Coral Gables, FL: University of Miami Press, 1972.

Middlebrook, Diane Wood. 1993. "What Was Confessional Poetry?" *The Columbia History of American Poetry,* ed. Jay Parini. New York: Columbia University Press.

Mielziner, Jo. 1965. *Designing for the Theatre: A Memoir and a Portfolio.* New York: Bramhall.

Miller, Arthur. 1953. *The Crucible.* New York: Dramatists' Play Service, 1954.

Moffett, Kenworth. 1977. *Kenneth Noland.* New York: Abrams.

———. 1981. *Jules Olitski.* New York: Abrams.

Moholy-Nagy, Laszlo. 1947. *Vision in Motion.* Chicago: Paul Theobald.

Mondrian, Piet. 1945. *"Plastic and Pure Plastic Art,"* in Harry Holtzman and Martin S. James, eds. *The New Art—The New Life: The Collected Writings of Piet Mondrian.* Boston: G. K. Hall, 1986.

Montefiore, Diane. 1994. *Feminism and Poetry: Language, Experience, Identity in Women's Writing,* 2nd ed. London: Pandora-Harper Collins.

Montrose, Louis Adrian. 1981. "'The Place of a Brother' in *As You Like It:* Social Process and Comic Form." *Shakespeare Quarterly* 32.

NEW YORK THEATRE CRITICS' REVIEWS. 1949. (New York: Critic's Theatre Reviews, Inc.) 8: 23.

Norberg-Schulz, Christian. 1971. *Existence, Space, and Architecture.* New York: Praeger.

THE NORTON INTRODUCTION TO LITERATURE. 1973. Combined Shorter Edition, ed. Carl E. Bain, Jerome Beaty, and J. Paul Hunter. New York: W. W. Norton.

Norwood, Gilbert. 1945. *Pindar.* Berkeley: University of California Press.

Patch, Howard R. 1927. *The Goddess Fortuna in Mediaeval Literature.* Cambridge, MA: Harvard University Press.

Piquenot, Alain. 1983. "Lecture de rhétorique de l'image: Le blocage, la rapture." *Degrés* 34: c-c 14.

Poirier, Richard. 1964. Review of *For the Union Dead,* in *Critics on Robert Lowell,* ed. Jonathan Price. Coral Gables, FL: University of Miami Press, 1972.

Procopiow, Norma. 1984. *Robert Lowell: The Poet and His Critics.* Chicago: American Library Association.

Propp, Vladimir. 1928. *Morphology of the Folktale,* 2nd ed. Austin: University of Texas Press, 1968.

Puttenham, George. 1589. *The Arte of English Poesie,* facsimile. New York: Da Capo Press, 1971.

Richards, James Maude, ed. 1942. *The Bombed Buildings of Britain, A Record of Casualties: 1940–41.* Chean, Surrey: The Architectural Press.

Ricoeur, Paul. 1984. *Time and Narrative,* vol 2, trans. Kathleen McLaughlin and David Pellauer. Chicago: The University of Chicago Press, 1985.

Righter, Anne. 1962. *Shakespeare and the Idea of the Play.* London: Chatto and Windus.

Ringle, Ken. 1991. "Political Correctness: Art's New Frontier." *The Washington Post,* 31 March, G 1 & 4.

Rosch, Eleanor. 1978. "Principles of Categorization," in *Cognition and Categorization,* ed. E. Rosch and B. Lloyd. Hillsdale, NJ: L. Erlbaum.

Rose, Barbara. n.d. *Helen Frankenthaler.* New York: Abrams.

Rosenthal, Mark. 1996. *Abstraction in the Twentieth Century: Total Risk, Freedom, Discipline.* New York: Solomon R. Guggenheim Museum.

Rudner, Richard. 1951. "On Semiotic Aesthetics." *Journal of Aesthetics and Art Criticism* 10: 67–77.

Sandler, Irving. 1971. "Abstract Expressionism," in *Art Since Mid-Century: The New Internationalism,* vol. 1. Greenwich, CT: New York Graphic Society.

Schefer, Jean-Louis. 1969. *Scénographie d'un tableau.* Paris: Editions du Seuil.

Schell, Edgar T., and J. D. Shuchter, eds. 1969. *English Morality Plays and Moral Interludes.* New York: Holt, Rinehart and Winston.

Schliefer, Ronald, Robert Con Davis, and Nancy Mergler. 1992. *Culture and Cognition: The Boundaries of Literary and Scientific Inquiry.* Ithaca NY: Cornell University Press.

Scholes, Robert. 1982. *Semiotics and Interpretation.* New Haven: Yale University Press.

Scott, Joan W. 1992. "Experience," in *Feminists Theorize the Political,* ed. Judith Butler and Joan W. Scott. New York: Routledge.

Schultz, James A. 1995. *The Knowledge of Childhood in the German Middle Ages.* Philadelphia: University of Pennsylvania Press.

Sears, Elizabeth. 1986. *The Ages of Man: Medieval Interpretations of the Life Cycle.* Princeton: Princeton University Press.

Sejnowski, Terrence. 1995. "The Hardware Really Matters," in *Speaking Minds: Interviews with Twenty Eminent Cognitive Scientists,* ed. Peter Baumgartner and Sabine Payr. Princeton: Princeton University Press.

Shahn, Ben. 1957. *The Shape of Content.* Cambridge MA: Harvard University Press.

Shakespeare, William. 1609. Sonnets, in Stephen Booth, ed. *Shakespeare's Sonnets.* New Haven: Yale University Press, 1977.

Shapiro, Michael. 1998. "Sound and Meaning in Shakespeare's Sonnets." *Language* 74: 81–103.

Sharpe, J. A. 1985. "Last Dying Speeches: Religion, Ideology, and Public Execution in Seventeenth-Century England." *Past and Present* 107: 144–67.

Sidney, Philip. 1595. "The Defense of Poesy," in Albert Feuillerat, ed., *The Prose Works of Sir Philip Sidney,* vol. 3. Cambridge: Cambridge University Press, 1962.

Smith, Harry T. 1982. "Tennessee Williams and Jo Mielziner: The Memory Plays." *Theatre Survey* 23: 223–35.

———. 1995. "Performative Devices and Rhetorical Desires: Ritual and Rhetoric in the Work of Jo Mielziner and Tennessee Williams." *Theatre History Studies* 15: 183–98.

Soby, James Thrall. 1963. Ben Shahn: Paintings. New York: George Braziller.

Soellner, Rolf. 1984. "*King Lear* and the Magic of the Wheel." *Shakespeare Quarterly* 35: 274–89.

Spevak, Marvin. 1968. *A Complete and Systematic Concordance to the Works of Shakespeare.* Hildesheim: George Olms.

States, Bert O. 1985. *Great Reckonings in Little Rooms: On the Phenomenology of Theatre.* Berkeley: University of California Press.

Stravinsky, Igor. 1936. *An Autobiography.* New York: Norton, 1962.

Sussman, Elizabeth, et al. 1993. *Whitney Museum of American Art: 1993 Biennial Exhibition.* New York: Whitney Museum.

Tarasti, Eero. 1994. *A Theory of Musical Semiotics.* Bloomington: Indiana University Press.

Thompson, John. 1959. Review of Lowell, *Life Studies,* quoted in Hamilton 1982.

TIME: THE WEEKLY NEWS MAGAZINE. 1967. Vol. 89 No. 22, 2 June, 1967, 67–74.

Treitler, Leo. 1995. "What Obstacles Must Be Overcome, Just in Case We Wish to Speak of Meaning in the Visual Arts?," in *Meaning in the Visual Arts: Views from the Outside,"* ed. Irving Lavin. Princeton: Institute for Advanced Studies.

Ubersfeld, Anne. 1977. *Lire le Théâtre.* Paris: Editions Sociales, 1982.

Umiker-Sebeok, Jean. 1995. "Behavior in a Museum: A Semio-Cognitive Approach to Museum Consumption Experiences." *Signifying Behavior: Journal of Research in Semiotics, Communications Theory and Cognitive Science* 1: 52–100.

Varagnac, A. 1948. "Les Catégories d'âge définies par les comportements cérémoniels," in *Civilisation traditionelle et genres de vie*. Paris: N.pub.

Waldman, Diane. 1977. *Kenneth Noland: A Retrospective*. New York: Solomon R. Guggenheim Museum.

Wellek, Réné, and Austin Warren. 1949. *Theory of Literature*. New York: Harcourt Brace.

Whitney, Geffrey. 1586. *A Choice of Emblemes*, facsimile. New York: Benjamin Blom.

Wilkin, Karen. 1990. *Kenneth Noland*. New York: Rizzoli.

Williams, Tennessee. 1953. *Camino Real*, in *The Theatre of Tennessee Williams*, vol. 2. New York: New Directions, 1971.

———. 1971. The Plays of Tennessee Williams, vols. 1 and 2. New York: New Directions.

Wolfe, Thomas. 1942. *You Can't Go Home Again*. Garden City, NY: Sun Dial.

Yeats, William Butler. 1925. *A Vision*. New York: Macmillan, 1938.

Zeki, Semir. 1991. "A la Quête de l'Essentiel: Entretien avec Balthus." *Connaissance des Arts* 477 (November): 90–98.

———. 1993. *A Vision of the Brain*. Oxford: Blackwell.

———. 1996. The Woodhull Lecture, in *Proceedings of the Royal Institute of London*.

INDEX

17; in nonobjective art, 103–17;
by ostention, 4–6, 9–11; versus
significance, 112; of signs
according to Peirce, 2–11; and
spirituality in art, 114–17

Metaphor, 126, 130–1: conceptual
metaphors, 112–13; wheel as,
33–4

Mielziner, Jo, 23; and Robert Edmond
Jones, 99; sets for Tennessee
Williams and Arthur Miller,
89–100

Miller, Arthur, *Death of a Salesman,*
sets for, 89, 92, 96, 98

Minority writers, 71–5, 134–7

Mondrian, Piet, 11, 106, 107, 108–9,
114, 140–41 n.9

Music: and cognitive science, 125–6;
meaning of, 1, 4–5, 17, 103;
Treitler on, 4

Narrative theory: in Greimas, 121–3;
verb tenses in, 144 n.8

Neural networks, *see* Cognitive
science

New Criticism, xii, 19, 77, 142 n.7

"New formalism," *see* Poetry

Newman, Barnett, *Stations of the Cross,*
114, 149 n.12

Nominalism and realism (in
language), 62, 67–8

Noland, Kenneth, 103–13

Nonobjective art: arguments against
meaning in, 110–14; meaning of,
103–17; position at end of
twentieth century, 116–17;
question of elitism, 116

Number, numerology, 26–31, 68–9

Odets, Clifford, *Awake and Sing,* set
for, 97

Olitski, Jules, and Noland, 107

Ostention, 4–6, 7–8, 62: cultural
evidence for meanings of, 97–100,
111–14; definition, 3–6; versus
iconicity, 5–6; and meanings in
stage sets, 95–6; versus
symbolization 69, 111

Parody, in postmodernism, 74–75,
101–2

Peirce, Charles Sanders, 133, 140 n.4,
141 n.3; symbols, 101; trichotomy
of signs, 2–3, 111

Poetry, 57–75: definition of form in,
59, 64–65; iconicity of sound
questioned, 69–71; and language,
58; "new formalism," in, 71–5;
possibility of semiotics of, 57–8

Postmodernism: and parody, 74–5,
101–2; and stage design, 100–2

"Props" (stage properties), semiotics
of, 94–5

Puryear, Martin, 21–2, 111

Realism (linguistic) *see* Nominalism
and realism

Rhyme, meaning of, 65–7

Rothko, Mark, and spirituality in art,
114–17

Semiotics: and cognitive science,
119–31; expression plane and
content plane, 13–21; intention in,
86–7; of nonobjective art, 103–17;
and Peirce, 2–11; of poetry, 57–9,
72; sign making process, 13–24;
signifying stages of life, 54–5; of
theater, 89–92, 100–02; as
theoretical base, xiv

Shahn, Ben, 137–8, and Mielziner's
sets, 98–9